FACE TO FACE
M. W. Hopkins and Noah North

FACE TO FACE
M. W. Hopkins and Noah North

H DORRANCE DEL. HOWLANDS SC.

FACE TO FACE
M. W. Hopkins and Noah North

MUSEUM OF OUR NATIONAL HERITAGE

An exhibition organized by
the Museum of Our National Heritage
Lexington, Massachusetts

September 11, 1988 – January 15, 1989

The exhibition will travel to

THE STRONG MUSEUM
Rochester, New York
February 24 – April 10, 1989

NEW YORK STATE HISTORICAL ASSOCIATION
Cooperstown, New York
May 1 – December 31, 1989

MUSEUM OF AMERICAN FOLK ART
New York, New York
February 15 – April 15, 1990

ISBN 0–9621107–7–9
88–063535

FRONTISPIECE Albion, New York, c. 1835

During the 60-odd years that naive art has been under discussion as an American art form, it has undergone many interpretations and evaluations. Making its appearance in the early 1920s through the growing appreciation of a few contemporary artists, folk art was not at first accepted as genuine "art" although its historical and utilitarian background was even then minimized in favor of stressing its purely aesthetic qualities. Portraits, when exhibited, were hung in formal settings where their lack of perspective and anatomical accuracy were emphasized, thereby depriving the sitters of any sense of personal identity. Artifacts such as weathervanes and decoys tended to be mounted on brackets or shelves against stark white walls, their dis-embodied silhouettes conveying little of the essence of their spirited past.

Gradually, however, the directness and simplicity of folk expression began to appeal to the collecting public and to be regarded as a valid part of the mainstream of early American life. Slowly galleries once dedicated to formal decorative arts started to offer primitive paintings and sculpture, and a growing number of pioneer collectors began to think in terms of finding worthy examples with which to enrich public collections or to enliven their own surroundings. With expanding research came a growing awareness of the historical value of 19th-century folk culture, and of what the pictures and the lives of the artists could convey to 20th-century scholars about earlier life and times.

The study of folk art has gradually broadened over the years rewarding both the art historians, who still value it primarily as a stimulating art expression, as well as the social historians, who learn from its pictorial images how 19th-century Americans viewed their farms, furnished their homes, and instructed their children.

Nina Fletcher Little

CONTRIBUTORS Mary Black was curator and director of the Abby Aldrich Rockefeller Folk Art Center; director of the Museum of American Folk Art; and curator of painting, sculpture, and decorative arts at the New-York Historical Society. She has organized exhibitions on Edward Hicks, Erastus Salisbury Field, and American primitive watercolors, among other subjects, and has published numerous books and articles on American folk art.

Nina Fletcher Little has researched and written about all aspects of American folk art since the early 1940s. She has published numerous books and articles and organized exhibitions of works of folk painters for many museums including the Museum of Fine Arts, Boston; the Worcester Art Museum; and the Abby Aldrich Rockefeller Folk Art Center.

Jacquelyn Oak began studying folk art when she was a member of the research department at the Shelburne Museum. She has written extensively about M. W. Hopkins and Noah North and other New York state folk artists and was a contributor to *American Folk Painters of Three Centuries* (1980) and *Folk Art's Many Faces Portraits in the New York State Historical Association* (1987). She has been registrar at the Museum of Our National Heritage since 1978.

Grant B. Romer, chief conservator, International Museum of Photography at George Eastman House, has published many articles and lectured widely about daguerreotypy and other forms of early photography. He has taught numerous courses in photographic conservation and is a practicing daguerreotypist.

William H. Siles, historian at the Strong Museum, specializes in 19th-century American social history.

David Tatham is chairman, Department of Fine Arts, Syracuse University. His numerous publications include *Winslow Homer Drawings 1875–1885* (1979); *Abraham G. D. Tuthill: Portrait Painter in the New Republic* (1983); and *Prints and Printmakers of New York State 1825–1940* (1986).

When research extends over a period of 13 years through five states, many people become involved in the process. For their support and assistance in various aspects of this project I am grateful to Gary Arnold, Ohio Historical Center; Jane Becker, Boston University; Georgia B. Barnhill, American Antiquarian Society; Donna K. Baron, Old Sturbridge Village; Robert Bishop, Museum of American Folk Art; Laura L. Chace, Cincinnati Historical Society; Deborah Chotner, National Gallery of Art; Donald Constable, Holland Land Office Museum; Robert P. Emlen, John Nicholas Brown Center for the Study of American Civilization; Gisele B. Folsom, Shelburne Museum; Wendell D. Garrett, *The Magazine Antiques*; Harvey Green, Strong Museum; Irene M. Gibson; Doris E. Hoot, Genesee Country Museum; Neil H. Johnson, Albion Village Historian; Richard Kerschner, Shelburne Museum; C. W. Lattin, Orleans County Historian; A. Bruce MacLeish, New York State Historical Association; Milo M. Naeve, The Art Institute of Chicago; Celia Oliver, Shelburne Museum; Daniel R. Porter, New York State Historical Association; Laura Roberts, New England Museum Association; Beatrix T. Rumford, Colonial Williamsburg; Paul D. Schweizer, Munson-Williams-Proctor Institute; Robert Shaw, Shelburne Museum; Joel D. Sweimler, Olana State Historic Site; and Joyce Ann Tracy, American Antiquarian Society.

Many folk art scholars offered consistent encouragement and willingly shared their thoughts about the work of M. W. Hopkins and Noah North. I am particularly indebted to Paul D'Ambrosio, New York State Historical Association; Charlotte Emans, Boston University; Colleen Cowles Heslip, Sterling and Francine Clark Art Institute; Joyce Hill, Museum of American Folk Art; Helen Kellogg; Nina Fletcher Little; Barbara Luck, Abby Aldrich Rockefeller Folk Art Center; Eugene W. Metcalf, Jr., Miami University; Elizabeth V. Warren, Museum of American Folk Art; and Carolyn J. Weekley, Abby Aldrich Rockefeller Folk Art Center.

Mary Black, Nina Fletcher Little, Grant B. Romer, William H. Siles, and David Tatham added their considerable skills and enthusiasm to every aspect of this project.

Nancy Clagett Muller's preliminary research on Noah North formed an important element of this study; I extend to her my thanks. Through many discussions, Philip N. Grime greatly assisted me in clarifying my thoughts about the nature of folk painting and Richard Pace increased my understanding of "democratic" likenesses.

Many people at the Museum of Our National Heritage listened patiently as the story of M. W. Hopkins and Noah North unfolded. My sincere thanks are extended to Serena Furman, the designer of the exhibition, and to the rest of the museum staff for their assistance in the production of both the exhibition and the catalogue.

Elizabeth and David D. Oak, my parents, supplied endless support and encouragement for this study.

To John Miller, I extend my deepest gratitude for his sustained interest and extraordinary effort throughout this project.

Barbara Franco's remarkable editorial skills made sense of my random thoughts; her insights and guidance made this exhibition and publication possible.

Jacquelyn Oak

The catalogue accompanying an exhibition of the work of M. W. Hopkins and Noah North, two upstate New York portrait painters of the 19th century, represents the culmination of 13 years of research. Its publication coincides with increasing debate about the definition and significance of folk art.

Should folk art be valued primarily for its aesthetic qualities emphasized by early collectors? Or is it better understood within the context of the society in which it was produced as scholars of material culture would maintain?

Jacquelyn Oak's exhaustive research into the lives of these two artists and their sitters has resulted in a case study that includes specific information rarely available for American 19th-century artists. These specifics provide a new body of factual information against which the theories about folk art can be tested. The exhibition serves as a vehicle for bringing new research to a public forum. It is a study that will add to the growing scholarship on American regional cultural history.

The Museum of Our National Heritage gratefully acknowledges the contributions of the following organizations and individuals toward the publication of this catalogue: American Folk Art Society; Bristol-Myers Pharmaceutical and Nutritional Group, courtesy of Raymond C. Egan; Mary and David Chambers; Mr. and Mrs. Barber B. Conable, Jr.; Mr. and Mrs. William Dixon; Dr. and Mrs. Ralph Katz; Sybil and Arthur Kern; Mr. and Mrs. William M. North; Elizabeth and David D. Oak; and Mr. and Mrs. Stephen Rubin.

Barbara Franco
Assistant Director for Museum Programs

FACE TO FACE

M. W. Hopkins and Noah North

FACE TO FACE

M. W. Hopkins and Noah North

William H. Siles

The Genesee Country in upstate New York is a region abounding in natural resources. Its rich soil, moderate climate, abundant water supply and potential for rapid development attracted land developers and thousands of pioneers. Settlers called the Genesee the "Promised Land." Many who persevered became solvent, some even wealthy, as a turnpike, the Erie Canal, and the railroad linked the region to national and international markets.

The Genesee Country is named after the Genesee River, which flows northward from Cuba, New York, near the Pennsylvania border, through Rochester to Lake Ontario. Genesee is an Indian word meaning beautiful, clear, open valley. The term applied to a stretch of river running from Mount Morris to Avon in Livingston County. During the late 18th century, American geographers referred to the land between present day Rome and Buffalo, New York, as the Genesee Country. Then, as knowledge of upstate New York improved, the term referred to the land west of Geneva, New York.[1]

The first stream of settlers in 1789 swelled to a flood by 1800. The 1790 census reported 1,075 people in an area from Geneva to Buffalo. By 1800, the population increased to 17,272 in the counties of Ontario, Steuben, and Genesee, then comprising all the lands in the Genesee Country.[2] In 1830, with a population of 368,110, western New York was recognized as a major growth area in the country. By 1835, Rochester (with a population of 14,414) and Buffalo (with 19,715 residents) were incorporated as cities, and the region's population reached 437,570. By this time, the Genesee had become known as the "Granary of America," and the country's most successful frontier region.[3]

The energy the settlers displayed in transforming the Genesee from a wilderness to a self-sustaining commercial society in little more than 10 years reflected a migration at once youthful and efficient. The first wave of settlement in 1789 was checked by Indian uprisings in Ohio and by the continued presence of the British in American forts. When General Anthony Wayne's army defeated the Indians at Fallen Timbers in northwest Ohio in 1794, and the British evacuated their troops from American soil under terms of the Jay Treaty of 1796, migration resumed in earnest.

The typical migrant was a married man with a family, traveling west with friends, neighbors, and relatives, often from the same locale. The average head of the family was 31 years old and had four children. Single men, some well educated in medicine and the law, settled among the families. On the whole, though, the frontier was settled by families. The enormous effort required to clear land, plant and harvest crops, and build and maintain shelter made labor a precious commodity in the sparsely populated wilderness. Family and group settlement provided pioneers with badly needed help and eased the burden of settling land far from home.[4]

The wave of settlers came mainly from New England. They were joined by families from New Jersey, Pennsylvania, eastern New York, and Maryland, as well as immigrants from England, Scotland, Wales, and Canada. The Yankees brought with them the tenets of Congregational and Presbyterian religion. The English, Dutch, and American southerners established Episcopalian, Baptist, Methodist, and Dutch Reformed religious societies in the West. The Catholics established St. John's church in Utica in 1819 and St. Patrick's in Rochester in 1820.[5] There were also nonpracticing Christians, spiritualists, and atheists in the settlements, as well as other groups who worshipped according to no denominational plan.

Although the Genesee Country was populated with families from a variety of geographic and religious backgrounds, the large migration of New Englanders of every class made the region a Yankee bastion. Concentrations of Yankees were found along the main highways between the river and Geneva, but the schoolhouse, church, and tavern marked their presence where good land could be obtained.[6]

Farmers living in central and western Massachusetts and Connecticut were pinched by a shortage of good, inexpensive land. The poor soil required enormous investments of labor to achieve a scanty yield. Depreciated state currencies, devalued by the Revolutionary War debt and farmer unrest as typified by Shays's Rebellion in Massachusetts in 1786, made many New Englanders feel that their future there was not bright. Lacking suitable alternatives, many younger men struck out for the Genesee. Some men visualized making profits on increases in land values, while others wanted to start businesses for themselves. Every settler started west with optimism and a strong will to succeed.[7]

Yankee values shaped the society planted in the Genesee. Thrift, simplicity, hard work, and belief in the sanctity of the Bible were the fundamental values — buttressed by religious and educational institutions that imparted the Calvinist work ethic and emphasized the importance of self-sufficiency and self-discipline. Practical knowledge was highly valued, especially knowledge of the marketplace, politics, and one's self. Religion and education helped individuals to achieve and preserve their economic, political, and religious freedoms. Settlers believed that self-sufficiency and self-restraint would assure the successful transplanting of eastern society to the western frontier, and with it the political and social democracy that they cherished.[8]

The growth of the Genesee Country economy required improvements in transportation eastward, both to stimulate commerce and to raise land values. The main objectives of the early settlers were to earn a living sufficient to pay for their properties and to make improvements on them. In a land far from cities where everything, but especially labor and capital, were scarce, these objectives were difficult to achieve. The cost of a typical farm of 120 unimproved acres was $1200 and an additional $450 was required to clear the usual quantity of 30 acres. Those who had made less than a 10 percent down payment found it difficult to earn enough from cash crops to pay their debt.

Before the construction of the Erie Canal, wheat was grown in limited quantities because of its low profit potential, due to the expense of hauling it to eastern markets. Agriculturists instead sought commodities with a high value in proportion to their bulk. Potash, beef, and whiskey were among the commodities that commanded high enough prices to cover the cost of transportation and produce a good profit.[9]

Income from agriculture rarely covered the costs of creating a farm prior to 1825. To supplement their incomes, farmers worked at other trades such as blacksmithing, carpentry, coopering, mill construction, and shingle making. Some farmers nevertheless could not meet their land payments. In 1819, the president of the Agricultural Society of Genesee County estimated the debt of the region west of the Genesee River at five million dollars. Although the annual interest rate on this debt was calculated at $350,000, farmers paid no more than $150,000 a year, leaving an additional $200,000 to accumulate each year at seven per cent compounded interest.[10]

The farmers' heavy debt led to a restructuring of the payment system by the land companies, while the increasing costs of land for homesteading led to the rise of farm tenancy. By 1827, when the principal and interest on their property surpassed the original maximum price, farmers received new mortgage contracts. Payments were scaled back, but bitterness remained between land holders and mortgage holders. Mortgage holders also agreed to accept cattle and grain as payment at prevailing market prices and this policy rescued thousands of settlers when the market price of all commodities rose after the Erie Canal opened in late 1825. On the other hand, property values doubled after 1825, making it impossible for many families with limited finances to afford good farm land.

Others who failed to meet their mortgage payments also became tenants. Many of these folk leased land from investors such as the Wadsworth family of Geneseo, New York, and worked it on shares. After 1825, the Genesee was marked by two distinct classes of citizens: property owners possessing comfortable frame, brick, and cobblestone houses, and renters living in modest accommodations.[11]

The fabulous economic growth after 1825 was due in large measure to the impact of the canal on transportation costs to eastern markets. The large cargo capacity of Erie Canal boats brought the cost of shipping a ton of wheat 95 percent and cut the time of transport from Rochester to New York City, for example, from 10 to five days. At prices between four and 10 dollars for a barrel of flour, wheat acreage increased 22 percent between 1821 and 1835. Millers built flour mills at numerous water power sites. Rochester, with a major falls on the Genesee, became America's flour milling center. The city's 21 flour mills produced 300,000 barrels of flour in 1840, two-thirds of the total amount shipped on the Erie Canal. The flour trade alone was worth six million dollars a year to Genesee farmers and millers in 1835. Land bordering the canal became five times as densely settled in 1835 as it had been in 1817. Population in counties where the canal was located jumped 45 percent, on average, between 1820 and 1840. Rochester's population, for example, rose from 331 in 1815 to 14,414 in 1835, an increase of more than 4,000 percent.[12]

By linking western New York to eastern markets, the Erie Canal created a bonanza for New York State's producers and retailers. The economy of upstate New York became fully integrated with New York City. At the same time, upstate New York became less reliant on Montreal, Philadelphia, and Baltimore, its traditional trading partners, and New York City became the "great depot and warehouse of the western world," as proponents of the canal had predicted.[13]

Economic success did not eliminate moral and political problems. Genesee citizens had their beliefs in economic opportunity, equality before the law, and political democracy tested when conflict broke out in September 1826, over the news that William Morgan of Batavia had been kidnapped. Morgan was a Mason who had shocked the fraternity when he announced his intention to publish its secrets in a book. In addition to profits, both he and his publisher, David L. Miller of the Batavia Republican Advocate may have wanted revenge against certain Masonic lodges in the area. When the Batavia Masons took steps to stop Morgan and Miller, Morgan disappeared and Miller's business was nearly destroyed by fire.[14]

Grand juries in several counties investigated the Morgan case and related "outrages" for four and one-half years, from October 1826 to mid-1831, with little success. Western New Yorkers, and eventually the entire nation, watched with disbelief and mounting anger as Masons worked to subvert the legal process. The guilty were hidden from the law, many witnesses were instructed not to testify, and courts packed with Masonic judges and juries acquitted members brought to trial. In Genesee County, for example, 26 different men were indicted for their part in abducting Morgan and attacking Miller; six came to trial and four were convicted and given light sentences. Reasonable people, inside the Masonic fraternity and out, clamored for a fair application of the law. Justice, it appeared, had been defeated by a stubborn elite who placed their solemn oath to protect each other as Masons above the law of the land.[15]

Antagonism against Masons resulted in the near obliteration of the fraternity in certain areas by 1832. The clergy argued that Masons held their fraternal oath more important than their commitment to Christianity. Some churches split over the issue, resulting in bitter contention within church communities. The undisguised attempt of certain Masons to destroy the judicial system supported the claim of some that Freemasonry was a threat to the country's experiment in republicanism. By 1830, upstate New York was divided politically, with a large majority of voters supporting an anti-Masonic ticket to prevent Masons from holding political office. Anti-Masons believed that an "aristocracy" of Masons had no place in a country peopled with common men, and its "paganism" had no role in communities valuing Christianity.[16]

One reaction to the controversy over politics, religion, and secret societies among local leaders in communities such as Rochester was to institute a revival of religion among the citizenry. Perhaps then, they reasoned, other evils such as intoxication, Sabbath breaking, and creeping materialism could also be eliminated.

Abuse of alcohol became a moral issue among religious and lay reformers. Traveling representatives of the Massachusetts Temperance Society, founded in Boston in 1826, spoke in upstate New York churches, schoolhouses, and public halls. In 1828, the Rochester Society for the Promotion of Temperance was formed and countywide temperance societies followed. The connection between temperance reform and religious revival was completed when ministers declared sobriety "a requirement of salvation."[17]

The Sabbatarian movement was another religious cause that arose in this fractured and contentious society. The movement was aimed mainly at Sunday-working canal towns but had an impact wherever the United States mails were carried by stage coach or steamer. The Sabbatarians deplored the practice of working on Sunday and the government's utter disregard for the Lord's day. A group of Rochesterians formed a Sabbatarian canal and stage line. Led by Elder Josiah Bissell of the Third Presbyterian Church in Rochester, the Sabbatarians were determined to boycott all enterprises in upstate New York that conducted business on Sunday. The group petitioned the United States Senate's post office committee to halt Sunday transportation of mail but was rebuffed by its chairman who urged Sabbatarians to use persuasion rather than the law to compel people to reform their work habits.[18]

Divided over the issues of alcohol consumption, Sabbath labor, and the Masonic scandal, members of the Third Presbyterian Church in Rochester extended an invitation to Charles Grandison Finney to lead a revival of religion in their church. Finney, an acclaimed revivalist preacher, arrived in early fall of 1830. By spring of 1831 western New York, including Rochester, had experienced one of the great religious awakenings in American history. After Finney's exhortations, area churches faced the world with unity of purpose, militancy, and a confidence in their ability to change society that was unthinkable only months earlier. Finney's plan was to preach seven days a week in country churches as often as he was invited. He visited nearly all the Congregational and Presbyterian churches from Seneca Falls to Batavia. Ministers copied Finney's methods and his philosophy of free will conversion, thereby igniting revivals in Methodist, Baptist, and Episcopal churches. Finney's movement was millenarian in nature, requiring nothing less than immediate reformation of individual behavior and the perfection of society. He and his followers believed that upstate New York and all of America could be converted in a matter of months, raising hopes that the beginning of the thousand-year reign of Christ on earth was possible in the 1830s.[19]

Finney's revival of religion touched the lives of the leading members of every town and village in the Genesee Country. Merchants, artisans, professionals, and manufacturers joined churches in large numbers, creating congregations of the most successful people in local society. They used their position to influence their neighbors and employees on matters of religion. All frivolous pastimes were avoided. In Rochester, for example, businessmen turned the theater into a livery stable and the circus building into a soap factory. The clergy rejoiced and used the income from their growing contributions to erect new churches and to hire expert revival ministers to keep the fires of salvation raging.[20]

Benevolent reformers also listened carefully to the message of the abolitionists who spoke from Genesee Country pulpits and in town halls. After the mid-1830s, the revivals created a climate of social reform congenial to the abolitionist program. Antislavery speakers argued for an immediate end of the "peculiar institution" as part of a reformation of the republic. Antislavery debates generated strong views on each side of the issue in the 1840s and led some churches to close their doors to the abolitionists. Yet the message took hold, and local antislavery societies were formed in Rochester and surrounding communities. Unlike temperance and anti-Masonry, abolition was not a widely popular reform. Its advocates risked personal attacks for supporting black freedom and the Genesee Country became a haven for escaped slaves.[21]

The issue of slavery split political parties, churches, and families. The resulting Civil War marked the end of an era in Genesee Country history. By then, wheat and flour were no longer preeminent in its economy. Wheat farming declined as the soil became depleted, and competition from western farmers, helped by cheap railroad rates, took away the wheat market. The importance of revivalism in the region's social and political life declined. The millenium never materialized; many Christians suffered relapses, and East Coast cities failed to respond to Finney's preaching.[22]

After the Civil War, the economy of the region prospered. Urban markets created a strong demand for fruits and vegetables, and the railroad, with its huge cargo capacity and speed, enabled growers to reach distant markets overnight. The new prosperity was not accompanied by the social and religious upheavals that earlier expansion had generated. A population, disillusioned with Perfectionism, more self-assured in its new wealth, and more interested in its display, curtailed outbreaks of religious extremism. After 1860, materialism won a victory over revivalism, society became more structured, and self-restraint lost out to the pursuit of self-satisfaction.

A manifestation of success was the "likeness" or painting of individuals and family members hanging in the parlor, dining area, or bedroom of a comfortable house. The people portrayed in many a painting had worked hard and some had experienced privation. Thus, the painting reflected the taste and values of the people themselves; it was simple, direct, and perhaps sentimental. The people portrayed were people of conviction and determination who set out to make a success of their lives and did so to the best of their ability.

The failure of revivalism did not overshadow the economic and social achievement of Genesee Country settlers. Canal houses, farming communities, manufacturing sites, and rail centers created a robust economy and significant opportunity for upward mobility. Farmers, merchants, bankers, millers, professionals, and tradesmen prospered as prices and land values rose during the first half of the 19th century. These people believed that success was based upon energy, enterprise, temperance, and hard work—cultivated in the church, school, and home—and applied these virtues in the workplace.

1. Enos Boughton, Stockbridge, Massachusetts to Oliver Phelps, February 7, 1791, Box 18, Phelps and Gorham Papers, New York State Library, Albany. Hereafter cited as PGPA; "Early description of the Genesee Country," n.d., Box W-2, Hubbell Papers, Princeton University, New Jersey; Richard A. Mordoff, *The Climate of New York State,* Cornell Extension Bulletin 764 (Ithaca, 1949), pp. 7, 14, 16–17, 19, 21, 28–35; George B. Cressey, "Land Forms," *Geography of New York State,* ed. John H. Thompson, (Syracuse, 1968), pp. 43–44.

2. Neil Adams McNall, *An Agricultural History of the Genesee Valley, 1790–1860* (1952; reprint, Westport, Connecticut, 1976), pp. 228–229; Paul Wallace Gates, "Agricultural Change in New York State, 1850–1890," *New York History* 50 (1969): pp. 114–141; Paul Wallace Gates, *The Farmer's Age: Agriculture, 1815–1860* (New York, 1960), pp. 247–248, 254–262.

3. Horatio Gates Spafford, *A Gazetteer of the State of New York* (Albany, 1813), pp. 6–7; J. H. French, *Gazetteer of the State of New York* (Albany, 1860), pp. 151, 288, 404.

4. *Heads of Family,* First Census of the United States, 12 vols. (Washington, D.C., 1907–1908), pp. 7, 138; Ralph V. Wood, Jr., *Ontario County, N.Y., 1800 federal population census schedule* (Cambridge, Massachusetts, 1963), pp. 9–13; Gravestone inscriptions, Pioneer Cemetery, Canandaigua, New York; Orsamus Turner, *Pioneer History of the Holland Purchase of Western New York* (Buffalo, 1850), pp. 472–489; "Sale of land in Township 10, Range 3," Box 70, Fol. 2, PGPA.

5. William H. Siles, "A Vision of Wealth: Speculators and Settlers in the Genesee Country of New York, 1788–1800" (Ph.D. Dissertation, University of Massachusetts, Amherst, 1978), pp. 147–150, 233–237; James H. Hotchkin, *History of the Purchase and Settlement of Western New York* (New York, 1846), pp. 24–25; Robert F. McNamara, *The Diocese of Rochester, 1868–1968* (Rochester, 1968), pp. 31, 33.

6. Frederick Jackson Turner, "Greater New England in the Middle of the Nineteenth Century," American Antiquarian Society *Proceedings* 29 (1919): pp. 222–241. Rufus Stickney Tucker, "Expansion of New York," *New England Historical and Genealogical Register* 76 (1922): pp. 301–307.

7. Judah Colt, "Journal of Judah Colt," *Buffalo Historical Society Publication,* 7 (1904): pp. 331–334; "Remarks of C. J. Hill," cited in *Proceedings of the Annual Festivals of the Pioneers of Rochester* (Rochester, 1846), p. 16.

8. McNall, pp. 41, 84; Gates, *The Farmers Age,* p. 33.

9. William H. Siles, "Pioneering in the Genesee Country: Entrepreneurial Strategy and the Concept of a Central Place," *New Opportunities in a New Nation,* eds. Manfred Jonas and Robert V. Wells (Schenectady, 1982), pp. 65–66; McNall, pp. 88–89, 101.

10. Ibid., pp. 102–103.

11. Turner, *Holland Purchase,* pp. 442–452, 566; McNall, pp. 52–54, 63–65.

12. Blake McKelvey, *Rochester, The Water Power City, 1812–1854* (Cambridge, 1945), p. 171; McNall, pp. 108, 118–119; N. E. Whitford, *History of the Canal System of the State of New York,* 2 vols. (Albany, 1906), pp. 2, 852–855, 883, 922–923.

13. "Memorial of the Citizens of New York . . . ," *NY Canal Laws,* I, p. 123, cited in Nathan Miller, *The Enterprise of a Free People* (Ithaca, 1962), p. 40.

14. Ronald P. Formisano and Kathleen Smith Kutolowski, "Antimasonry and Masonry: The Genesis of Protest, 1826–1827," *American Quarterly,* 28 (Summer, 1977), p. 147.

15. Ibid., pp. 148–149, 154–155.

16. See, for example, Session Meeting Minutes, The Congregational Church of Plattsburg, New York Records, 1804–1876; Covenant Meeting Minutes, First Baptist Church of Romulus, New York Records, 1818–1898; Convenant Meeting Minutes, First Baptist Church of Williamson, New York Records, 1826–1878; Covenant Meeting Minutes, Second Baptist Church of Walworth, New York Records, 1832–1866; and the Covenant Meeting Minutes, First Baptist Church of Marion, New York, Records, 1804–1904. Study Center for Early Religious Life in Western New York Record Collection, Olin Library, Cornell University, Ithaca, New York.

17. Paul E. Johnson, *A Shop Keeper's Millennium* (New York, 1978), pp. 79–83.

18. Ibid., pp. 85–86.

19. Whitney R. Cross, *The Burned-over District, The Social and Intellectual History of Enthusiastic Religion in Western New York, 1806–1850,* (Ithaca, 1950), pp. 155, 158, 199; Johnson, pp. 95, 109.

20. Ibid., pp. 102–104, 114–115. See also, Covenant Meeting Minutes, First Baptist Church of Palmyra, New York Records, 1835–1865; Annual Meeting Minutes, First Baptist Church of Williamson, New York Records, 1826–1878; and Records, Methodist Episcopal Church of Corning, New York, 1832–1897. Study Center for Early Religious Life in Western New York Record Collection, Olin Library, Cornell University, Ithaca, New York.

21. Thayer Gauss, "Diary of Thayer Gauss, 1798–1879," November 27, 1837; May 27, 1838; April 20, 1840; November 9, 1841; February 9, 1842; June 22, 1842; October 28, 1842; January 12, 1843. Study Center for Early Religious Life in Western New Record Collection, Olin Library, Cornell University, Ithaca, New York; Cross, pp. 226, 280–281, 353.

22. Sidney Ahlstrom, *A Religious History of the American People* (New Haven, 1972), pp. 740–743, 744–748; Marion L. Bell, *Crusade in the City: Revivalism in Nineteenth Century Philadelphia* (Cranbury, New Jersey, 1977), pp. 39, 161, 252.

M. W. Hopkins and Noah North represent the last generation of an American tradition of artisan painters that begins in the 17th century in the Hudson River Valley, moves east to Connecticut, and then follows westward settlement of upstate New York and Ohio in the 19th century. Common themes appearing in the work of artists whose lives span three centuries unite them as members of a specific craft tradition. These craftsmen mastered their trade in associations of long or short duration with other painters, some academically trained, others little taught. The relationships among them were often based on family ties, shared patronage, and apprenticeships. An unexpected number of these artisan painters were political or social activists in their communities. Their works show common stylistic elements, best characterized as honest, linear, two-dimensional, decorative, and were based on similar design sources.

The Duyckinck cousins—Evert and Gerardus—whose painting styles are almost indistinguishable one from the other, learned their profession from Gerrit Duyckink, the father of Gerardus, a limner and glass painter who had learned the trade of "glass burning" from his father. Gerrit Duyckinck set another non-painterly pattern for his successors on the American scene by becoming an active participant in a political revolt opposing the English administration of New York led by Jacob Leisler and other supporters of William of Orange with Dutch sympathies. The art historian, Waldron Phoenix Belknap described the Leisler faction as "the equivalent of the Whig party in England" and "the framework of the Whig party in New York throughout the 18th century."[1] In a 1694 affidavit, Duyckink testified that he was present when instructions from the new monarch, William of Orange were delivered to Leisler rather than the old Council. He also described painting a new name on a captured vessel before Leisler fell into the hands of the English administrators of New York in 1691 and was hanged.[2] Duyckinck's leading role in this event foreshadowed the involvement of later painters in American Whig Party affairs. Milton W. Hopkins and Noah North continued the tradition of democratic sympathies that many New England and New York painters of the 19th century supported and embraced.

In addition to the linear, uncompromising style of portraiture that carries through the generations of limners, two stylistic elements further tie the earliest Hudson River school of painters to their contemporaries and to artists like Hopkins and North who followed them. One was painters' access to common sources for painting materials and supplies. In New England, New York, and Tidewater, Virginia, early 18th-century painters used a comparatively limited range of English mezzotint engravings produced between 1690 and 1746 as sources for costumes, backgrounds, poses, and decorations. An even more tantalizing connection in this early 18th-century period was the extensive use of one distinctive design and type of English molding for both rectangular and oval frames. The gold-leafed wooden frames have bracketed elements interspersed between carved bellflower motifs set against a diapered background. Frames with this decoration are seen surrounding New York portraits by Gerrit, Gerardus, and Evert Duyckinck III; John Watson; Pieter Vanderlyn; and John Heaton; as well as on works of art by at least three limners of this period working in New England.

Mary Black

1. Waldron Phoenix Belknap, *American Colonial Painting: Materials for a History, Cambridge, Mass.*, The Belknap Press of Harvard University Press, 1959, p. 109.

2. *Ibid.*, p. 111.

3. Rita S. Gottesman, *The Arts and Crafts in New York, 1726–1799*, New York: New-York Historical Society, 1938, pp. 129–130, quoting advertisement appearing in *The New York Weekly Post Boy*, 18 August 1746.

4. *Ibid.*, p. 354, quoting advertisement appearing in *The New-York Gazette or the Weekly Post-Boy*, 18 November 1754.

5. George C. Groce and David H. Wallace, *The New-York Historical Society's Dictionary of Artists in America, 1654–1860*, New Haven and London, Yale University Press, 1957, pp. 172–173.

6. *Ibid.*, p. 197.

7. William Dunlap, *A History of the Rise and Progress of the Arts of Design in the United States*. Reprint of the 1834 Edition, introduced by James T. Flexner and edited by Rita Weiss, New York: Dover Publications, Inc., 1969, vol. 1, p. 144.

8. Nina Fletcher Little, "Winthrop Chandler," *Art in America*, vol. 35, no. 2 (April 1947), pp. 77–168.

9. The portraits of Captain and Mrs. Samuel Chandler are owned by the National Gallery of Art, the gift of Edgar William and Bernice Chrysler Garbisch.

Limners in the Duyckinck family continued into the fourth generation with Gerardus Duyckinck II, who, following the death of Gerardus Duyckinck in 1746, advertised that he was continuing his father's business in painters' and decorators' supplies, identifying himself as a limner and instructor in drawing and painting on glass.[3] No work has been attributed to this final generation of painters to bear the Duyckinck name, but the listing of pigments in his 1754 advertisement in a New York newspaper recalls the palettes employed by almost every one of the earlier painters in New York. The one exception is Prussian blue, introduced later. The colors he offers include "White-Lead, Red-Lead, Spanish Brown, English, French, Spruce, and Stone Oker, Indian and Venetian Red, Ivory, Frankford and Lamp-Black, Umber Cullin's Earth, Smalt's Prussian Blue, Vermillion, Verdigrase, the whole ground in Powder or in Oil."[4]

The tradition established by the Duyckincks was carried on by a step great-grandson of the first Evert. Abraham Delanoy, Jr., a child of Evert Duyckinck II's widow by her second husband, was born in New York in 1744. He played a role in the transmittal of the linear style portraits of the Hudson River to rural Connecticut, where the style flourished and developed from the mid-1760s to the first decades of the 19th century. After studying for a year in London with American-born Benjamin West in about 1766, Delanoy returned to New York. In 1768 he was in Charleston, South Carolina, where he is believed to have stopped on his way to the West Indies. By 1771 he was back in New York and near the end of his career painted portraits in and around New Haven, Connecticut, before his death in Westchester County, New York, in 1795.[5]

Connections among artists working in this style who were contemporaries is suggested by the repeated pattern of overlapping patronage. The Beekman family presents one such example. Delanoy's great aunt married into this powerful New York family and two of his identified portraits are of his Beekman cousins, Cornelia and Magdalena, portrayed as children by his older stepcousin, Evert Duyckinck III. A third artist, John Durand, painted the six children of James Beekman in 1766, the same year that he appears to have entered upon the New York scene.[6] Beekman family records refer to him as "Monsieur Duran," leading to speculation that he might have come to the colonies from the West Indies. His style and American working dates coinciding with those of Delanoy suggest an association between the artists that may have been established through Delanoy's Beekman relatives. Durand preceded Delanoy to Connecticut, painting there briefly in the late 1760s. He later traveled to Virginia, where William Dunlap, the first—but not always reliable—American art historian, tells of Robert Sully's report of Durand's painting "immense numbers" of portraits, which "R. Sully" characterized as "hard and dry," but "strong likenesses."[7]

John Durand began painting in Connecticut at about the time that Winthrop Chandler, born in Woodstock, Connecticut, in 1747, was beginning his career.[8] Chandler was 23 when he painted the earliest of his known portraits—the Reverend and Mrs. Ebenezer Devotion. Among Chandler's finest works are the life-sized, full-length images of his sister-in-law and brother, Captain and Mrs. Samuel Chandler.[9] These monumental likenesses, exuberantly costumed—he in his

Revolutionary War uniform and she in moire taffeta, fine lawn, delicate lace, and pinked ribbons—are related stylistically to the later work of Simon Fitch, Chandler's neighbor in nearby Lebanon, Connecticut, most notably his rocklike figures of Hannah and Ephraim Starr of Goshen, Connecticut.[10]

It is in paintings signed by or attributed to Reuben Moulthrop, born in East Haven, Connecticut, in 1763, that the "hard, dry" style, dark outlining of arms and hands, and excellent likenesses of Durand are most closely imitated.[11] Durand had vanished in 1782, but Moulthrop's first attempts were in New Haven at about the time that Delanoy was working there. The kinship in style between Delanoy and Durand, and the overlapping New Haven patronage of Delanoy and Moulthrop, suggest that Moulthrop may have assisted the older artist and through him became familiar with the work of Durand. Moulthrop, like many other professional limners, had an allied profession, the unusual craft of modeling miniatures in wax. While his oil portraits were apparently limited to Connecticut subjects, by the turn of the century his wax miniatures were being exhibited from Boston, Massachusetts, to Harrisburg, Pennsylvania.

During this period, Connecticut offered more enthusiastic patronage of this style of portraiture than any other area. Ralph Earl, although born in Worcester County, Massachusetts, in 1751, began his career in New Haven in 1774. Three years later, his Loyalist sympathies forced his flight to England and abandonment of his American wife and two children. In London, Earl entered Benjamin West's studio 18 years after Delanoy. In 1783 and 1784 he exhibited works at the Royal Academy.[12] Shortly after his return to America in 1785, Earl was cast into New York's debtors' prison for three years. During this time he painted some 20 portraits of prominent New Yorkers who befriended him, including James Duane, the mayor of New York, Alexander Hamilton, and their friends, wives, and children, all of whom came to the prison to pose. Dr. James Cogswell met Earl in this way. He and his brother, Dr. Mason Fitch Cogswell, both became Earl's patrons and helped to supply him with sitters. Their father, the Reverend James Cogswell, had married the widow of Ebenezer Devotion and presumably, the Winthrop Chandler portraits of the Devotions were known to the Cogswell family.

In 1788, Earl was able to pay his debts and was released from prison as Mason Fitch Cogswell was appointed trustee of the painter's estate. Earl followed Cogswell to Connecticut, locating first in Fairfield and Litchfield counties. The diaries and records of Earl's Connecticut subjects show that the painter and his wife often stayed at the homes of sitters as their guests. In the early 1790s, Earl moved to Hartford, but made visits to Middletown and New London, as well as returning to the two counties where he had earlier found patrons. He revisited New York and Long Island in search of commissions and eventually extended his territory to southern Vermont. He finally settled in Massachusetts. Throughout his career Earl's style varied from the elegant manner learned from West to the simplicity and power seen in his portraits of Roger Sherman.

Earl may have influenced Moulthrop, but there is greater evidence of his inspiration in the work of a slightly younger painter, Joseph Steward, born in Worcester County, Earl's birthplace, in 1753. Like

10. Fitch's biographer is William L. Warren, "Captain Simon Fitch of Lebanon 1758–1835, Portrait Painter," *Connecticut Historical Society Bulletin*, vol. 26, no. 4 (October, 1961), pp. 97–129.

11. Ralph W. Thomas, "Reuben Moulthrop 1763–1814," *Connecticut Historical Society Bulletin*, vol. 21, no. 4 (October, 1956), pp. 96–111.

12. Elizabeth Mankin Kornhauser, "Ralph Earl as an Itinerant Artist: Pattern of Patronage," in *Itineracy in New England and New York*, edited by Peter Benes, Boston University Press, 1986, pp. 172–179.

13. Thompson R. Harlow, "The Life and Trials of Joseph Steward," *Connecticut Historical Society Bulletin*, vol. 46, no. 4 (October, 1981), pp. 97–164.

14. Nina Fletcher Little, "John Brewster, Jr., Deaf-Mute Portrait Painter of Connecticut and Maine," *Connecticut Historical Society Bulletin*, vol. 25, no. 4 (October, 1960), pp. 97–129.

15. Barbara C. and Lawrence B. Holdridge with a biography by Mary Black, *Ammi Phillips: Portrait Painter 1788–1865*, New York, Clarkson N. Potter, Inc., pp. 9–18.

16. Jonathan Edwards' portrait is owned by Yale University Art Gallery, New Haven, Connecticut.

17. Nina Fletcher Little, "Little Known Connecticut Artists, 1790–1810," *Connecticut Historical Society Bulletin*, vol. 22, no. 4 (October, 1957), pp. 98, 111–112.

Earl, or possibly with his help, Steward counted the Reverend James and Dr. Mason Fitch Cogswell among his most supportive patrons. Steward reached his craft by a circuitous route. After graduating from Dartmouth College, he entered the ministry. He married in Hampton, Connecticut, in 1789 and took up residence there. By 1793 failing health caused him to seek a new profession so he turned to portrait painting. By 1796 he had established a painting studio in Hartford; the following year he opened a museum in the new State House in Hartford using his own and others' works as exhibits.[13]

At about the time of his marriage, Steward took the deaf mute John Brewster, Jr., born in Hampton in 1766, as a student. The portraits by both men display powerful likenesses of New England citizens that influenced later artists not only because of their accuracy and somber beauty, but also because they were known to a large audience through exhibition. Steward's paintings were on view in his early museum. Brewster's portraits were on display in patrons' houses and village inns within a wide-ranging territory that extended from Portland and York, Maine, south to Salem and Newburyport, Massachusetts, and west to Hartford and central Connecticut.[14]

At the beginning of the 19th century, both Brewster and Moulthrop were still working in the general areas of Connecticut where Winthrop Chandler initiated a new generation of New England limners: ones previously visited by the two New York artists, Durand and Delanoy. Frequently cooperating or learning from each other and each other's works, New England limners began to fill a demand for likenesses in Connecticut unprecedented in the new republic. Moulthrop and four itinerant artists of the next generation in turn influenced the early style of Ammi Phillips, the limner whose style is closest to that of both Hopkins and North.

Phillips was born in Colebrook, in the northwest corner of Connecticut, in 1788.[15] It was probably there that Jonathan Edwards, Jr., the minister of the Colebrook Congregational Church, sat in 1796 to Reuben Moulthrop for his portrait.[16] Four years later, when Edwards left the congregation to become president of Union College, the Colebrook Congregationalists attended church in nearby Norfolk where Ammi Ruhamah Robbins had been minister since 1761. It seems likely that Phillips would have known another Moulthrop portrait—Robbins' son Thomas, painted in East Haven in 1801. When Moulthrop was again in the area to execute the 1812 portrait of the Reverend Robbins, Phillips was working nearby in Berkshire County, Massachusetts, and across the New York border in Rensselaer and Albany Counties. Robbins provides an interesting link between Phillips and M.W. Hopkins, since he served as a missionary to help establish the Presbyterian Church in Hopkins' childhood home of Pompey, New York.

During Phillips' youth other painters traveled through central and western Connecticut, leaving behind canvases that the young artist might have seen. Nathaniel Wales advertised his skills in Litchfield where he offered likenesses "on Canvas or glass, for Eight dollars each."[17] Surviving portraits by Wales of Middletown and New Haven subjects presage Phillips' habit of placing both male and female subjects in the same positions three quarters of the way up

the canvases. The result is curious as the women in fashionable high-crowned lace bonnets dominate and fill their canvases in a way that the men with face-framing Napoleonic hair styles do not.

The outlining of the face and backlighting of the figure in Phillips' earliest known adult portrait of Gideon Smith of Stockbridge, Massachusetts, are remarkably similar to an 1803 likeness painted in Durham, Connecticut by Uriah Brown, who advertised his skills as a painter of faces in Salem, Massachusetts in 1805, and later in New York City. Three portraits of the formidable Halls of Cheshire, Massachusetts exhibit the same technique and are the work of a mysterious figure named J. Brown. He signed and dated the portrait of Mercy Barnes Hall in 1809, at the same time that he painted the dour visage of her husband Calvin, and a full-length portrait of their daughter Laura.[18] From the evidence of his early portraits of girls and young women, Phillips must certainly have known Laura Hall's standing figure since her pose served as his inspiration at least six times, most noticeably in his paintings of two identically dressed Harriets of the Albany, New York area.[19]

A fifth influence on Phillips was Samuel Broadbent, who was a physician as well as an artist. Broadbent circled Colebrook in the first decade of the 19th century, creating portraits in towns and families closely associated with the Phillips family, their friends and relatives. Phillips' early adult portraits are similar in pose and setting to those by his older contemporary, who was born in Wethersfield, Connecticut, in 1759.

Milton William Hopkins was just a year younger than Ammi Phillips. Although he was born in Litchfield County, his family moved to Pompey, New York when he was 13 years old. Hopkins, however, maintained close ties with friends and relatives in western Connecticut: both his wives were born in Guilford. In the second decade of the 19th century he returned to Connecticut and, like Phillips, would have encountered the work of the many artists who painted portraits in Connecticut before them. Intermarriages in Noah North's and Ammi Phillips' families further link the two artists to Phillips. Halsey Phillips, Ammi's brother, married Sally Hungerford of Colebrook, Connecticut and by this union became the brother-in-law of Noah North's mother, Olive Hungerford. In 1842 Phillips portrayed Nancy Hungerford, probably a relative of the Hungerford sisters.

Portraits by Phillips, Hopkins, and North share certain characteristics. The male hand and arm laid over the cresting rail of decorated chairs, utterly disassociated from the subject's torso, is a characteristic detail of Phillips' work that both Hopkins and North knew and used. Women's costumes with lacy collars and caps depicted by Phillips seem to be the prototypes borrowed by Hopkins and North. In the portrait of Pierrepont Edward Lacey and his dog Gun, attributed to Hopkins, several elements seen in Phillips' work are combined. The boy's stance recalls five of Phillips' standing figures of boys: from Charles Barstow painted in 1811, to John Yonnie Luyster painted in 1838, about the time that Hopkins was painting young Master Lacey.

M. W. Hopkins, and his associate, Noah North (who was 20 years his junior), were members of the sixth and seventh generations of

18. Mr. and Mrs. Calvin Hall's portraits are owned by the Abby Aldrich Rockefeller Folk Art Center, Williamsburg, Virginia; "Laura Hall Kasson" is owned by the New York Historical Association in Cooperstown, New York.

19. The two Harriets are Harriet Leavens of Lansingburg, New York, owned by the Fogg Art Museum, Harvard University, Cambridge, Massachusetts, and Harriet Campbell owned by Oliver F. Eldridge.

painters in America since Evert Duyckinck established the tradition of limning that would have a remarkably strong and lasting effect on the guild of painters who followed. Each succeeding generation built on the experience and practice of those who had preceded them, going from place to place where patronage or blood and marital ties led them. Following former neighbors and friends to new frontiers, painters widened the geographical scope of their influence. Enlightened in their thinking, 19th-century limners were likely to be abolitionists, temperance-oriented, and liberal in their political outlook.

Well-trained and experienced professionals, these artisans provided a needed service for their patrons in supplying likenesses to remember and pass on to succeeding generations. The proliferation of these canvases was startling. Remaining bodies of work include scores for Gerardus Duyckinck and hundreds for Ammi Phillips that only hint at their artistic productivity. While the paintings had undisputed value as family records, they also provided inspiration for pose, style, and technique to each new generation of rural traveling artists. The close analogies in works by succeeding generations of artists, such as the Duyckincks, and between Hopkins and North, affirm frequent master and apprentice relationships.

From the beginning, some members of this profession sold artists' pigments, canvas, oils, varnishes, and frames to their contemporaries. By the late 18th century, the custom of setting up small exhibitions of their work at inns and taverns in areas to which they traveled was well established. One example of this was the 11 portraits of the Caleb Hubbard clan, all painted by their cousin, Erastus Salisbury Field, between March and Christmas, 1837. For a quarter century this exhibition lined the walls of main rooms on the first floor and stair hall of the Hubbard Tavern in Plumtrees, just south of Sunderland, Massachusetts. It was unusual only because such a large number of portraits remained on public view for so long.

Successful careers as artisan painters often depended not only on painting skill, but on the ability to attract patronage in a number of related fields. As photographs began to replace painted likenesses in the early 1840s, Noah North, Joseph Whiting Stock, and Erastus Salisbury Field were only three of many painters who turned to photography as a new medium for taking likenesses. Stock's several annual raffles of his subject pieces and portraits of famous figures provided a supplement to his income. While academically trained artists like Samuel F. B. Morse turned to invention to supplement his artistic vocation, and John Vanderlyn returned home to Kingston, New York, bitter and disillusioned because he was deprived of long sought commissions, the country painter—adaptable and not easily discouraged—continued to ply his trade as best he could. Vanderlyn grudgingly acknowledged Phillips' success as an itinerant and spoke of country painting as more "genteel" than any "Mechanical business," and saw the vocation as an "agreeable" and profitable way of "passing ones time."

About 1815, the American portrait painter Abraham Tuthill (1776–1843) began his journeys to the recently settled towns of central, northern, and western New York State. If he was not the first artist to travel extensively in these regions, he was certainly the most durable, for he lived by his brush in upstate New York for at least a quarter of a century. During these years, and especially after the opening of the Erie Canal in 1825, he competed with an ever larger, constantly changing array of other artists, all of whom hoped to exploit the era's booming demand for portraits. In the 20th century we have tended to describe Tuthill and any other painter who worked in several locations as "itinerants," but this catch-all term fails to distinguish among the several patterns of practice that produced the rich bounty of portraits in New York State between 1815 and 1845. We can comprehend some of the differences among them by briefly considering four portrait painters, each of whom can be distinguished from the others in terms of background, expectations, and accomplishments. Tuthill serves as a good point of departure, for no other painter working in upstate New York in these years could claim so distinguished an education or so cosmopolitan a background.[2]

Tuthill is the chief example of the academy-trained painter who worked in provincial regions presumably because his skills had proved inadequate to meet the more demanding standards of the larger eastern seaboard cities. As a young man, he had left his native Long Island to study in Europe, where he lived in France and England for about eight years. In London he became a pupil of the illustrious Benjamin West, president of the Royal Academy of Art.[3] On his return from Europe around 1808, he attempted a career in New York City in direct competition with the leading portrait painters of the period. At a time—the first two decades of the 19th century—when even such exceptionally able academy-trained painters as Samuel F. B. Morse, John Vanderlyn, and Rembrandt Peale struggled to find commissions in the older cities, it is not altogether surprising to find that Tuthill failed. Seeking work and less daunting competition, he went to areas of new, rapid, and prospering development in New York State, occasionally ranging beyond into Ohio and Michigan. For several years Buffalo was the center of his operations, but even while living there he occasionally traveled along the route of the Erie Canal to other parts of the state, executing portraits in Rochester, Syracuse, Utica, and many smaller communities. He promoted his pedigree as a pupil of West, but it seems to have given him little advantage over other painters. He spent his adult life as an artist; he had no other occupation.[4]

A second kind of portrait painter was the aspiring younger artist for whom "itinerancy" in the towns and villages of New York State was only an early stage in a career whose later phases were spent in residence in an urban center of culture. Charles Loring Elliott (1812–1868) was a celebrated instance. Art-struck as a youth in rural Cayuga County, and then trained by his father to be an architectural draughtsman, he went to New York City at about age 17 to study with the distinguished but aging painter John Trumbull. Finding Trumbull unwilling to teach him, Elliott spent six months in John Quidor's studio instead. Around 1830, he returned to upstate New York and

PORTRAIT PAINTERS IN UPSTATE NEW YORK, 1815–1845

David Tatham

Democratic people may amuse themselves momentarily by looking at nature, but it is about themselves that they are really excited.

In democratic societies where all are insignificant and very much alike, each man, as he looks at himself, sees all his fellows at the same time.

Alexis de Tocqueville[1]

1. Alexis de Tocqueville, *Democracy in America*, trans. George Lawrence (New York: Harper & Row, 1966), p. 484.

2. For Tuthill, see David Tatham, *Abraham Tuthill: Portrait Painter in the Young Republic*, exhibition catalogue (Watertown, New York: Jefferson County Historical Society, 1983), which cites (p. 51) the most important earlier literature on the artist. See also Tatham, "Abraham Tuthill at Mrs. Trollope's Bazaar," in Gabriel P. Weisberg and Laurinda S. Dixon, eds. *The Documented Image* (Syracuse: Syracuse University Press, 1987), pp. 1–12.

3. The extent of Tuthill's study with West is not known, nor is any of Tuthill's European work.

4. Tatham, Tuthill. For Tuthill in Buffalo, see Alfred Frankenstein and Arthur D. Healy, "Two Journeymen Painters," *Art in America* 38 (February 1950) pp. 47–63.

5. Theodore Bolton, "Charles Loring Elliott: An Account of His Life and Work," *Art Quarterly* 5 (Winter 1942), pp. 58–96.

6. *Brief Sketch of the Life of O. A. Bullard* ([New York:] Albert Norton, 1851). Barbara N. Parker, "The Dickinson Portraits by Otis A. Bullard," *Harvard Library Bulletin* 6 (1952), pp. 133–137.

7. *Brief Sketch*, front wrapper.

8. Records of the Catalogue of American Portraits, National Portrait Gallery, Smithsonian Institution. Eight genre and historical subjects are recorded in the Inventory of American Paintings, National Museum of American Art.

opened his own studio in Syracuse. This town had grown by leaps and bounds since the construction of the Erie Canal in the early 1820s, but it was hardly large enough to support a portrait painter. To earn his livelihood Elliott traveled to several other sites throughout central and western New York to find sitters. But he kept his eye on the best portrait work in New York City and by 1839 had developed his skills sufficiently to return to the metropolis and succeed handsomely as an artist, soon gaining a national reputation. Where Tuthill's work in upstate New York had represented the best of his maturity, Elliott's represented only growth toward maturity. Interesting and capable as Elliott's early work is, his historical importance rests on his post-1840 portraits.[5]

Few painters of this second type reached Elliott's level of distinction and success. Otis Bullard (1816–1853) of Howard Village in Steuben County moved at age 21 from an apprenticeship in wagon-making and sign-painting to a career in portrait painting. After trying unsuccessfully to gain entry to classes at the National Academy of Design in New York in 1837, he took instructions in Hartford, Connecticut, from the portrait painter Philip Hewins (1806–1850). In a decade of painting in several locations in New England and New York, Bullard claimed to have recorded the likenesses of more than 800 individuals. Since some of them, such as Emily, Lavinia, and Austin Dickinson of Amherst, Massachusetts, shared the same canvas, the number of paintings was somewhat less than the number of faces, but leaves little doubt about Bullard's industriousness.[6]

Bullard aspired to be more than a provincial portrait painter, however, and by the mid-1840s he had established a studio in New York. There, while still painting portraits, he broadened his range of subjects and began a series of genre and historical subjects. He soon attempted to exploit the late-1840s vogue for panoramas by executing a grand scale view of New York City, which included "every building on the West side, together with the principal incidents of Broadway."[7] Though he met with no great success in these efforts, he had managed, like Elliott, to move beyond itineracy. Instead of relocating from town to town, and traveling through the hinterlands seeking sitters, he now expected sitters to come to him. While Elliott's exceptional skills of characterization and mastery of style gained him a distinguished reputation, Bullard's plainspoken, less accomplished portrayals brought him little more than a steady income. He never entered the first rank of American painters. Fewer than a dozen of his portraits are now recorded, though many others, unsigned, must survive.[8]

Tuthill, Elliott, and Bullard were life-long professional artists, but this was not true of most of the third and most numerous type of itinerant portrait painter in upstate New York. Many of this type farmed or practiced a trade while painting portraits as a sideline. Others abandoned a trade in an attempt to make a full-time career of portraiture and, failing at or tiring of it, turned (or returned) to something else. A few, men and women alike, were amateurs who limned only friends and relatives. Hardly any had academy training. Most taught themselves or learned from self-taught practitioners, and emulated the fashionable styles of the era, insofar as they could.

They approached easel painting more as a craft than a fine art, knowing and presumably caring little about the history or theory of the art they practiced.

These were the artisan painters of Federal and Jacksonian America—though the term "artisan," like "itinerant," is an umbrella that covers many different cases. Deborah Goldsmith (1808–1836) offers an especially interesting instance. Born in North Brookfield, New York, by age 17 she had begun painting portraits of friends and family in watercolor. Over the next 10 years she painted in Madison and adjoining counties. At the time of her death in her mid-20s, she was married and the mother of two children.[9] Self taught, but alert to the conventions of portraiture as it was practiced around her, she painted in a manner that Tuthill, Elliott, and even Bullard would have found inept, but despite her limited skills, her works have a powerful presence. The best of the artisan painters managed to communicate the earnest and deeply affectionate feeling they sometimes felt for their subjects, as well as their own satisfaction in having made something of worth.

Despite the steady advances made over the past half century in documenting their lives and works, we still do not know enough about the artisan painters to say with much confidence how many practiced in upstate New York, or how many portraits they painted. A fair guess might be that in upstate New York between 1815 and 1845, at least a dozen artisan painters produced several thousand likenesses.

Artists of all types plied their trade to satisfy an unprecedented demand for portraits. The demand came from a rapidly growing population that had established a robust agrarian and mercantile society in a region that had been wilderness within living memory. Having brought forth villages and towns, canals and turnpikes, and a bountiful life in a democracy, these citizens, men and women alike, solemnly celebrated themselves by commissioning their own likenesses. Never before or since have the appearances of so large a portion of a nation's population been recorded in paint. Almost never grandiose or idealized, and nearly always hewing to plain style, these portraits show people who were, as Alexis de Tocqueville said, "very much alike."

We can gain a useful perspective on this legion of artists and their multitudinous patrons from Tocqueville, that most perceptive of visitors to Jacksonian America. While he did not discuss the practice of portrait painting itself in his *Democracy in America* (1835–40), his observations on the impact of democracy on the arts in general help us to understand especially the artisan portraitists. In his visit of 1831–32, during which he traveled through upstate New York, he compared the new American society with the long-established cultures of Europe. Many of the aristocratically oriented social institutions and ways of thought of those cultures were so ingrained that even the arrival of republican forms of government, as in France, had not deeply altered them. Concerning the practice of artisans and artists, Tocqueville observed that in Europe, where a person's class, occupation, and location were relatively fixed, and often had been perpetuated through generations,

9. Sandra C. Shaffer, *Deborah Goldsmith*, 1808–1836 (East St. Louis, Illinois, 1975). Mirra Bank, *Anonymous Was a Woman* (New York, 1979).

19

all those who practice the same craft [tend to form] into a distinct class, always composed of the same families who know one another and among whom a corporate public opinion and sense of corporate pride soon develop. Hence each craftsman . . . has not only his fortune to make but also his professional standing to preserve. Corporate interests count for more with him than either his own self-interest or even the purchaser's need. So, in aristocratic ages the emphasis is on doing things as well as possible, not as quickly or cheaply as one can. In contrast, when [as in Jacksonian America] every profession is open to all, with a crowd of folk forever taking it up and dropping it again, when the craftsmen don't know or care about one another and indeed hardly ever meet . . . each, left to himself, only tries to make as much money as easily as possible. . . .[10]

10. Tocqueville, *Democracy*, pp. 465–66.

11. Ibid., p. 466.

Tuthill, whose studies with West in London can hardly have prepared him to paint portraits "quickly or cheaply," managed to bridge the two cultures. It would be interesting to know what he thought of the work of the self- or locally-trained artisan painters who for the most part lacked the subtleties of color and modeling that distinguished his own portraits. Elliott, too, must have viewed himself as an exception, rising above the common practice. Most artisan painters apparently saw little point in attempting to depart from common practice to emulate Tuthill's or Elliott's strengths. Tocqueville suggests why they did not.

Craftsmen in aristocratic societies work for a strictly limited number of customers who are very hard to please. Perfect workmanship gives the best hope of profit. The situation is very different when privileges have been abolished and . . . men are continually rising and falling in the social scale. . . . Democracies [always have] a crowd of citizens whose desires outrun their means and who will gladly agree to put up with an imperfect substitute rather than do without the object of their desire altogether. The craftsman easily understands this feeling, for he shares it. In aristocracies he charged very high prices to a few. He sees that he can now get rich quicker by selling cheaply to all.

Now, there are two ways of making a product cheaper. The first is to find better, quicker, more skillful ways of making it. The second is to make a great number of objects that are more or less the same but not so good. In a democracy every workman applies his wits to both these points.[11]

So it seemed in the 1830s. After about 1845, when the camera began to supplant the artisan painter as a maker of cheap likenesses, and the painted portrait itself came increasingly to be seen as an object appropriate only for persons of certain rank or station, the "rage" for portraits began to abate.

The work of the artisan painters of the first half of the century seemed to the next generation to be quite inferior specimens of art, valuable only for their quaintness, their family associations, and what they evoked of "olden times." Not until the 1920s did artists, critics, historians, and collectors begin to view these portraits in a new and more positive light. The tenets of modernism that had by then re-

shaped the ways of seeing art encouraged an ahistorical approach to them. Disconnected from their times, and purely in terms of design, a fair number of artisan portraits proved to be quite satisfying works of art. Further, the modernist attraction to the primitive found more to commend in the presumed naivete of painters such as Hopkins and North than in the more learned styles of Elliott and Tuthill. But as the works of the artisan grew in critical esteem and general popularity, it became difficult to ignore their historical context and by the 1960s the great era of research into these artisan (or "folk" or "naive" or "primitive") portraits had begun.

The recent growth of knowledge about itineracy in Jacksonian America enables us to see with ever more detail the context from which these portraits emerged. We now know that painters who traveled regularly—true itinerants—shared the roads, inns, hotels, taverns, and boarding houses of upstate New York with many other itinerants, including singing masters, dancing masters, peddlers, preachers, lecturers, and entertainers, some visiting a community for a day, others for a week or a season. We know more about how such painters advertised themselves, used advance subscription sheets, and scaled their fees. Other painters were not itinerants in this sense, but rather traveled to the same few locations periodically, while spending most of their time at their "home offices." Others did not travel so much as they moved, lock, stock, and barrel, to places where they hoped they would find better opportunities. It has become increasingly clear that the more a painter traveled, the more portraits he or she saw, but it is less clear that this had any significant influence on style. From diaries, memoirs, newspapers, and the paintings themselves has come an ever growing body of data about individual painters and sitters, correcting misconceptions and misattributions.[12]

In an ideal world, we would like to know three things about the making of any portrait. First, and most difficult to retrieve from the past, would be the particulars of the portrait's creation, including the motives and expectations that were at work on both sides of the easel. Second would be the local and regional circumstances that encouraged the making of the portrait and its use, such matters as population and geography, social expectations and economic fluctuations, availability of painters and conventions of decor, and much else having to do with time and place. Third would be the impress of the national and international currents of thought that determine the conventions of style in portraiture throughout western culture at any given time, allowing a likeness painted in 1840 in Albion, New York, to be comprehensible in Albion, Michigan, as well as in Montreal, Edinburgh, and even Calcutta. Knowledge as extensive as this is a large order, but one that has already been satisfied in the cases of some portraits.

Having found that the study of a portrait by Hopkins or North can be as visually and intellectually rewarding as one by Tuthill or Elliott, we can perhaps find some satisfaction in knowing that countless other painted faces as worthy as these await our attention. The hope that they may all someday be documented and explicated as well as the works by M. W. Hopkins and Noah North have been is

12. The state of research is reflected in Peter Benes, editor, *Itineracy in New England and New York*, proceedings of the 1984 *Dublin Seminar for New England Folklife* (Boston: Boston University, 1986).

13. Tocqueville, *Democracy*, p. 404. I have in fact adapted the older translation of Henry Reeve for this line. The Lawrence translation reads, "in his eyes something which does not exist is just something that has not been tried yet."

something that Tocqueville would have found distinctively American. This is, he said a "land of wonders, in which everything is in constant motion and every movement seems an improvement." With characteristic optimism, the American thinks that "what is not yet done is only what one has not yet attempted to do."[13]

Portraits painted by artist Noah North (1809–1880) have been included in every major folk art exhibition in recent history.[1] Preliminary research of his life and work, first published in 1977, presented a straightforward study of an upstate New York farmer who painted portraits in a plain, linear style associated with Connecticut artists of the late-18th century.[2] North depicted his neighbors—small town judges, businessmen, merchants, and farmers—during the 1830s. These likenesses, valued by folk art scholars and collectors, accurately reflected the newly-found, middle-class social status of the sitters and projected a directness and immediacy rarely found in folk portraiture.

In 1982, in the midst of planning for a comprehensive exhibition of North's work, the discovery of a portrait nearly identical to those by North, but signed "M.W. Hopkins, Albion, 1833," completely altered the scope of the project. Investigation into the identity of Milton William Hopkins (1789–1844) produced an unusually rich collection of biographical data that provided a microcosm in which to study the work of folk artists of the period. The details of Hopkins' life raised provocative questions about many assumptions about folk painters in the past. Documentary evidence from census records, newspaper articles, advertisements, family genealogies, and church records provided new insights into the varied activities and geographic mobility of portrait painters in the first half of the 19th century. What began as a study of regional artistic activity expanded into a reassessment of the role of the folk painter in American life. The specific information about the artists challenged many long-held generalizations and theories about folk painting.

Traditionally, the work of folk painters has been valued as an individual creative expression praised for its originality and inventiveness. The fact that portraits painted by Hopkins and North are so similar that in some cases they are virtually indistinguishable challenged the individualism so often claimed for folk artists and raised the inevitable question of what relationship existed between the two men. Once the identity of M. W. Hopkins had been established, it became clear that at least one-half of the portraits previously attributed to North actually had been painted by Hopkins.[3]

Circumstantial evidence points to the strong possibility that North served an apprenticeship with Hopkins. In addition to the overwhelming stylistic similarities in their work, the coincidence of their locations further supports a teacher and student relationship. Travel between Alexander, New York—North's home—and Albion, where Hopkins offered to give lessons in portrait painting, was relatively easy. One male, aged 20 to 30, is missing from the North family in 1830,[4] the same year in which the Hopkins household showed an additional male of the same age living with their family.[5] The earliest documented portraits by North date from 1833,[6] the same year Hopkins advertised as a portrait painting instructor.[7]

The implication that one folk artist taught another to paint in a specific style refutes the widely-held concept that folk artists were "untrained." The style in which they painted, commonly described as primitive, naive, and unschooled, was an acquired, prescribed methodology that reflected a conscious aesthetic. An analysis of the social, economic, and political status of the subjects painted by Hopkins and North reveals a group of well-educated, moderately affluent people

Jacquelyn Oak

1. *The Flowering of American Folk Art* (Whitney Museum of American Art, 1974); *Masterpieces of New York State Painting* (Museum of American Folk Art, 1976); *Making Faces: Aspects of American Folk Portraiture* (Abby Aldrich Rockefeller Folk Art Center, 1978); and *American Folk Painters of Three Centuries* (Whitney Museum of American Art, 1980).

2. Nancy C. Muller and Jacquelyn Oak, "Noah North (1809–1880)," *The Magazine Antiques* (November 1977) pp. 939–945.

3. Jacquelyn Oak, "American folk portraits in the collection of Sybil B. and Arthur B. Kern," *The Magazine Antiques* (September 1982), pp. 564–570.

4. United States Census, Genesee County, New York, 1830; on deposit, Genesee County Courthouse, Batavia, New York.

5. United States Census, Orleans County, New York, 1830; on deposit Orleans County Courthouse, Albion, New York.

6. Judging by Dr. Stoddard's age noted on the back of his portrait, these paintings were painted between January 1 and February 11, 1833.

7. Hopkins advertised as a teacher of portrait painting in Albion in March 1833. The Stoddard portraits, painted by North prior to his possible instruction by Hopkins, lack many details seen in the paintings done after March 1833.

8. Rochester area painters who were members of the National Academy included Alvah Bradish (1806–1901), Grove S. Gilbert (1805–1885), Thomas LeClear (1818–1882), J.D.L. Mathies (born 1816), and William Page (1811–1885). See Clifford McCormick Ulp, "Art and Artists in Rochester" in *Rochester Historical Society Publication Fund Series*, XIV (1936), pp. 29–53.

9. Charles Bergengren reaches a similar conclusion in "Plain Portraits in America, 1760–1860" *Folk Art and Art Worlds*, (ed.) John Michael Vlach and Simon J. Bronner, (Ann Arbor: UMI Research Press, 1986) pp. 85–120.

10. Neil G. Larson, "The Politics of Style: Rural Portraiture in the Hudson Valley during the Second Quarter of the Nineteenth Century." (M.A. thesis, University of Delaware, 1980).

11. Elizabeth M. Kornhauser and Christine S. Schloss, "Paintings and Other Pictorial Arts" (ed.) Gerald R. Ward and William N. Hosley, Jr., *The Great River Art and Society of the Connecticut Valley 1635–1820* (Hartford: Wadsworth Athenaeum, 1985), p. 137. Another interesting discussion of the interaction of rural and urban cultures is found in Sally McMurry's article, "City Parlor, Country Sitting Room: Rural Vernacular Design and the American Parlor, 1840–1900," *Winterthur Portfolio*, (Winter 1985) pp. 261–280. I am grateful to Jane Becker for calling this reference to my attention.

who perceived themselves as pioneering republicans. There is increasing evidence that they sought democratic, unpretentious "correct likenesses" painted in a plain style and rejected European-inspired images painted in an academic tradition. Many academically-trained portraitists practiced in the Rochester area and their services surely were not beyond the financial means of most of these citizens.[8] The selection of painters such as Hopkins and North seems to support the emergence of a conscious and distinctive American taste among members of certain segments of rural society that was perceived by them as more honest and more democratic than the work of academic artists.[9]

Studies of other artists have reached similar conclusions. In his socio-political study of the work of Ammi Phillips (1788–1865), Neil G. Larson has shown that Phillips painted country democrats and created images that reflect a self-conscious, rural autonomy.[10] Elizabeth Mankin Kornhauser has proposed a theory that the "plain" style of 18th-century Connecticut portraiture was consciously chosen by patrons and deliberately executed by portraitists. Her research on Ralph Earl (1751–1801) indicates that he painted "academic" style portraits for his New York City patrons and "folk" style portraits for his rural Connecticut sitters. This rural versus urban dialectic may prove to be integral to the elucidation of American folk portraiture in the future.[11]

In many folk art histories, it has been assumed or implied that the artists were full-time painters. Biographical evidence about Hopkins and North, however, proves that they were, at best, part-time artists who had to pursue a number of diverse vocations to support themselves and their families. Although the exact methodology of folk painters is largely unknown, the "part-time" aspect of their painting careers must have dramatically limited their productivity and prompted a manner of working significantly different from that of their academic counterparts.[12] Hopkins and North were, apparently, oblivious of the classical art historical principles of the development of line to mass, plane to recession, and multiplicity to unity. It is unlikely that they made sketches or anatomical studies before they pictured a subject. Instead, they developed "short hand" solutions to problems of perspective, rendering, and modeling that allowed them to obtain accurate likenesses, but afforded little opportunity for stylistic development.[13]

Both Hopkins and North were trained in an artisan and shop tradition, rather than in an artist's studio. Hopkins worked as a chairmaker, did "house, sign, and fancy" painting, and a variety of related crafts. North, too, engaged in decorative painting, offering his services as a "carriage, sign, and ornamental" painter late in his career. The portraits they painted reveal their craft training in their nonhierarchical perspective, attention to detail, and the way they applied paint. Reminiscent of sign painting, type on books and newspapers is meticulously lettered and, in one case, Hopkins employed graining—a method of furniture decoration—to simulate pattern on a sitter's dress. One of the most remarkable characteristics, shown in several portraits by North, is a chair whose decoration has actually been stenciled directly on the support. These elements of the craft tradition add an interesting dimension to their paintings.

Many folk art histories have described the folk artist as an outsider segregated from mainstream society.[14] Biographical information about Hopkins and North, however, proves that these artists did not function in a cultural vacuum but, rather, were active participants in a flourishing rural society that was a focal point for many social reform movements of the period. The rural upstate New York society in which both families lived included schools, churches, libraries, and a continuation of many similar well-established New England traditions in which they participated. Both Hopkins and North participated in the the anti-Masonic controversy that began in nearby Batavia, New York, and expanded into a political issue in the presidential elections of 1828 and 1832. Hopkins, particularly, was an outspoken advocate of the temperance movement, antislavery, and the Presbyterian church. North followed his father's example in a comparable pattern of civic involvement. The genealogical evidence about the sitters reveals a system of peer patronage in which artists and sitters were often related, members of the same community, or acquainted through religious or secular affiliations.

Folk painters such as Hopkins and North have often been labeled as itinerants, suggesting that they randomly sought portrait commissions throughout the countryside. Biographical evidence about the two men, however, indicates a different pattern. With the exception of a few years in Ohio, North spent all of his life in one of three contiguous counties in western New York. As an adult, Hopkins spent 10 years in Connecticut, 19 years in New York, and seven years in Ohio. In each case, he bought property and engaged in other commercial ventures. Hopkins made several trips to the South: in 1828–29 to Richmond, Virginia, partly in conjunction with a Presbyterian convention and, later, in the 1840s, to Jackson, Mississippi, as a "notorious agent" of the underground railroad.[15] While he supported himself either by painting portraits or giving instruction in theorem painting, the purpose of his trips appears to be more directly related to his religious and antislavery activities than to a search for new commissions.

The migratory pattern of Hopkins and North from Connecticut through New York State was a common one in the 19th century. A number of interesting parallels appear when their careers are placed within the context of other comparable artists working at the same time and, in some cases, in the same places.

Hopkins' and North's work is especially close to that of Ammi Phillips, who painted in western Connecticut and in the Albany, New York, area from about 1810 until the 1860s.[16] A number of coincidences connect Hopkins, North, and Phillips both geographically and genealogically, making it conceivable that the three artists knew each other or, at least, had seen one another's work. Hopkins and Phillips were contemporaries whose families were from adjacent towns in Litchfield County, Connecticut. Hopkins returned to Connecticut as a young man, where he may have learned the crafts of chairmaking or ornamental and portrait painting by which he later made his living. Family connections between North and Phillips are even more specific. The parents of Phillips and North came from the small town of Colebrook, Connecticut, and helped to settle its namesake, Colebrook, Ohio, in the 1840s. Phillips' brother, Halsey,

12. One of the most informative and entertaining accounts of the methodology of academic portrait painting is Thomas Sully's (1783–1872) *Hints to Young Painters*, written in 1851 and revised by Sully in 1871, a year before his death. He describes the proper painting room and lists supplies that must be procured for the proper execution of a portrait (pp. 5–8) and assumes that the student has had some prior instruction: "I take it for granted that the beginner has partly fitted himself under the tuition of an able professor and that he has acquired the power to draw from memory the human figure in any position" (pp. 5–6). He continues: "When the person calls you to make arrangements for the intended portrait, observe the general manner, etc., so you may determine the attitude you had best adopt. The first sitting may be short, pencil sketches on paper, of different views of the person, will be sufficient to determine the position of the portrait. At the next sitting, make a careful drawing of the person on gray canvas—the drapery also, if time will allow should be put in. I find that two hours is long enough to detain the sitter. I seldom exceed that time; and six sittings of two hours each is the time I require." (pp. 9–10) (reprinted, with explanatory notes, (ed.) Faber Birren, New York: Reinhold Publishing Corporation, 1965).

13. I am grateful to Philip N. Grime for proposing the "part-time" painter theory. In his controversial book *Plain Painters*, (Washington, D.C.: Smithsonian Institution Press, 1988), John Michael Vlach argues that "plainness" (i.e. two-dimensionality, distortion, lack of correct perspective, etc.) results from a low level of expertise in handling the requirements of the studio tradition (p. 32). The style, Vlach contends, is a result of incompletely developed skills on the part of the artists. "To improve their basic abilities plain painters have to see the right pictures, read the right books, and study with the right teachers. Beyond this, they must also practice constantly to train their eyes and hands to capture their vision. Only this way do plain painters become fine painters." (p. 16)

14. For a particularly insightful overview see Ibid., pp. 161–175.

15. William Richard Cutter, *New England Families* (New York, New York: 1914) p. 1046.

16. See Barbara C. and Lawrence B. Holdridge, with introduction by Mary Black, *Ammi Phillips Portrait Painter 1788–1865* (New York: Clarkson N. Potter, Inc., 1968).

17. Ibid., p. 51. The portrait is in the collection of the Chrysler Museum, Norfolk, Virginia.

18. It also might have been one John Phillips born 1822, who came to America about 1837 from Scotland and studied for a short time in Rochester with Thomas LeClear. See Clifford McCormick Ulp, "Art and Artists in Rochester," *Rochester Historical Society Publication Fund Series XIV* (1936), p. 36 and George C. Groce and David H. Wallace, *The New-York Historical Society's Dictionary of Artists in America 1564–1860* (New Haven: Yale University Press, 1957), p. 504.

19. A portrait easily attributable to Phillips of one Mariah Durkee Soggs, which, according to family history, was painted in Genesee County, has recently come to light. See Christie's auction catalogue for May 28, 1987, p. 41. The whereabouts of the portrait are unknown.

20. For more information about Tuthill see Alfred Frankenstein and Arthur K. D. Healy, *Two Journeymen Painters* (Middlebury, Vermont: Sheldon Museum, 1950) and David Tatham, *Abraham Tuthill: Portrait Painter in the Young Republic* (Watertown, New York: Jefferson County Historical Society, 1983).

21. Tuthill's anti-Masonic panorama, entitled "Immolation of Morgan," is described in *The Republican Advocate* (Batavia, New York) June 18, 1828. "We have lately seen this painting with its 8 feet by 11, executed by Mr. Tuthill, portrait painter of this village. It represents the execution of Morgan . . . laid in the magazine at Fort Niagara. . . . The countenance of Morgan expresses the hopelessness of despair, and the tight drawn lips display the convulsive feeling which pervades the human frame in the agonies of death. . . . Taken as a whole this painting is but little inferior to any we have seen. . . . Mr. Tuthill has been engaged in this work for the last three months and we trust he will receive the patronage his picture so richly deserves."

married Sally Hungerford, North's aunt, and, in 1842, Ammi painted Nancy Hungerford, North's cousin.[17] An advertisement in the *Livingston County Whig*, June 9, 1846, mentions a "Mr. Phillips" who painted portraits in Mount Morris, New York, where North resided.[18] Further investigation may prove that Phillips worked in this area of New York State in addition to the counties near Albany.[19]

Another artist who worked in the same upstate New York counties as Hopkins and North was Abraham G. D. Tuthill (1776–1843).[20] Many similarities exist in their lives and it is interesting to speculate that they might have been acquainted with one another's work. Having studied in London with Benjamin West (1738–1820), Tuthill executed at least 12 portraits of prominent residents of the Watertown, New York, area from about 1815 until about 1820. During the same period, Hopkins lived in Evans Mills, adjacent to Watertown, and may have seen some of the Tuthill likenesses. In the mid-1820s, Tuthill painted in the canal towns of New York as far west as Buffalo, and in Batavia, 20 miles south of Albion, where Hopkins resided, and six miles from North's home in Alexander. Tuthill spent several months in Batavia, where he painted portraits and at least one panorama that was widely exhibited.[21] One group of family portraits with exceptional provenance and solid attribution shows a direct connection between Tuthill and Hopkins. The portraits of William Brown, Jr., and Lemuel and Maria Brown Brooks, attributed to Tuthill, c. 1827, were still owned by the family in Odgen when Hopkins depicted their parents, William and Rachel Willey Brown, in 1835. All five portraits were owned by direct descendants until given to the Genesee Country Museum in 1982.[22]

In the same group of family portraits were the likenesses of Norman and Elizabeth Brown Savage, signed and dated "D. Brokaw 1846." The Savages were related to the Browns and Brookses by marriage, and, according to family tradition, the portraits were also done in Ogden. Although seven other portraits signed by Brokaw have been discovered, little is known about the artist. The Allen Memorial Art Museum at Oberlin College in Ohio has identified him as one David Brokaw (born 1812), who came to Oberlin about 1842 from Evansburg, Pennsylvania, a small town northwest of Philadelphia.[23] During the 1840s, he must have painted portraits in and around Oberlin. In the 1850 Ohio census Brokaw is listed as a daguerreotypist and later expanded his business to offer ambrotypes in his "Photographic Gallery of Art." In a portrait done about 1845, still owned by the family, Brokaw depicted Lyman Hill, a carpenter who worked on several Oberlin College buildings. Family tradition tells of Hill walking from Albion, New York, to Oberlin about 1837.[24] Brokaw's somber style differs significantly from that of Hopkins and North, but the provenance of the Brown, Brooks, and Savage portraits and the probable New York connection seen in the portrait of Lyman Hill suggests that Brokaw, along with Hopkins, North, and Tuthill, painted in the Rochester area as well as Ohio.

A Hopkins genealogy mentions another undiscovered artist who was working in the same circle of sitters and artists as Hopkins and North. Alpheus Barrett (1806–1876) ". . . removed with his parents to Jefferson County, New York, and when 17 years of age, went to Albion, New York, where he studied painting under Milton W.

Hopkins."[25] Barrett was 17 in 1833, the year in which Hopkins' advertisement to teach portrait painting first appeared. No portraits signed by Barrett have been discovered, but in Albion in the mid-1830s, he advertised his services as painter, gilder, and glazier—skills he would have learned from Hopkins.[26]

William Lawrence Utley (1813–1887), who worked briefly in Genesee County and Cleveland in the 1830s and '40s, had a career almost as varied as that of M. W. Hopkins. Born in Monson, Massachusetts, Utley came to Alexander, New York, in 1833 where, according to a family history, he stayed with his uncle and studied portrait painting with ". . . Mr. V. R. Hawkins, a celebrated artist" and with ". . . a recluse artist near Lockport."[27] V. R. Hawkins was a prominent citizen of the area, having been a businessman and postmaster in Alexander, and merchant and canal boat entrepreneur in Albion, but there is no evidence that he was an artist or even a "painter." It is interesting to speculate that, over the years, the names became confused and "Mr. Hawkins" actually was "Mr. Hopkins." Like Hopkins and North, Utley moved from western New York to Ohio about 1840 and to Racine, Wisconsin, shortly thereafter. Among his vocations were tavern keeper, carpenter, and daguerreotypist and, from 1848 until 1852, he served in the Wisconsin legislature on the antislavery platform.[28]

Randall Palmer (1807–1845), a native of Oneida County, New York, also painted in many towns in upstate New York including Albany, Auburn, Geneseo, LeRoy, Penn Yan, Seneca Falls, and Syracuse in the 1830s. Palmer's portraits are larger in format than many other folk paintings and more intricately detailed, usually showing a full-length figure surrounded by objects of interest to the sitter. Nevertheless, they resemble the "plain" style of portraits painted by Hopkins and North. Portraits signed "Mr. Palmer," "Ch. B.R. Palmer," and "Charles R. Palmer" found in New York State are all from his hand.[29]

The growing body of information about upstate New York painters made it necessary to depart from previous methods of folk art interpretation in order to incorporate new information into a serious reappraisal of the work of Hopkins and North. Interest in folk art first developed in the 1920s among art dealers, collectors, and critics who found visual similarities between folk and modern art.[30] In 1977, at a conference on American folk art at the Henry Francis duPont Winterthur Museum, art historian Kenneth Ames departed from this interpretation by asserting that the meaning of folk art was social rather than aesthetic and called for new criteria by which folk art could be evaluated.[31] Many collectors and critics, shocked by the suggestion that folk art could be judged by anything but contemporary aesthetics, reacted strongly to Ames' theory. In a review of *Perspectives of American Folk Art*, the publication that accompanied the Winterthur exhibition, folk art collector, historian, and critic Jean Lipman challenged the opinions of almost all of the contributors to the book.[32] Despite the outrage of some folk art specialists, art historians and other students of material culture have increasingly shown that an interdisciplinary approach can provide important insights into artists and their work. In one such study of the work of Ammi Phillips, Neil G. Larson confronted inadequacies in past scholarship

22. Located in Mumford, New York, south of Rochester.

23. Marcia Goldberg and Molly Anderson, *Ancestors* (Oberlin, Ohio: Oberlin College, 1980) p. 27.

24. Ibid. The likeness of one Jacob Ilger, a Methodist circuit preacher, signed by Brokaw, is owned by the Summit County [Ohio] Historical Society, and that of an unidentified woman, with an Oberlin history, belongs to the Oberlin College Historical Portrait Collection. See Robert Doty, *American Folk Art in Ohio Collections* (Akron, Ohio: Akron Art Institute, 1976), unpaginated. For a complete discussion of Brokaw, see Jacquelyn Oak, "Genesee Country Portraits," *The Magazine Antiques*, in press.

25. Timothy Hopkins, *John Hopkins of Cambridge, Massachusetts and Some of his Descendants* (San Francisco: 1932) p. 225.

26. Ibid. In 1842, he married M. W. Hopkins' niece, Louisa Juliette Hopkins, in Albion.

27. See William Lawrence Utley, "Ancestors of William Lawrence Utley, Son of Hamilton and Polly Squires Utley." unpublished manuscript, 1924, unpaginated, on deposit at the New England Historic Genealogical Society, Boston, Massachusetts. At least five paintings by Utley have come to light, the most notable of which is the portrait of the Hamilton Utley family, owned by the Western Reserve Historical Society, Cleveland. See *The Magazine Antiques* (January 1946) p. 41 and Lynette F. Rhodes, *American Folk Art from the Traditional to the Naive* (Cleveland: Cleveland Museum of Art, 1978) p. 23.

28. Ibid.

29. Laurence B. Goodrich, "Randall Palmer (1807–1845) Artist of Seneca Falls and Auburn, New York," *New York History* (April 1964) pp. 161–174.

30. See Beatrix T. Rumford, "Uncommon Art of the Common People: A Review of the Collecting and Exhibiting of American Folk Art" in *Perspectives on American Folk Art*, ed. Ian M. G. Quimby and Scott T. Swank (New York: W. W. Norton, 1980) pp. 13–53.

31. Ibid., pp. 293–324.

32. *The Magazine Antiques* (November 1980) p. 1053 and p. 1058: "This book, proposing new 'perspectives' may prove to be influential for scholars of American folk art—but I hope not. Its price for a small format . . . book of a dozen complex essays, illustrated with miniscule, not very good halftones and line drawings . . . will be tolerated only by a few specialists. These few, however, are important. They help make decisions in collecting and set examples for publications and exhibitions. That is why this book is worth comment . . . as a potentially dangerous opinion maker not only in the field of American folk art, but of art history and criticism as a whole."

33. See Neil G. Larson, "The Politics of Style: Rural Portraiture in the Hudson Valley during the Second Quarter of the Nineteenth Century" (M.A. thesis, University of Delaware, 1980), p. 10. "American primitive portraiture has not simply been evaluated by modern standards of style, it has been viewed and evaluated as if it were, in reality, modern art. Severing all links to its age and culture, the validation of rural art has not come from its intrinsic quality but from the quality projected on it through its appeal to contemporary abstract taste."

34. See John Michael Vlach, "'Properly Speaking': The Need for Plain Talk about Folk Art" and Eugene W. Metcalf, Jr., "The Politics of the Past in American Folk Art History" in *Folk Art and Art Worlds* (ed.) John Michael Vlach and Simon J. Bronner (Ann Arbor: UMI Research Press, 1986) pp. 14–26 and 27–50, respectively. See also John Michael Vlach, *Plain Painters* (Washington, D.C.: Smithsonian Institution Press, 1988).

35. For information about specific artists see Marianne Balazs, "Sheldon Peck," *The Magazine Antiques* (August 1975), pp. 273–284; Paul S. D'Ambrosio and Charlotte M. Emans, *Folk Art's Many Faces* (Cooperstown, New York: New York State Historical Association, 1987) pp. 133–141; and Colleen Cowles Heslip, *Mrs. Susan Waters 19th-Century Itinerant Painter* (Farmville, Virginia: Longwood College, 1979), pp. 9–10.

and argued that the standards by which folk painting have been evaluated since the 1940s have done more to establish the point of view of the critics than reach an understanding of the subject.[33]

While the debate over how folk art should be evaluated continues, scholars have begun to call for a new methodology to investigate and interpret folk art.[34]

A historical methodology for the evaluation of folk paintings may include many elements. By investigating the works in a cultural context, previously unexplained meanings become apparent. By separating aesthetic and socio-historical judgments, one is able to view works of art more accurately. Further, by analyzing the lives of the painters, new interpretations and clearer understanding of their works can be reached.

The research on North and, subsequently, Hopkins, began prior to the introduction of contemporary material culture methodology. Extending for almost 13 years, the project developed and evolved from a standard art history investigation into an interdisciplinary cultural history project combining these newer patterns of interpretation. The extensive biographical information about both artists afforded an unusual opportunity to view each artist as a man of his time, rather than an isolated figure known only by a few remnants of his art. Despite gaps, the data now available about these two artists are far more encyclopedic than the scant information available about other artists, particularly women, and allows the researcher to ask questions that previous studies have not addressed.

Are these "correct likenesses" equally important as historical artifacts and works of art? Probably they are. The interconnected lives of painters and sitters tell us about the creation of the portraits and the preference of the folk artists' clientele. While one can look at the portraits in light of modern art's dissolution of realism through cubism and abstract expressionism, this view has nothing to do with the paintings' creation nor their intent. The application of 20th-century aesthetics to 19th-century art work does nothing to promote understanding of the artists, their subjects, or their world.

Are Hopkins and North typical of American folk painters? Probably they are. Unfortunately, since most folk painters have not been investigated as extensively, it is difficult to determine whether similar biographical information exists for others. Some of the most thorough folk art studies, however, have shown that contemporaneous folk artists shared concerns of temperance, abolitionism, and religious reform, followed similar migratory patterns, and served a similar clientele.[35]

Were Hopkins and North at the best place at the best time to be scrutinized by cultural history methods? Probably they were. One can evaluate them as prosperous citizens of the frontier and first generation Jacksonian Americans. Previous studies have analyzed folk artists as citizens of an established society, still defined by 18th-century values and still relatively dependent on continental standards. Surely, Hopkins and North relied on the precedents of late-18th century society to define the parameters of their lives, but they were also products of a newly-settled area of America and members of a generation eager to express its independence from Europe and to fulfill the promise of the egalitarian nation envisioned by the founding fathers.

It is not at all surprising that Noah North turned his hand to daguerreotypy in the middle of his artistic career after settling in Mount Morris, New York. All of the factors that made western New York State a rich ground for the artisan portrait painter were also favorable for those engaged in the new portrait medium of daguerreotypy. The recently established transportation system, the prospering rural society, the growing population, and the steady traffic of tourists, migrants, and commerce through the area created a perfect environment in which to seek profit from daguerreotyping. North's training as a painter was in the making of likenesses. Daguerreotypy represented the latest novelty in that field and offered the potential of greater profits in return for less labor than painting. In 1844 one could become actively involved in what promised to be a lucrative business.

The daguerreotype was the first truly practical photographic process. Optical drawing aids using lenses, such as the camera obscura, had suggested to the minds of many the possibility of fixing the image by chemical means. J.L.M. Daguerre, a French painter, after years of experimentation evolved such a process in 1837. After negotiating the sale of the invention to the French government, the details of the method were announced to the world in Paris on August 19, 1839. The process was immediately taken up by hundreds of experimenters and spread widely throughout the western world.

The daguerreotype, named after the inventor, was unlike modern photography in a number of significant ways. It was entirely formed of metals, utilized no negative in the direct creation of the image, and could only be seen as a positive in certain lighting conditions. Although requiring practice to master, the process was relatively simple. A metallic plate composed of a pure layer of silver on a copper support had to be polished to a mirror-like finish, then sensitized to light by fuming the surface with iodine. After camera exposure, the latent image was brought out by exposing the plate to the vapors of metallic mercury, which deposited tiny droplets wherever light had reached the plate. After dissolving the light sensitive layer a highly detailed and delicately modulated image was visible by a combination of refracted and reflected light. Initially, poor camera optics and relative slowness of the process restricted its successful application to still-lifes and views. The small size of the plate, the minute detail of the image, and the general precious delicacy of the daguerreotype found ready appreciation by an audience with a developed taste for painted miniatures.

The working details of the daguerreotype process reached America in September 1839. Soon after, itinerants giving demonstrations and lessons began ranging the countryside seeking to exploit the public curiosity created by glowing newspaper accounts of the new process. Samuel F. B. Morse, the artist and inventor, played a central part in introducing the daguerreotype to America. Morse was an influential role model for American artists beginning his career as an itinerant portrait painter and achieving success as an academic artist. From 1841 to 1843 he dedicated himself to daguerreotypy by promoting the process, teaching the method, and adapting it to serve the needs of portraiture.

The commercial potential of the daguerreotype as a portrait medium was rapidly grasped in America despite the poor camera

 "THE MIRROR WITH A MEMORY"

THE DAGUERREOTYPE AS
A PORTRAIT MEDIUM

Grant B. Romer

29

optics and low sensitivity, which made it necessary to pose from five to 10 minutes outdoors in bright sunshine. Scientifically talented men, Morse among them, applied themselves with "Yankee" skill to make the process more suited to portraiture by reducing the exposure time and moving the operation indoors. Within a year of the first efforts, sufficient improvements were made to allow the first daguerreotype portrait studios in the world to be opened in New York City and Philadelphia.

Despite long exposure times of one to three minutes, miniature picture scale, and poor quality many people were willing to pay the relatively large sum of five dollars to experience the "great novelty" firsthand. Jeremiah Gurney began his long career in March 1840 and gave the following account of the first days of his studio in New York:

> My sign at the doorway was a frame of four small daguerreotypes and the first, I believe, ever exposed for this purpose on Broadway. It was perfectly astonishing to see the multitudes who stopped to look at these pictures, and one perhaps in a thousand would rush upstairs to know something more about this new art. But is usually resulted in the knowledge, simply, that they went away with five dollars less in their pockets in exchange for a shadow so thin that it often required the most favorable light to detect that it was anything more than a metallic looking-glass.[1]

1. *British Journal of Photography* (June 4, 1886), p. 362.

2. *The Life and Works of George Fuller* (Boston and New York: Houghton-Mifflin, 1886), pp. 14–15.

Many would-be practitioners who were drawn to the novelty out of curiosity were also aware of the commercial potential that multitudes offered. George Fuller wrote to his father in 1840, revealing such thoughts:

> . . . you have heard much (through the papers) of the daguerreotype. . . . Augustus and I went to see the specimens. . . . Now this can be applied to taking miniatures or portraits on the same principles that it takes landscapes. M. Gourand is now fitting up an apparatus for the purpose. . . . The plate (metallic) costs about $1.50, and is easily prepared, but 2 minutes time is required to leave a complete impression on a man's countenance, perfect as nature can make it. He will give me instructions for $10.00, and the apparatus will cost $51.00 making in all $61.00 only, for the whole concern. . . . This is a new invention, and consequently a great novelty, of which everyone has heard, and has a curiosity to see. It is just what the people in this country like, namely, something new. I think anyone would give $7.00 for their perfect likeness. We could clear ourselves of all expenses in two weeks.[2]

Hundreds invested in lessons to learn the daguerreotype process in 1840. Amateurs loaded their trunks of apparatus on steamers in New York, sailed up the Hudson to Albany, and traveled on the Erie Canal or railroad westward to Buffalo and to all the frontier towns on the Great Lakes and inland waterways. As the many newspaper advertisements document, by 1841 virtually every town of any size in the country had been visited. Many of those seeking quick fortunes were disappointed. Few rural customers, no matter now curious, were willing to put down such a high price for the images.

The first wave of daguerreotypists did not seriously threaten the portrait limners of the country. Dim, miniature images on "metallic

looking-glasses" could not compete with large paintings in full color that served as highly visible symbols of class status. Painted portraits remained objects of reverence and decoration in the parlors of the prosperous rural elite. Rural patrons had always prized the work of limners like Hopkins and North for their ability to capture "correct likenesses." The daguerreotype offered the potential, at least in theory, to produce a scientifically "true" likeness that could satisfy their desire for verisimilitude.

By 1844 the daguerreotype process had been substantially improved; exposure times for portraits had been reduced to between 40 seconds and two minutes. Contrast and sharpness of the image were also dramatically enhanced. Most importantly, the general public was accepting of the new portrait medium. Daguerreotypists were able to establish themselves more or less permanently in the centers of greatest population density in upstate New York: Albany, Buffalo, Canandaigua, Rochester, Saratoga, Syracuse, Troy, and Utica.

The daguerreotype business evolved into a network of suppliers and practitioners. Supply businesses were established in New York City to import and manufacture the necessary materials for the process. Studios in the upstate urban centers were supplied from New York City and they, in turn, supplied the rural operators along the trade routes to the western frontiers. The Meade Brothers in Albany, for example, sent out agents to work the smaller hamlets and seasonal tourist activity at Niagara. These agents also encouraged new daguerreotypists in order to extend profits from the sale of materials. Those who showed particular interest in the business were often lured by stories of "quick money" for "easy work."

W. H. Sherman, who learned the daguerreotype process from a "Professor Avery" in Clinton, New York, in 1846 wrote

> The first daguerreotypists, outside of the cities, were generally those who had no previous training suited to fit them for the calling. One had been brought up on a farm, and fancied he would find in it easier work and better pay than following a plow or swinging a scythe. Another had learned a trade which he thought less promising than the new art, which he could learn in a few weeks. A doctor or schoolmaster, who had leisure time at his disposal, saw, or believed he saw, a profitable and pleasant way of employing it.[3]

In 1845, a traveling daguerreotypist working in Lockport, New York, wrote home to his brother in Canandaigua, New York:

> There is a regular excitement here, my room being crowded full most of the time. The high ones are going a rush for it. I have taken some of the best families in Lockport and am going to have lots this week . . . we took 42 from monday to friday night . . . my half of the profits amounted to $19.39. . . .[4]

Such reports of profits made it easy to convince new practitioners to invest $50 in lessons, the then customary fee for a few days' instruction, and another $25 for a basic outfit consisting of a quarter-plate sized camera, tripod stand, two sensitizing boxes, a mercury bath for developing, a hand-buff for plate polishing, a vise to hold the plate, a head-rest clamp that could be mounted to the back of a chair, and

3. *The Photographic Times* (January 30, 1891), p. 53.

4. *Image* (Vol. 27, No. 1, March 1984), p. 14.

enough plates and chemicals to conduct business. The entire outfit could be packed into a standard sized trunk and was as easily transported as painting supplies and apparatus.

Those giving instruction, however, were often in need of instruction themselves. Many took advantage of their students by selling them inferior equipment and chemicals to ensure that there would be little competition. Others were happy to have the newly-made daguerreans survive the initial trials and tribulations of the craft so that they could be counted on as steady customers for plates, chemicals, cases, better equipment, and "secret" proprietary formulas.

James Ryder, who learned from a "travelling professor" in Ithaca, New York, in 1845 recounted

> . . . He encouraged me, praised my work as promising and satisfactory, assured me I was surprisingly good for a beginner, and told me it would be greatly helpful for me to work out the difficulties alone, rather than to depend upon him. The fact was I asked too many questions, many of which he could not answer. In the first few years most practitioners were plodding in the dark, something like "the blind leading the blind." . . . In our work repeated trial was the rule—we would try and try again without knowing the cause of the failure. Many a day I would work blindly and almost hopelessly, pitying my outraged sitters, and pitying myself in my despair and helplessness. The weak excuses and explanations I made to cover my ignorance were many. The lies I told, if recorded, would make a big book which I would dislike to see opened. "You moved!" headed the list. . . .[5]

Noah North probably learned the basic operations of the daguerreotype process from such an agent. He could have encountered traveling daguerreotypists when he himself was painting portraits in Ohio and New York State. Little is known about his activities between 1839 and 1842, when he settled in Mount Morris, New York, with his new wife and growing family. In 1845, the year that North first advertised his services as a daguerreotypist, there was no resident daguerreotypist in the town although it had been visited by one as early as 1840. Tourists traveling to Niagara often visited the gorge and falls at nearby Letchworth and would have been likely customers. North's experience and reputation as an artist must have been an advantage, especially when compared to the farmers, blacksmiths, printer's devils, and schoolmasters then turning to the trade. He could have easily combined daguerreotypy with his other occupations of decorative painter and farmer. From his advertisements, he had already given up portrait painting and concentrated on the decorative crafts of carriage and ornamental painting and glazing.

Despite his skills as a painter, North may have met difficulties and discouragements in working the process. The fact that he advertised as a daguerreotypist for a little over two years points up the problems facing new practitioners. Those promoting the process never mentioned the practical difficulties of the craft or any of the hidden mysteries that attended the enterprise. W. H. Sherman, a "country operator" who survived the early days of itinerant daguerreotypy in western New York commented:

5. James F. Ryder, *Voigtlander and I, In Pursuit of Shadow Catching* (New York: Arno Press, 1973), p. 16.

. . . before long hardly a country village could be found in the parts which I visited that had not its resident daguerreotypist already on the retired list, but not, grieve to say, on half pay. Rather because he had not been able to make it half pay. [6]

We do know that North faced competition from several traveling daguerreotypists who set up shop in Mount Morris during his brief career.

Few daguerreotypists identified their work, just as many limners neglected to sign their paintings. Although North could have produced between 100 and 300 daguerreotypes during the few years he devoted to daguerreotypy, no known examples of his work exist. The abundant body of anonymous and primitive daguerreotypes that are to be found in western New York indicate that many provincial daguerreotypes produced work that exhibited the traditional characteristics of folk paintings. The persistence of this same rural aesthetic in early daguerreotypes that mimic the forthright qualities of folk paintings supports the theory that rural clients dictated the way in which they were depicted whether in a painting or a daguerreotype. The involvement of North in both portrait media raises interesting questions about the transition from folk painting to folk photography.

A good deal of evidence suggests that rural and urban clients demanded different lighting in their daguerreotypes. Many urban daguerreotypists taught their students to employ strong chiaroscuro to give three dimensional relief to a portrait, but one such student wrote back to his teacher for a rural location in 1843:

> . . . I have tried the light as you proposed, but they do not like the dark on one side of the face, and I can't sell a picture that where one side of the face is darker than the other, although it seems to stand out better and look richer. [7]

In 1846 a rural daguerreotypist from Kingston, New York, wrote specific instructions to his pupil:

> One object in getting good pictures is getting an even light over the countenance and body and not have one side dark and the other light—to accomplish this you sometimes have to work considerable. [8]

In fact, extra labor was involved in arranging the sitter and using reflectors to avoid strong shadows on a sitter's face in a rural studio, usually a rented room with only a side light source. When encountered in a daguerreotype, such effects are far from accidental. They are deliberate responses to the clients' tastes and similar to the conventions found in contemporary portraits. Marcus Root, a self-taught portrait limner from Ohio, who also became one of the most successful urban daguerreotypists in Philadelphia, wrote from experience:

> Although persons ignorant of artistic effect may find fault with the most effectively disposed lights and shadows, I would counsel every heliographer to give his productions the highest possible artistic value. [9]

6. *The Photographic Times* (January 30, 1891), p. 53.

7. George Eastman House Collection of the Business Papers of Southworth and Hawes (unpublished), L. C. Champney to A. S. Southworth, Bennington, Vermont, March 9, 1843.

8. George Eastman House Manuscript Collection, unpublished handwritten notebook: Kingston, New York, November 9, 1845, "Mr. George and Jas. Perry's System of Daguerreotyping as Given by Mr. Jas. C. Spencer—Daguerrian Atelier."

9. Marcus Root, *The Camera and the Pencil* (Philadelphia: Lippincott, 1864), p. 263.

Pleasing the sitter was even more difficult for the daguerreotypist than for the painter. A harried urban daguerrean artist recorded the following exchange with a sitter:

> Gent: I don't want these dark looking pictures that I see specimens of in your gallery downstairs.
> Proprietor: Well, sir what kind do you wish to have?
> Gent: I want pictures without those confounded dark marks under the eyes and nose, with a black streak across the mouth, and deep shadows under the chin and neck.
> Prop: I understand you, sir; like Queen Elizabeth, you wish your portrait to have no shadows at all. You want something that is fair, clear and smooth, without anything to mark the outlines of the features–you don't like shade about the picture.
> Gent: Yes, yes! exactly so—exactly so.
> Prop: Well, sir, to get good pictures . . . I must have those very marks you are opposed to, as it is impossible to produce good pictures without them. I might, to be sure, get a something, but then I would be ashamed of it, and would never think of stamping my name upon it as eminating from this establishment.
> Gent: Well, anyhow, don't put them on too strong.
> Prop: Sir! I shall not put them on at all; nature does that, not I.[10]

10. *The Photographic and Fine Art Journal* (December 1854), vol. 7, p. 359.

11. William Welling, *Photography in America* (New York: Thomas Y. Crowell, 1978), p. 59.

Sitters commonly expected the daguerreotypist to accommodate their desires to be depicted in a certain fashion as if the daguerreotypist had a painter's control. For instance, some innocent rural clients requested that they be rendered in different clothes than those they wore. North might have been more understanding of such a request than the perturbed urban daguerreotypist, but certainly no better able to fulfill it.

A daguerreotype produced a likeness that could serve as an object of contemplation for others both present and future. North's earlier portraits served the same function. His advertisement for daguerreotype portraits in the *Livingston County Whig* in 1845 advised "those who are desirous to 'secure the shadow 'ere the substance fade' that Now is the time while life, health, and opportunity offers." Although the daguerreotype was touted as "Nature's own" method of fixing a likeness, and "scientifically" accurate and true, the fact was that many a distorted, uncomplimentary, and lifeless portrait was also produced.

Like the portraits painted for rural clients in the 1830s and 1840s, many of the early daguerreotype portraits relied heavily on the clothes, jewelry, or attributes of literacy or a trade to produce a complimentary likeness. In 1846 the *Christian Watchman* pointed out that in daguerreotypes

> Jewelry is generally deemed indispensable to a good likeness. Extraordinarily broad rings—gold chains of ponderous weight and magnitude, sustaining dropsical headed gold pencils, or very yellow faced gold watches, with a very small segment of their circumference concealed under the belt—bracelets, clasps, and brooches—all of these, in their respective places, attract attention, and impress the spectator with a dazzling conception of the immense and untold riches of those favored beings whose duplicate daguerreotype he is permitted to behold.[11]

We can assume that North's daguerreotypes showed men and women in their best clothes, holding books and displaying jewelry and children in elaborate dresses, cheeks tinted, holding toys or baskets of flowers some with the family dog close at heel. Daguerreotypes of this description are quite common. Many of them would be considered masterpieces of American folk art if they were large paintings and not daguerreotypes. There is every indication that itinerant daguerreotypists worked in much the same fashion as itinerant portrait painters and had similar experiences in working with rural clients. The new daguerreotype continued aspects of the earlier painters' craft and clearly responded to many of the same influences in exactly the same fashion.

Much has been said about the negative impact of photography on the portrait limner's art and existence without fully analyzing the vast body of paintings and photographs. While photography after 1860 began to displace painted portraits, the daguerreotype and the folk art portrait coexisted side by side. The folk art elements in composition, lighting, and pose, common to both folk portraits by artists like Noah North and early daguerreotypes, suggest that the daguerreotype was much more influenced by painting trends, both urban and provincial, than it influenced them. Documentation from advertisements and contemporary accounts indicates that the people who commissioned, sat for, and made folk portraits were the same who commissioned, sat for, and made daguerreotypes. There is a direct connection between the two trades as evidenced by the careers of such men as North.

For the American public, both urban and rural, the daguerreotype offered what they ardently desired: a "true" likeness that would be democratically available to the greatest number of people. This sentiment was expressed in the 1846 novelette, *The Daguerreotype Miniature*.

> In the grand centennial march of the world's advancement, the nineteenth century has thus far outstripped all its predecessors in the grandeur and usefulness of its discoveries and improvements . . . twenty years ago, it was regarded as an epoch in a man's existence when he finally resolved, at the earnest solicitation of all the junior members of his household, to have himself "taken" down upon canvas, shadowed forth in all the magnificence of "full length", or "head and shoulders". Much consultation and deliberation were necessary—many private putting together of heads, between the worse and better halves—before the grand undertaking was finally resolved upon. . . . People thought a great deal of pictures in those days.
>
> In the solitude of dim old chambers orphans knelt, and gazed upon the lineaments of lost parents looking down upon them from walls. They beheld the eyes that once gazed upon them, the lips that had kissed their cheeks, now shadowed forth upon the canvass, and they blessed the art which could preserve the looks of those they loved so well.
>
> But, many could not, then, possess the "counterfeit presentiment" of their friends. Many there were who felt, when, the coffin-lid was pressed down upon the dead ones, that they had looked their last upon the beloved features. Henceforth the likeness

of the lost one was to live only upon the tablet of their memory.

But now, it is not so. The mystic art, which compresses sunlight into shadow, has brought the possession of the portraitures of friends within the compass of every one's means. In the space less than that in which I have written these paragraphs, a picture faithful to the life, is impressed upon the plate. . . .[12]

The daguerreotype met a cultural need for small, but accurate likenesses. The following reference in an 1871 *Harper's Weekly*, comparing silhouettes and oil portraits, suggests that the daguerreotype served as substitutes for the smaller scale silhouettes and miniatures.

12. *The Daguerreotype Miniature,* G. B. Zieber & Company, 1846.

13. *Harper's Weekly,* Supplement, December 16, 1871.

Two classes of artists used to appear occasionally in retired villages—the oil-portrait painter and the silhouette or shadow-portrait cutter. The former was always the more popular of the two. His pictures were bigger and more striking, and when hung up in the parlor—an apartment sacred to visitors, and opened only on grand occasions—made an impressive show. The silhouettes . . . being diminutive, the likeness, however perfect, was not easily recognizable. . . . Now and then, in old-fashioned country parlors, we see specimens of these shadow portraits hanging over the fireplace which have held their own against the faded glories of the most ambitious life-size pictures in oil, in fly-specked gilt frames, which are supposed to adorn the walls.[13]

Large scale portrait paintings were perhaps coming to be already viewed as old-fashioned long before 1871, especially the stylized attempts of rural and itinerant artists. It may be suggested that fashion, more than photographic invention, brought an end to the folk portrait tradition. While North did not continue in the daguerreotype business that flourished in western New York in the 1850s, others established notable careers. For instance, Samuel D. Humphrey began working in Canandaigua in the mid-1840s, made some of the first daguerreotypes of the moon, and wrote and published one of the first American manuals on the daguerreotype. After successfully beginning the world's first photographic journal, Humphrey moved to New York City in 1852. Other itinerant portrait painters, such as Josiah Hawes of Massachusetts became masters of daguerreotype portraiture.

North lived long enough to see daguerreotypy decline as a viable trade in the late 1850s, a victim of evolving tastes and technology. After 1860 photography began to replace both the daguerreotype and the painted portrait as the chosen medium to capture likenesses. Western New York continued to be a fertile ground for the commerce of photography in which North had, for a brief time, played a role. His work as folk painter and daguerreotypist sheds new light on the complex relationship between folk painting and daguerreotypy.

FACE TO FACE

M. W. Hopkins and Noah North

FACE TO FACE

M. W. Hopkins and Noah North

Milton William Hopkins, born August 1, 1789, in Harwinton, Litchfield County, Connecticut, was the son of Hezekiah (1758–1834) and Eunice Hubbell Hopkins. The Hopkins family was among the original settlers of Harwinton having purchased land in the 1730s. Milton William's grandfather, Hezekiah (1701–1780), a farmer, presided at the first town meeting and was chosen "constabool" [sic] in 1740.[1] The painter's father served in Captain Aaron Foote's company in the Revolution in 1777 and may have had previous service in the Connecticut militia.[2] In 1800, lured by the offer of military tracts, Hezekiah Hopkins moved the family to Clinton, New York, and later, in 1802 to Pompey Hill, New York, a hilltop town several miles west of Cazenovia, where he took over the operation of the Pompey Hill tavern.[3]

In the early 1800s, Pompey was a thriving cultural center located at the intersection of two major thoroughfares, the Cherry Valley Turnpike and the Seneca Road. An 1822 account of a trip from New York City to Niagara Falls and back, by stagecoach and canal boat, described passing through "Marcellus, Onondago Hill [Pompey Hill], Onondago Hollow [Pompey Hollow], three villages with churches and taverns as usual. . . ."[4] Living in a tavern that served as the focal point for many community activities, the Hopkins children would have had access to a wide variety of people and events. The Presbyterian church, established by Connecticut missionary Reverend Ammi Ruhamah Robbins, was another influence.[5] Pompey even boasted an academy, founded in 1800, that would have given Milton William and his siblings access to some formal education courses in addition to studies in drawing and penmanship.

M. W. Hopkins returned to Connecticut about 1807. Although other members of his family attended Yale College, college records indicate that Hopkins never attended. Instead, at the age of 18 he probably returned to the more settled areas of Connecticut to learn a trade. He could have learned the skills of painting or chair decorating, by which he later made his living, studying with a number of artists or artisans in the area. During this period in Connecticut he had an opportunity to become acquainted with the work of several Connecticut portraitists: Reuben Moulthrop (1763–1814) in Colebrook and Guilford, c. 1812–1814; Samuel Broadbent (1759–1828) in Winsted, c. 1812; and Ralph Earl (1751–1801) in and around Hartford.[6]

In 1809 Hopkins married Abigail Pollard (1790–c. 1817) in Guilford, where their son, Henry Pollard, was born in 1810.[7] How Hopkins supported his family at this time is unknown. Mrs. Hopkins died sometime after the birth of their son and in 1817, Hopkins married Almina Adkins (1790–1861), daughter of John and Marcia Griffing Adkins, prosperous residents and one of the founding families of Guilford.[8] During the same year, Hopkins and his new wife and child moved to Evans Mills, New York, a village in the northern tier adjacent to Watertown. It is possible that they decided to join Almira's brother, William Griffing Adkins (1795–1835), who was a doctor in Jefferson County.[9]

What Hopkins did to support the family in Evans Mills also remains unclear. Located on the south side of the Black River, Watertown, in Jefferson County, grew with the establishment of saw and

1. Timothy Hopkins, *John Hopkins of Cambridge and Some of His Descendants* (San Francisco: Stanford University Press, 1932), p. 46.

2. Henry P. Johnston, ed., *The Record of Connecticut Men in the Military and Naval Service During the War of the Revolution 1775–1783* (Hartford: 1889), p. 503.

3. Sylvia Shoebridge, et. al., *Pompey Our Town in Profile* (Pompey, New York: 1976), pp. 131–132.

4. The account continues: ". . . saw a blue lion on a sign with yellow grass and red trees. Looked very imposing. Enquired for the artist; could neither find him or his name. Great pity as would recommend him to the patronage of the 'Academy of Fine Arts' who doubtless would be proud of such a promising pupil." Louis Leonard Tucker, ed., *A Knickerbocker Tour of New York State, 1822 Our Travels, Statistical Geographical, Mineorological, Geological, Historical and Quizzical* (Albany: The New York State Library, 1968), pp. 98–103.

5. Robbins' portrait was painted by Reuben Moulthrop (1763–1814) in Colebrook, Connecticut. See Barbara C. and Lawrence B. Holdridge *Ammi Phillips Portrait Painter 1788–1865* (New York: Clarkson, N. Potter for the Museum of American Folk Art, 1969), p. 10.

6. A detailed study of these Connecticut painters is included in an essay by Elizabeth M. Kornhauser and Christine S. Schloss "Paintings and Other Pictorial Arts" in Gerald W. R. Ward and William N. Hosley, Jr., (eds.) *The Great River Art and Society of the Connecticut Valley, 1635–1820* (Hartford: Wadsworth Atheneum, 1985), pp. 135–183.

7. Vital Records, Guilford, Connecticut, on deposit, New England Historic Genealogical Society, Boston.

8. Ibid.

9. Cleveland Abbe, *Abbe-Abbey Genealogy* (New Haven: 1916), p. 189.

from Tarragon

Advices from
ult. express a
tion may take
Ministry, and a
respecting fish
feared the
would receive

Sir Wm. A
Lisbon, and Si
sailed for Eng
residents prese
dress on his de
made a suitabl

There is son
the reduction
Spain; as also
ment, or at lea
of M. de Vill
lowering the in
debt.

A London

grist mills. In 1821, the area had several sawmills, grainmills, 25 houses, a post office, two stores, two taverns, a schoolhouse, a tannery, a clothier's works, and a distillery and, as its name suggests, more hydraulic power than any other county in the state.[10] Hopkins probably farmed since he purchased several acres of land about 1820. During this period he joined the Masonic fraternity, taking the three degrees to become a Master Mason in Sacket's Harbor, just south of Watertown, in 1817. Hopkins also served as a lieutenant and captain in the New York State militia from 1818 to 1820.[11] Showing what would prove to be a life-long interest in religion, Hopkins helped establish the First Associated Congregational Society of LeRay in March of 1823.[12] With the births of son, George Gilbert, in 1819 and daughters Abigail, in 1820 and Charlotte Maria, in 1821, the family expanded to six. During this same period, Hopkins may have seen portraits painted by Abraham G. D. Tuthill (1776–1843) in Sacket's Harbor and Watertown.[13]

The Hopkinses moved to Albion, an Erie Canal town some 25 miles west of Rochester, in late 1823. The economic opportunities offered in the canal towns drew many people westward. Only lightly settled before 1820, the counties bordering the canal west of the Mohawk River grew rapidly. Between 1810 and 1835 the region trebled in population, becoming even more populous than the longer-settled sections of eastern New York outside of New York City.[14] A description, written in Buffalo in 1832, suggests the transformation of the area:

Canal boats filled with emigrants and covered with goods and furniture are almost hourly arriving. The boats are discharged with their motley freight, and for the time being, natives of all climates and countries patrol our streets, either to gratify curiosity, purchase necessaries, or to inquire the most favorable points for their future location. Several steamboats and vessels daily depart for the far west, literally crammed with masses of living beings to people those regions. Some days, near a thousand thus depart. As I have stood upon the wharves and seen the departure of these floating taverns, with their decks piled up in huge heaps with furniture and chattels of all descriptions, and even hoisted up and hung to the rigging; while the whole upper deck, and benches, and railing, sustained a mass of human bodies clustering all over them like a swarming hive—and to witness this spectacle year after year, for many months of the season, I have almost wondered at the amazing increase of our population, and the inexhaustible enterprise and energy of the people! What a country must the vast border of these lakes become![15]

In Albion, the first evidence of Hopkins' occupation appears in the *Newport Patriot* of September 24, 1824:[16]

M. W. Hopkins informs the inhabitants of Newport and vicinity that he has established in this village the business of *House and Sign Painting, Gilding, Glazing, and Chairmaking,* in their various branches and engages to do this work in the best manner. He keeps constantly on hand for sale *Paints, Oil, Spirits, Turpentine, Copal Varnish,* Putty, &c, &c.[17]

10. Hamilton Child, *Geographical Gazetteer of Jefferson County* (Syracuse: 1890). p. 521.

11. Hugh Hastings, ed., *Military Minutes of the Council of Appointment of the State of New York 1783–1821* (Albany: State of New York, 1901), pp. 1889, 2133. I am grateful to John D. Hamilton for calling this reference to my attention.

12. Franklin B. Hough, *A History of Jefferson County in the State of New York* (Albany: 1854), p. 194.

13. See David Tatham, *Abraham Tuthill Portrait Painter in the Young Republic* (Watertown: Jefferson County Historical Society, 1983).

14. Ronald E. Shaw, *Erie Water West* (Lexington, Kentucky: University of Kentucky Press, 1966), pp. 262–263.

15. As quoted in Ibid., pp. 273–274, originally appearing in the *Rochester Daily Advertiser,* June 9, 1832.

16. Albion was called Newport until the name was changed in 1826.

17. *Newport Patriot* (Albion, New York, September 24, 1824).

Hopkins is the only house and sign painter and chairmaker advertising in Albion during this period, although towns of this size typically supported several chairmakers and decorators. Apparently the business prospered because in early 1825 he was able to purchase a large parcel of land on courthouse square in central Albion. Hopkins' acquaintance with cabinetmakers Henry and Asa Howard from neighboring Batavia is documented by the fact that he sold them a lot on courthouse square in May 1825, but it is not clear what other business connections they may have had. No documented chairs made by either Hopkins or the Howards have come to light, but a later advertisement for October 3, 1827, gives an idea of the Howards' wares:

> H. and A. Howard. Have just received a good assortment of the first rate trimmings for cabinet work and are now ready to furnish their friends and the publick with any article in their line finished in the newest style and made in the best manner and of materials to suit their customers, mahogany, etc. They will also furnish other Cabinet makers in this vicinity with such Trimmings as they have, as cheap as can be purchased elsewhere. Bedstead screws may be had by the quantity. Also, wanted in payment for any work in their line, Cherry boards, Whitewood boards, and Cherry logs for which a generous price will be allowed.[18]

18. *Orleans Advocate* (Albion, New York, September 12, 1827).

19. Isaac S. Signor, *Landmarks of Orleans County, New York* (Syracuse: 1894), p. 255.

The Hopkins family was received by letter into the Albion Presbyterian Church in July 1824, where another daughter, Flora Ann, born in Albion in January of the same year, was baptized.[19] According to church records, in early 1826 Hopkins was appointed a trustee of the First Presbyterian Society and by this time, Almira Hopkins had given birth to another son, Richard Rush, who was born the previous April.

An event in nearby Batavia in 1826, the so-called "Morgan affair," affected Hopkins directly and eventually brought him into public notice as a witness in the trials. In August, 1826 William Morgan, an impoverished stonemason who had taken at least two Masonic degrees, conspired with David C. Miller, publisher of *The Republican Advocate* in Batavia, to expose the secrets of Freemasonry in a pamphlet, entitled "Morgan's Illustrations of Masonry," probably copied from an English example. Fellow Masons in western New York reacted angrily and tried to prevent Morgan from publishing the work. Failing that, they attempted to burn Miller's printing office. In a final effort, the Masons abducted Morgan and intended to punish him as a traitor for revealing the order's secrets. They succeeded in having him charged with a trifling criminal offense and jailed in Canandaigua, 50 miles east of Batavia. A judge dismissed the charge, but the Masons had him re-arrested for an old debt and put back into jail. "Unknown benefactors" paid Morgan's bail and, soon after, he disappeared forever.

Miller pressed charges against the Masons and broadcast news of the abduction in *The Republican Advocate*. Masons and non-Masons alike formed ad hoc committees to investigate the crime. Witnesses testified that the "unknown benefactors"—all prominent Masons—had placed Morgan in a closed carriage and taken him 100 miles to

Fort Niagara, where he was again held captive. Rumors regarding Morgan's fate were exceptionally diverse. Loyal Masons claimed he was taken to Canada and turned over to "friendly" Canadian members of the craft. As late as the 1850s, Morgan was reportedly spotted in Boston, South America, and Smyrna.[20]

By the 1820s, Freemasonry's public standing was somewhat ambiguous. While it was well-known by outsiders that the fraternity could be convivial, benevolent, mystical, patriotic and charitable, its potentially controversial features were its secrecy, secularism, and elitism. Morgan's unsolved disappearance and probable murder was viewed by many as a conspiracy. From 1826 to 1831 in Genesee, Ontario, Niagara, Orleans, and Monroe counties, more than 20 grand jury investigations were held and dozens of Masons were indicted in at least eighteen separate trials. While no Masons were convicted of kidnapping or murder, several were convicted on lesser charges such as assault and battery. The evidence introduced at the trials suggested, however, that the conspirators drowned Morgan in the Niagara River. As publicity became widespread, anti-Masonry became an issue in national politics. In 1828, the newly-formed anti-Masonic party nominated William Wirt to oppose Andrew Jackson—a notable Freemason—for president. At first, Masonic responses were mixed. Some lodges issued disclaimers of any connection to Morgan; others remained silent and many eventually suspended operations or went underground. To counteract the furor, Masonic newspapers were established to praise the ideals of Masonry and discredit its critics. The "excitement" as it was called, subsided in the 1830s and, in some areas, was replaced by antislavery agitation. By 1838, the anti-Masonic party had merged with the Whigs.[21]

In February 1828, Hopkins entered the controversy by signing a public proclamation made by Orson Nicholson, an Albion doctor, agreeing that " . . . ancient Freemasonry is not worthy of existence in this enlightened republic."[22] It is not surprising that Hopkins renounced his Masonic affiliation and publicly sympathized with anti-Masonry. Those involved in the reform movements of temperance and abolition typically took a stand against Freemasonry, as did many churches. Hopkins' participation in the Presbyterian Church and reform movements made him a leading candidate for anti-Masonic affiliation.[23]

Throughout early 1828, Hopkins pursued a variety of occupations and no advertisements for his painting and chairmaking business appeared. He conducted several auctions of household goods and canal commodities, and by April, was working for Albion entrepreneurs Harvey and Harmon Goodrich as captain of their canal boat.

April 30 The New and Splendid boat *Florida* Elegantly fitted for the accommodation of *Passengers* will leave this port at 9 o'clock to-morrow morning for Albany. For freight or passage apply to Capt. Milton W. Hopkins of H. & H. Goodrich.

Judging by first-person descriptions, the seven-day round trip to Albany offered less than desirable accommodations. In her account of a trip on the canal en route to Cincinnati, Ohio, in late 1827, Englishwoman Frances Trollope described the conditions:

20. The best studies on the subject are Ronald P. Formisano and Kathleen S. Kutolowski, "Antimasonry and Masonry: The Genesis of Protest, 1826–1827," *American Quarterly* 29 (Summer 1977), pp. 139–165; Kathleen Smith Kutolowski, "The Janus Face of New York's Local Parties: Genesee County, 1821–1827," *New York History* (April 1978), pp. 145–172; Kathleen Smith Kutolowski, "Freemasonry and Community in the Early Republic: The Case for Antimasonic Anxieties," *American Quarterly* 34 (Winter 1982), pp. 543–561; Kathleen Smith Kutolowski, "Antimasonry Reexamined: Social Bases of the Grass-Roots Party," *The Journal of American History* (September 1984), pp. 269–293; and William Preston Vaughn, *The Antimasonic Party in the United States, 1826–1843* (Lexington, Kentucky: 1983).

21. The most helpful primary source for a record of events surrounding the Morgan incident is the newspaper, *The Republican Advocate*, published in Batavia from 1811 until 1867. The entire run is available on microfilm, New York State Library, Albany.

22. *The Orleans Advocate* (Albion, New York, February 20, 1828).

23. An interesting comparison of reform movements appears in Ellen Dwyer, *The Rhetoric of Reform: A Study of Verbal Persuasion and Belief Systems in Anti-Masonic and Temperance Movements, 1825–1860*, Ph.D. dissertation, Yale University, 1977.

THE NEW & SPLENDID BOAT FLORIDA,

ELEGANTLY FITTED FOR THE ACCOMMO-
DATION OF **PASSENGERS,**

WILL leave this port at 9 o'clock to-morrow morning, for Albany. For freight or passage, apply to Capt. Milton W. Hopkins, or H. & H. Goodrich.

Albion, April 30, 1828.

NOTICE.

POONAH PAINTING.

THE Subscriber would inform the ladies of Richmond, that he intends stopping in the city for a short time, and offers his services as teacher of Poonah (or Theorem) Painting. The high state of perfection to which the art has lately been carried, the ease and facility with which it is acquired, (compared with the usual mode) renders it a desirable object for every lady who wishes to have a knowledge of this ornamental part of education.

Only thirty six hours are necessary to acquire a knowledge of the art. He has taken a room at Miss Turner's boarding house, Main-street, where specimens may be seen, and terms made known. Married ladies or others, can have private lessons at their dwellings if they choose.

M. W. HOPKINS.

Reference to Rev. Wm. J. Armstrong, Rev. Stephen Taylor and Rev. A. Converse.

dec 15

. . . I can hardly imagine any motive of convenience powerful enough to induce me again to imprison myself in a canal boat. . . . The accommodations being greatly restricted, every body, from the moment of entering the boat, acts upon a system of unshrinking egotism. The library of a dozen books, the backgammon board, the tiny berths, the shady side of the cabin, are all jostled for in a manner to make one greatly envy the power of the snail; at the moment, I would willingly have given up some of my human dignity for the privilege of creeping into a shell of my own.[24]

In another recollection from 1838, Harriet Martineau echoes the miserable conditions of canal travel:

I would never advise ladies to travel by canal, unless the boats are quite new and clean; or at least far better kept than any I saw or heard of on this canal. . . . The heat and noise, the known vicinity of a compressed crowd, lying packed like herrings in a barrel, the bumping against the sides of the locks, and the hissing of water therein like an inundation, startling one from sleep; these things are very disagreeable.[25]

Hopkins did not remain on the canal for long. In February of 1829, the Goodriches sold the canal boat.

For Sale The New and Elegant *Boat Florida* run but one season and having superior accommodations and furniture. *Also* four first rate *Boat Horses and Boat Harness*—all in good condition, and will be sold at a great bargain for Cash or approved paper. Harvey Goodrich.[26]

Near the end of 1828, Hopkins traveled to Richmond, Virginia, probably to attend an important Presbyterian convention. During his stay, he advertised lessons in "Poonah" or theorem painting, an easy task for one skilled in the art of stenciling.

Poonah Painting. . . The subscriber would inform the ladies of Richmond that he intends stopping in the city for a short time, and offers his services as a teacher of Poonah (or Theorem) Painting. The high state of perfection to which the art has lately been carried, the ease and facility with which it is acquired (compared with the usual mode) renders it a desirable object for every lady who wishes to have a knowledge of this ornamental part of education. Only thirty-six hours are necessary to acquire a knowledge of the art. He has taken a room at Miss Turner's boarding house, Main-street, where specimens may be seen and terms made known. Married ladies or others can have private lessons at their dwellings if they choose. *M. W. Hopkins* Reference to Rev. Wm. J. Armstrong, Rev. Stephen Taylor and Rev. A. Converse.[27]

The Reverends Armstrong, Taylor, and Converse, named in Hopkins' advertisement, were well-known ministers in the Richmond area and leaders of the Presbyterian convention.[28] A recommendation from any one of them would have provided immediate credibility and respect for a visiting craftsman.

24. Frances Trollope, *Domestic Manners of the Americans*, Donald Smalley, ed., (New York: Alfred A. Knopf, 1949), p. 369.

25. As quoted in Ronald E. Shaw, *Erie Water West* (Lexington, Kentucky: University of Kentucky Press, 1966), pp. 209–210, originally appearing in Harriet Martineau, *Retrospect of Western Travel* (New York, 1838, Vol. I), p. 77.

26. *The Orleans Advocate and Anti-Masonic Telegraph* (Albion, New York, February 11, 1829).

27. *The Constitutional Whig*, (Richmond, Virginia, December 16, 1828 through January 31, 1829).

45

———o———

AN ADDRESS

delivered before the Orleans County Temperancce Soiety, January 13th 1830,

BY M. W. HOPKINS.

Mr. President,

The object of our meeting togethes, for the purpose of suppressing Intemperance, is no longer a new or novel one. To the credit of our nation it may be said, that the most enlightened part of the community all over the U. S. are taking a deep interest in this important subject ; and their efforts have had a most happy effect. State, county and town societies, have rapidly multiplied, and the consequent reform is manifest to every person that takes any pains to learn the fact. Although, it is hardly 3 years since associations of this kind were formed to any considerable extent, yet the diminution in the sale and use of ardent spirits, throughout our country, is almost incredible.

Another announcement in the Richmond paper indicates that Hopkins also taught in a painting and drawing academy while in Richmond.

Miss Turner takes this method of correcting a report that is circulating in the country that her school is discontinued and of informing the public of a new arrangement made in the institution for the ensuing year. She has secured the assistance of a gentleman whose classical education, moral worth and experience in teaching eminently qualify him for the duties of his station. . . . Every pupil of a suitable age will be taught Drawing as a means of acquiring accuracy, of improving the taste and of facilitating the acquisition of Penmanship. Teachers will be furnished for instructing in Music, Painting on Velvet, Wood, and Paper, and Fancy Work.[29]

It is probable that Hopkins, living at Miss Turner's boarding house at the time, was the ". . . gentleman whose classical education. . . ." qualified him to teach at the school. Stenciling on fabric, another term for "Poonah" or "theorem" painting, is specifically mentioned as part of the curriculum.

The many unclaimed letters awaiting Hopkins at the post office in Albion suggest that he remained in Richmond through the summer of 1829.[30] Assuming that he fathered Almira Hopkins' son born in June 1830, he must have returned sometime in September 1829.

Hopkins was back in Albion at least by November 1829, when he testified for the people in the trial of Morgan conspirator Elihu Mather held at the Orleans County court house. Mather allegedly drove the carriage containing Morgan from Gaines, a village just north of Albion, to Lewiston. In his testimony, Hopkins described himself as a "former Freemason" who renounced after 1826 and ". . . has not met with a lodge since 1826." Although Hopkins testified that a Mason "considered [the Masonic oaths] the most solemn thing he ever took upon himself but has since discovered the charge blinded him to the nature of the oath; before the charge, the candidate is told that the oath is not to interfere with religion or politicks." Hopkins continued by describing the various oaths used regularly in Masonic meetings.[31] While the evidence against him was conclusive, Mather, a member of a wealthy and distinguished Orleans county family, was acquitted.

Hopkins continued to be interested in church affairs. As recording secretary of the Orleans County Sabbath School union, he submitted a report ". . . on the present state of the Sabbath schools in the several towns in the county."[32] Hopkins was also becoming more involved in the temperance movement during this period. As a leading spokesman, his address to the Orleans County Temperance Society on January 13, 1830 was quoted at length in the newspaper:

. . . . There is no habit to which our countrymen are addicted that is half so common or that produces half the misery as that of intemperance. . . . We call then upon every benevolent person to join in this work of reformation. . . . Then if you would save yourselves and children from a *slavery* worse that that of the manacled African, a *disease* more dreadful than the plagues of Egypt, a depravity which will only fit you for the company of devils, and

28. Howard McKnight Wilson, *The Lexington Presbytery Heritage*, (Verona, Virginia, 1971), pp. 81, 141.

29. *The Constitutional Whig* (Richmond, Virginia, December 19, 1828).

30. *The Orleans Advocate and Anti-Masonic Telegraph* (Albion, New York, throughout July, 1829).

31. *The Craftsman* (Rochester, New York, November 24, 1829).

32. *The Orleans Advocate and Anti-Masonic Telegraph* (Albion, New York, December 30, 1829).

these evils, which is
respectfully submitted,
thorizing the selection
sent the wants of the
t on the floor of Con-
n, and to the character
o portion of our citi
t a practical enjoyment
dom ; and there is none
at which cultivates a
n the governours and
ect as this must be in
eved that it would be
epresentation, with the
e allowed to that of the
e United States.
ready for the reception
waits the necessary le-
operation ; as one ob-
ave to recall to your at-
of providing suitable
officer charged with its

he principles involved
it will be proper to re-
the United States, re-
ain call the attention of
t. Nothing has occur-
gree, the dangers which
pprehend from that in-
organized. In the spir-
compromise which dis-
y and its institutions, it
whether it be not possi-
ntages afforded by the
the agency of a bank of
modified in its principles
viate constitutional and

able to organize such a
ry officers, as a bank of
ent, based on the pub-
osits, without power to
e property, which shall

May its influence be eternal.

<div align="right">ANDREW JACKSON.</div>

THE CRAFTSMAN.

THE FINE ARTS.

Our country is filled with pretenders and daubs in the art of painting as well as in the art of editing, and when and wherever we discover "modest merit," an obligation we owe to society, as well as to the possessor, induces us to contribute our "mite" in presenting the genuine artist in a correct light to the publick. We are pleased with the labours of a young gentleman by the name of PAGE, domiciled in the Arcade Hotel of Mathies. His likenesses are strikingly excellent, and his painting gorgeously rich.

Let those who had the patience to sit, and the mortification to be caricatured by that most miserable of all miserable apologies for an artist, HOPKINS, examine the portraits by PAGE, and they will be enabled to discern the difference between genius and education, and stupidity and ignorance—between that genius which " collects, combines, amplifies and animates," and that commodity which deranges, degrades and darkens every subject it touches.

Mr. PAGE is not unknown to the lovers of the fine arts, and we confidently predict that experience, perseverance, and ambition will eventually elevate him to a proud rank among the most distinguished living artists of our country. Let the admirers of taste and talent foster the budding genius of our rising artists, who are too frequently suffered to pine in solitude and die neglected, for the want of proper and generous patronage and countenance, and we shall no longer be dependant on that genius which only blooms beneath " Italian skies," nor be taunted with the reproach that Americans are a pigmy race—an inferiour species of the human family.

" Full many a gem, of purest ray serene,
The dark, unfathomed caves of ocean bear;
Full many a flower is born to blush unseen,
And waste its sweetness on the desert air."

MARRIED...In Litchfield N. H. Samuel Sprake, of

the torments of the damned, taste not, touch not, handle not ardent spirits. Banish the poison from your houses, from your circles, from the community, and stop not until our happy country is delivered from such a desolating scourge.[33]

Interest in the temperance movement extended to other members of M. W. Hopkins' family. In March, his brother Sheldon M. Hopkins, also a resident of Albion, delivered an address before the Saratoga County Temperance Society with similar rhetoric: "There is not in this world of woe a more afflicting spectacle than the life of the tippler. . . . He knows his property must go, his children suffer, his wife die of a broken heart and himself die a drunkard but he cannot stop drinking! How unconquerable is this appetite once formed."[34]

Well-known locally for his speaking abilities on behalf of temperance, Hopkins was again called in June 1830 to testify in the trial of another Morgan conspirator, Ezekial Jewett, the keeper of the fort at Fort Niagara, who was accused of harboring William Morgan until he could be transfered. Hopkins' Masonic credentials were cited: ". . . witness has taken three regular degrees . . . been in quite a number of lodges in this state . . . has set in a lodge in Canada (Kingston) . . . [repeats several oaths] . . . has attended lodges in Watertown, Brownville, Champion, Barre, Gaines, Holley, . . . Rochester.[35] Like Elihu Mather, Jewett, another well-to-do resident of Orleans County, was found not guilty.

During 1829 and 1830, Hopkins must have begun to take likenesses although no portraits that can be conclusively dated from this period have been discovered. In 1830, Elijah J. Roberts, the editor of the pro-Masonic newspaper, *The Craftsman*, published in Rochester, attacked Hopkins, calling him ". . . that miserable of all miserable apologies for an artist."[36] His criticism may have been prompted by Hopkins' well-publicized position against Freemasonry. It also reflects a more urban opinion of the plain painting style practiced by Hopkins and other rural artists.

> The Fine Arts. Our country is filled with pretenders and daubs in the art of painting as well as in the art of editing, and when and wherever we discover 'modest merit' an obligation we owe to society, as well as to the possessor induces us to contribute our 'mite' in presenting the genuine artist in a correct light to the publick. We are pleased with the labours of a young gentleman by the name of *Page* domiciled in the Arcade Hotel of Mathies. His likenesses are strikingly excellent, and his paintings gloriously rich. Let those who had the patience to sit, and the mortification to be caricatured by the most miserable of all miserable apologies for an artist, *Hopkins*, examine the portraits by *Page* and they will be enabled to discern the difference between genius and education and stupidity and ignorance—between that genius which collects, combines, amplifies and animates and that commodity which deranges, degrades and darkens every subject it touches. Mr. *Page* is not unknown to the lovers of the fine arts, and we confidently predict that experience, perseverance, and ambition will eventually elevate him to a proud rank among the most distinguished living artists of our country. Let the admirers of taste and talent foster the budding genius of our rising artists who are too frequently

33. *The Orleans Advocate and Anti-Masonic Telegraph* (Albion, New York, February 3, 1830).

34. *The Orleans Advocate and Anti-Masonic Telegraph* (Albion, New York, March 24, 1830).

35. *The Craftsman* (Rochester, New York, June 19, 1830).

36. *The Craftsman* (Rochester, New York, December 22, 1830).

at the Stand of John H. Nichols & Co., who intends to keep pace with the times.

JOHN J. WALBRIDGE.

Gaines, March 14, 1833. 29-tf

Portrait Painting.
MILTON W. HOPKINS

WILL pursue his profession in this place, for a short time.

LADIES AND GENTLEMEN

are invited to call at his room and examine specimens of his work.

☞ Lessons will be given to pupils who may desire, for a few weeks.

Albion, March 20, 1833. 29tf

SHERIFF'S SALE.

BY virtue of an Execution issued out of the Clerk's office of Orleans county, to me di-

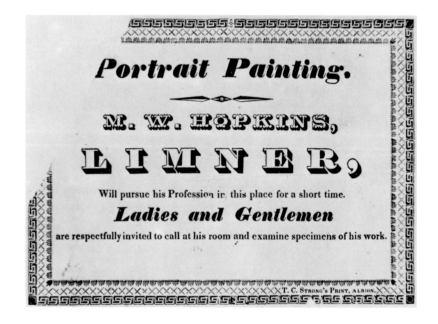

suffered to pine in solitude and die neglected for the want of proper and generous patronage and countenance and we shall no longer be dependent on that genius which only blooms beneath 'Italian skies' nor be taunted with the reproach that Americans are a pygmy race—an inferior species of the human family.[37]

Throughout 1831 and 1832, Hopkins continued his anti-Masonic and temperance activities and consummated several land transactions in Albion. The Hopkinses' 10th and last child, Theodora Jane, was born in February 1833. Whether motivated by finances or greater self-assurance, Hopkins began to give portrait painting lessons in Albion in March 1833:

> *Portrait Painting* Milton W. Hopkins will pursue his profession in this place for a short time. *Ladies and Gentlemen* are invited to call at his rooms and examine specimens of his work. *Lessons* will be given to pupils who may desire for a few weeks. Albion, March 20, 1833.[38]

The younger Noah North, who lived in Alexander, some 20 miles south of Albion may have started to study with Hopkins at least as early as March 1833. Although two signed portraits of F. and Abijah W. Stoddard "No. 7" and "No. 8" "by Noah North" were done between January 1 and February 11, 1833, the portraits North executed after March 1833, show greater stylistic development and a progressive understanding and command of the elements of more formal portraiture. Hopkins tried to sell the central Albion property in early 1834.[39] By December, Hopkins had sold the property and moved the family to a farm five miles southeast of Albion.

Based on the number of dated portraits from this period, Hopkins and North were actively painting during 1836. Extant portraits indicated that both worked in Orleans, Genesee, and Monroe counties from 1833 until 1836. Of the 74 known portraits painted by Hopkins and North, 84 percent are identified; of these, 72 percent were done in this area at the time.

Possibly in search of new portrait commissions, or possibly because of his increasing involvement in the abolition movement, Hopkins moved the family (including all 10 children) to Ohio in 1836. They stayed very briefly in Cleveland then purchased a farm in Williamsburgh, Clermont County, about 20 miles east of Cincinnati. Many portraits that date from this period were painted in several towns throughout Ohio, such as Columbus, Lancaster, and Oberlin, suggesting that Hopkins was traveling throughout Ohio during the late 1830s. By 1839, he had established a studio in Columbus.

> *Portrait Painting* The subscriber having permanently located himself in the city of Columbus offers his services as an Artist. Ladies and Gentlemen are respectfully solicited to call at his Gallery in Armstrong's Block, over Miller and Brown's store, High Street, and examine specimens of his work. M. W. Hopkins April 23, 1839.[40]

The portrait painting advertisement, which cost one dollar for three insertions in the paper, only ran one week. Presumably, Hopkins was sufficiently confident and had enough work to call the space a "gal-

37. Ibid. His scathing denunciation of Hopkins notwithstanding, E. J. Roberts proved to be a good art critic; Page (1811–1885) was elected a member of the National Academy in 1837 and served as president of the academy from 1871 to 1873. He is remembered today chiefly as a colorist and leading exponent of figure painting among the American Romantics. See George C. Groce and David H. Wallace, *The New-York Historical Society's Dictionary of Artists in America 1564–1860* (New Haven and London: Yale University Press, 1957), p. 483.

38. *The Orleans Advocate and Anti-Masonic Telegraph* (Albion, New York, March 20, 1833). The signed portrait of UNIDENTIFIED MAN by M. W. Hopkins in the collection of the New York State Historical Association, Cooperstown, dated 1833 and bearing a similarly worded label further supports that Hopkins was seriously pursuing portrait painting.

39. "FOR SALE The subscriber offers for sale his very desirable situation in the village of Albion, consisting of a House, Barn, Out-houses, Fruit Yard, Garden, &c. The house is two stories in front, and one and a half in the rear. Building well-finished and painted surrounded with shade trees and shrubbery. A superior fruit yard embracing probably as good a variety of choice fruits as can be found in the country, and a good garden, situated on the rise of Main and Mattison Sts., nearly opposite the Presbyterian Meeting house. M. W. Hopkins Albion, February 5, 1834." *The Orleans Advocate and Anti-Masonic Telegraph*, February 5, 1834. The remnants, or 20th century re-plants, of the fruit yard still exist on the grounds of the Orleans County Court House.

40. *The Ohio Statesman* (Columbus, Ohio, April 23, 1839).

lery." The location in central Columbus, near the State House, was in a very commercial section of town and Hopkins' clientele was fairly sophisticated.[41]

By December 1839, Hopkins offers a house for rent in Columbus and refers prospects to his "portrait gallery":

> *House for Rent* A pleasant and convenient house with five rooms, a cellar, well and other appurtenances. Possession will be given immediately by applying to M. W. Hopkins at his Portrait Gallery, Armstrong's Block, High Street, Columbus, Ohio. December 25, 1839.[42]

Hopkins must have remained in Columbus until spring 1840, when he is listed on the census of Franklin County, Columbus.[43] In December 1840, Hopkins may have been the unnamed artist who advertised as a portrait painter.

> *Portrait Painting* Portraits taken at Armstrong's building over Miller and Brown's store for five dollars each—also a few Oil Paintings for sale. Call and see, &c. December 7, 1840.[44]

Identified portraits by Hopkins done in Cincinnati, Columbus, and Oberlin about 1840 have come to light, but his artistic activities seem to be curtailed at this time. One can surmise that two secondary source references must be accurate when they named M. W. Hopkins as a "notorious agent for the Underground Railroad":

> He received many commissions to paint portraits of southern planters and men of wealth in the southern states, and, at length, at the invitation of southern friends, journeyed to Jackson, Mississippi. Here he was busy with his work, when, without warning, he received an anonymous communication informing him that it had become known that he was an Abolitionist through former friends at Columbus and within two days had to leave town. He returned to his old home in Ohio.[45]

By 1843, he opened a studio in Cincinnati where "Hopkins, M. W. Portrait Painter, Elm St. Bet. 8th and 9th" advertised as a portrait painter:

> *Portrait Painting* M. W. Hopkins Respectfully invites Ladies and Gentlemen to call at his Gallery on the south side of Elm Street Three doors below Ninth and examine specimens of portraiture in Oil Colors.[46]

Hopkins died of pneumonia at age 54, in April, 1844.

> *Died* Suddenly at his farm near Williamsburgh, Clermont Co., Ohio. On Wednesday, 24 inst. Mr. Milton W. Hopkins, Artist, of this city. He went to the country on business on Thursday, previous—was taken suddenly ill—sent for his family the next day and died the Wednesday following.[47]

Hopkins' family was apparently located in Cincinnati, rather than in Williamsburgh at this time. In 1847, Almira Hopkins and children were ordered by the sheriff of Clermont County to sell the farm, proceeds to go to one James C. Wilson of Columbus, Franklin

41. During this period, for example, he painted the portrait of Virginia Ada Wright, whose father was clerk of the Ohio House of Representatives and later, mayor of Columbus.

42. *The Ohio Statesman* (Columbus, Ohio, December 25, 1839).

43. United States Census, Franklin County, Ohio, Columbus, Ohio, 1840; on deposit Franklin County Courthouse, Columbus, Ohio.

44. *The Ohio Statesman* (Columbus, Ohio, December 7, 1840). "Oil paintings" in this context referred to landscapes, still lifes, or "fancy pieces" to distinguish them from portraits. If this is Hopkins' advertisement, such "fancy pieces" would be an additional artistic endeavor for which no documented examples have come to light.

45. Henry P. Johnston, ed., *The Record of Connecticut Men in the Military and Naval Service During the War of the Revolution 1775–1783* (Hartford: 1889), p. 503. See also Timothy Hopkins, *John Hopkins of Cambridge and Some of His Descendants* (San Francisco: Stanford University Press, 1932), p. 46.

46. R. P. Brooks, *Cincinnati Business Directory* (Cincinnati, Ohio, 1844), p. 18. The 1844 directory was a reissue of the 1843 directory.

47. *Cincinnati Daily Atlas* (Cincinnati, Ohio, April 29, 1844).

changed hands at 22s. 6d. and 2800 to arrive at 23s. per barrel.

London Grain Market.--The duty on foreign Wheat has fallen 1s. per qr. this week. In other articles there is no variation.

Died,

Suddenly, at his farm near Williamsburgh, C'e mont Co. Ohio, on Wednesday, 24th inst. Mr. MILTON W. HOPKINS, Artist, of this city. He went into the country on business, on Thursday previous—was taken suddenly ill —sent for his family the next day, and died on the Wednesday following.

In Switzerland Co. Ind. on the 25th of December last, Mrs. MATILDA FACEMIRE, consort of A. G. Facemire, in the 26th year of her age. On the 2d of March J. B. FACEMIRE, aged one year and seven months. On the 19th of April, Mrs. HANNAH FACEMIRE, consort of John Facemire, aged 61 years.

County.[48] Almira Hopkins died in 1861 and, in 1863, the family moved M. W.'s body from Williamsburgh to Spring Grove cemetery, Cincinnati. The cemetery records list the cause of death as "lungs," which at that time meant "lung fever" or pneumonia. Hopkins is buried in a plot adjacent to that of Cincinnati art patron Nicholas Longworth (1782–1863), suggesting that his family and friends clearly wanted him remembered as an artist. It also raises the possibility that Longworth may have sponsored Hopkins and served as patron.[49]

At least one of Hopkins' children followed an artistic vocation. In 1869, Lewis Cheeseman Hopkins opened the "Hopkins Gallery of Art" at 158 West Fourth Street, Cincinnati.

> The splendid collection of paintings of the French, German, and Italian schools of art, recently imported by L. C. Hopkins and forming the most varied and complete Gallery of Foreign Art ever exhibited in the West, will be opened to the public on Friday, November 27. In the collection will be found gems from the studios of Achenbach, Millner, Von der Beck, Fraulein. . . . Also copies of the works of great masters in the Galleries of Munich, Dresden, Vienna, Antwerp, Venice, Milan, etc. Admission Free.[50]

L. C. Hopkins also participated in the "Picture Galleries of the Exposition of 1872."

> *A New Era* in the History of American Culture. A Partial listing of home and foreign artists represented. . . . Achenbach, Leutze. . . . Bougereau . . . F. E. Church, Kensett, Geo. Inness, Rembrandt Peale . . . Gifford, Whittridge, Vedder. . . . James Hart. . . . The vestibule will contain statues and busts by Powers, Rogers and others from the galleries of Miles Greenwood, Nathan Butler and L. C. Hopkins. The south wall of the North Hall will be devoted to photography.[51]

The rather colorful and varied career of M. W. Hopkins negates many of the assumptions about folk artists that have portrayed them as untrained and isolated, concentrating only on creating works of art. Hopkins was at least trained as a decorative painter and probably received some formal education. Portrait painting was never his only source of income; he pursued farming and teaching and had a brief career in business. He owned property, reared a large family, and, throughout his life remained active in church and civic affairs, and the leading reform movements of his day. The facts of his life present a detailed image of a rural portrait painter who worked in a specific style for a circle of patrons who selected him because of his artistic skills and progressive outlook.

48. Manuscript, Clermont County Courthouse, Batavia, Ohio.

49. Longworth, a lawyer and real estate speculator, became one of the country's wealthiest men in the 1830s. During this time, his name and fortune were associated with nearly every arts and educational institution in Cincinnati. He was exceptionally supportive of individual artists. A contemporary noted that "there was never a young artist of talent who appeared in Cincinnati and needed help, that Mr. Longworth, if asked, did not willingly assist him." His most famous protege was sculptor Hiram Powers (1805–1873). See Daniel Hurley, *Cincinnati The Queen City* (Cincinnati: Cincinnati Historical Society, 1982), p. 30. Further research in the voluminous Longworth papers in the Cincinnati Historical Society may reveal a direct link to Hopkins.

50. *Cincinnati Daily Enquirer* (Cincinnati, Ohio, November 24, 1868).

51. *Cincinnati Daily Enquirer* (Cincinnati, Ohio, August 25, 1872).

The family of folk painter Noah North (1809–1880) came from Connecticut. Throughout the late 18th century, the North family lived in Litchfield County, settling on a farm between Colebrook and Winchester. In addition to farming, Noah's grandfather, Martin, worked as a woodworker, making chairs, coffins, churns, and similar articles.[1] Martin fathered four children by his first wife, Abigail Eno. Noah, Sr. (1785–1824), the painter's father, was born in Winchester.[2]

In 1804, Noah, Sr., married Olive Hungerford (1788–1849) and in 1806, they joined the many New England settlers heading west and left Connecticut for New York, settling first in Marcellus, adjacent to Pompey, outside Syracuse. Two years later, they moved to the wilderness near Batavia, New York, in what became the village of Alexander. The Norths bought land on the Dodgeson Road from the Holland Land Company, which had begun extensive sales in 1800 from offices in Batavia.[3]

Noah North, Sr. was a farmer actively involved in the community. His participation in the establishment of a public library in Alexander in 1811 suggests an interest in cultural affairs.[4] He served in the War of 1812 and, a few years later, in the militia.[5] After becoming a Master Mason in Olive Branch Lodge, Batavia, in 1814, he served as treasurer of the lodge in 1819 and 1820.[6] At the time of his death in 1824, he had "engaged in so many cases of public trust" a special town meeting was called in his memory. He had earned the reputation of a "man of superior attainments who personally attended to the education of his children, fitting several of them to be teachers."[7] Noah, Jr., born on June 27, 1809, was the third of eight children.[8] Throughout the 1820s, following the death of her husband, Olive North and her children maintained the farm and continued to participate in various church, cultural, and agricultural activities in the Batavia area. The Norths were consistent winners at many Genesee County agricultural fairs and cattle shows in the 1820s and 1830s.[9]

It is possible that the North and Hopkins families were acquainted prior to the 1820s. Both emigrated from neighboring towns in Connecticut to the same area of upstate New York during the first decade of the century. The young Noah North could also have met M. W. Hopkins, 20 years his senior, through the network of anti-Masonic activities in which both men participated during the late 1820s.

Despite the fact that his father had been a Master Mason and, more importantly, an elected officer of Olive Branch Lodge, North, like many others, was outraged by the Morgan incident. In 1832, he was a delegate and special committee member to a convention of "Democratic, Anti-Masonic Young Men of the County of Genesee" held in Batavia.[10] The convention "enthusiastically" supported the anti-Masonic candidates for president, vice-president, and governor. At 23, North was not only continuing the tradition of civic involvement established by his family, he had already attained a measure of local recognition that might prove useful to an aspiring painter.

Given his family's situation, North presumably would have been expected to continue to help run the family farm in the early 1830s. Interestingly, however, there is one male, aged 20 to 30, missing from the North family in 1830, the same year the Hopkins household shows an additional male of the same age living with the family in Albion.[11] While the earliest documented portraits for both artists

1. Irving E. Manchester, *The History of Colebrook, Connecticut* (Winsted, Connecticut, 1935), p. 121.

2. Dexter North, *John North of Farmington, Connecticut and His Descendants* (Washington, D.C., 1921), p. 33. The name "Noah" recurs frequently in the North family; the most notable Connecticut member was Deacon Noah North (1733–1818), Martin's brother, who was for many years a representative to the state legislature, church deacon, and influential citizen of Torrington. See *The Magazine Antiques*, Vol. XLIV, No. 1 (July 1943), pp. 18–19.

3. Although the town records were destroyed by fire, Noah, Sr.'s grandson, Safford E. North, noted that both he and his father were born on the farm on which Noah, Sr. settled in 1808. See Safford E. North, ed., *Our Country and Its People, A Descriptive and Biographical Record of Genesee Country, New York* (Boston, 1899), pp. 513–514.

4. F. W. Beers, *Gazetteer and Biographical Record of Genesee County, 1788–1890* (Syracuse, 1890), p. 162.

5. Hugh Hastings, ed., *Military Minutes of the Council of Appointment of the State of New York 1783–1821* (Albany, State of New York, 1901), pp. 1879 and 2159. Abijah W. Stoddard and James R. Jackman, two subjects painted by his son, served in the same regiment as surgeon and ensign, respectively.

date from 1833, Hopkins began painting portraits prior to the December 1830 critique of his work that appeared in a Rochester, New York, publication.[12] One can speculate that North, a year and a half older than the eldest Hopkins child, George Gilbert, was living with the family, studying portrait painting, and working with M. W. Hopkins.

Stylistic evidence in North's earliest paintings supports this theory and suggest that he received some artistic training in the early 1830s, even before Hopkins advertised painting lessons.[13]

By 1834, the market for North's work had spread well beyond Alexander. In Holley, New York, a village on the Erie Canal to the north of Alexander and several miles east of Albion, he painted Eunice Eggleston Darrow Spafford and in the same year painted her daughter-in-law, Sarah Angelina Sweet Darrow. Perhaps North's sister, Olive, who died of cholera in Holley the next year, introduced him to the village. The majority of portraits attributed to North and Hopkins was completed in the vicinity of Genesee, Orleans, and Monroe Counties from the period 1833 until about 1836. In or about 1836, North, probably accompanying the Hopkins family, moved to Ohio. As early as June, North advertised as a portrait painter in Ohio City.

> PORTRAIT PAINTING N. North will pursue his profession in this place for a short time. Ladies and Gentlemen are respectfully invited to call at his room and examine specimens of his work. Room over the Brick Store opposite the Columbus Block. Ohio City, June 23, 1836.[14]

He apparently achieved success as a portraitist remaining at least another year, as he is listed in the business directory for Cleveland and Ohio City, 1837–1838, as "N. North, Portrait Painter; room over the Brick Store opposite the Columbus Block, Ohio City."[15]

During his stay in Ohio City, he resided at the Ohio City Exchange, a hotel that has been described as "the finest building west of Albany, a magnificent brick building of five storeys, crowned with a noble dome and having splendid balconies in front, supported by pillars of Ionic Order."[16] Ohio City was incorporated on March 3, 1836, on the west bank of the Cuyahoga River across from (and now part of) Cleveland. The area, claimed by the Connecticut Land Company, was first settled in the late 18th century largely by people from New England. With the completion of the Ohio and Erie Canal in 1832, linking the Ohio River with Lake Erie, the importance of the two cities escalated rapidly. In 1839 alone the canal carried 19,962 passengers to Cleveland and Ohio City.[17] The attraction of new opportunities in these booming towns lured North and Hopkins to Ohio. North left the Cleveland area in the late 1830s and may have joined Hopkins in Cincinnati. A secondary source indicates that his advertisements appeared in newspapers in Cincinnati and across the river in Kentucky in the late 1830s, but no evidence of North in this area has come to light.[18]

North is not listed in the 1840 census in any town in Ohio or New York, but by June 1841, he returned to New York State, where he married his neighbor, Ann C. Williams (1808–1872), daughter of

6. David Seaver, *Freemasonry at Batavia, New York, 1811–1891* (Batavia, New York, 1891), p. 30. Gaius B. Rich, husband of Aphia Salisbury Rich, a sitter depicted by Hopkins about 1833, was initiated in the same class.

7. Safford E. North ed., *Our Country and Its People, A Descriptive and Biographical Record of Genesee County, New York* (Boston, 1899), p. 514.

8. The other children were Thetis (1806–1870), Launcelot M. (1807–1865), Alcimeda (1811–1833), James Agard (1813–1893), Olive F. (1814–1835), Aurelia N. (1816–1896), and Zaxie C. (1817–1891). See Dexter North, *John North of Farmington, Connecticut and His Descendants* (Washington, D.C., 1921), 61.

9. *The Republican Advocate* (Batavia, New York, October 29, 1834). The Norths won in categories as diverse as "best sow and pigs," "best fruit and garden vegetables," and "best bed quilt."

10. A report of the convention appears in *The Republican Advocate* (Batavia, New York, October 30, 1832).

11. Census, Genesee County, New York, Batavia, New York, 1830; census, Orleans County, New York, Albion, New York, 1830.

12. *The Craftsman* (Rochester, New York, December 22, 1830).

13. North's first known portraits of Isaac C. and Calista Gates Bronson were painted on small, roughly planed wood panels, using flat areas of paint, and an overall naivete in composition quite different from his later portraits. These qualities, although prized today by folk art enthusiasts, suggest a date in the early 1830s, before his skills were fully developed. Elements of Hopkins' and North's later style—hands resting on a Hitchcock-type chair, salmon highlights in facial features, black clothing contrasting with somber background—appear in these portraits, but in a rudimentary fashion that suggests a student's work. After the

Daguerreotype Portraits.

N. NORTH would inform the inhabitants of Mt. Morris village and vicinity, that he has taken rooms over J. A. Mead's Store on Main street, where with a complete apparatus, he is prepared to take Daguerreotype Likenesses in miniature size, and put them up in neat Morocco cases, or otherwise, when desired.

Ladies and gentlemen are respectfully invited to call and examine specimens of his work.

N. B. He would say to those who are desirous to "secure the shadow ere the substance fade," that NOW is the time, while life, health and opportunity offers.

Mt. Morris, Sept 9, 1845. tf

DAGUERREOTYPE LIKENESSES.—N. NORTH has established a Daguerreotype Gallery over J. A. Mead's store. We have seen a number of pictures taken by him and we think they are equal to any that has been taken in our village. Call and see for yourselves.

DAGUERREOTYPES.

The subscriber has taken rooms over Williams' Store, (room occupied by N. North,) for the purpose of taking Likenesses. Gentlemen and Ladies are requested to call.

ap7 2t W. L. THOMPSON.

Thorp and Clarissa Williams, in Darien. By April 1842, the Norths had moved to the village of Mount Morris, Livingston County, where a daughter, Mary Ann, and three years later, a son, Volney were born.[19] North purchased land near Mount Morris and probably returned to farming during the early 1840s, since no evidence of portrait painting activity exists in local primary source materials.[20] North's interest in politics surfaced again in Mount Morris when, in January 1844, he signed a petition inviting the Whigs of Livingston County to a meeting to organize a County Clay Club.[21] In both 1845 and 1846 he ran for and was elected assessor on the Whig town ticket.[22]

North turned to ornamental painting in March 1844. Advertisements reading, "NOAH NORTH Carriage, Sign, House and Ornamental painter—Shop on Chapel Street, two doors below the Methodist Church," began appearing on a regular basis.[23]

Perhaps motivated by the need to supplement his ornamental painting business or, more likely, by a genuine interest in taking a "correct likeness," North learned the daguerreotype process. An announcement of his new occupation appeared in the local newspaper in September 1845:

DAGUERREOTYPE PORTRAITS N. North would inform the inhabitants of Mt. Morris village and vicinity that he has taken rooms over J.A. Mead's store on Main Street, where with a complete apparatus, he is prepared to take Daguerreotype likenesses in miniature size, and put them up in neat Morocco cases, or otherwise, when desired. Ladies and Gentlemen are respectfully invited to call and examine specimens of his work. N.B. He would say to those who are desirous to "secure the shadow 'ere the substance fade" that *Now* is is the time while life, health and opportunity offers. Mt. Morris, September 9, 1845.[24]

This advertisement and one for ornamental painting ran concurrently in the newspaper until November 1845, when the daguerreotype advertisement appeared alone. Evidently the new "mirror images" were readily accepted by the populace and met with significant public approval. A local endorsement of his work appeared in the newspaper:

Daguerreotype Likenesses—N. North has established a Daguerreotype Gallery over J. A. Mead's Store. We have seen a number of pictures by him and we think they are equal to any that have been taken in our village. Call and see for yourselves.[25]

To date, no daguerreotypes marked by North have been discovered, and, like many others, he may not have marked his work. His career as a daguerreotypist, however, is well documented in local newspaper advertisements. In April, 1846 one W. L. Thompson joined North in the business and advertised that "he has taken rooms over Williams store (room occupied by N. North) for the purpose of taking likenesses. Gentlemen and Ladies are requested to call.[26] By September, a "Mr. Barnes" was competing with North and Thompson for daguerreotype business.

completion of several other portraits these elements are more confidently executed. Two other portraits, those of Abijah W. Stoddard and his wife were completed by North between January 1 and February 11, 1833, fully two months before Hopkins advertised as a teacher of portrait painting. These likenesses, signed "By Noah North," show North's greater mastery of aspects of more formal portraiture. Assuming accurate and consistent numbering, North executed only three paintings between Abijah W. Stoddard, "No. 8," done prior to February 11, 1833, and "No. 11," the posthumous portrait of Dewit Clinton Fargo painted on July 7. Other portraits from 1833 include "No. 15," of the Reverend Hugh Wallis whom his sister, Alcimeda had married about 1830, and that of his neighbor, Oliver Ide Vaughan.

14. *Ohio City Argus* (Ohio City, Ohio, June 23, 1836).

15. Julius P. Bolivar Mac Cabe, *Business Directory for Cleveland and Ohio City* (Cleveland, 1837), p. 131.

16. Richard N. Campen, "The Story of Ohio City," unpublished manuscript, on deposit, Western Reserve Historical Society, Cleveland, 1968, p. 9.

17. Ibid.

18. This is affirmed but not documented by Ohio researcher Rhea Mansfield Knittle in *The Magazine Antiques*, March 1932, p. 152. Mrs. Knittle's notes have been destroyed and primary sources contain no mention of North's artistic activity in Cincinnati or Kentucky.

19. Dexter North, *John North of Farmington, Connecticut and His Descendants* (Washington, D.C., 1921), p. 61.

20. Land records, Wyoming County Courthouse, Warsaw, New York.

21. *Livingston County Republican* (Geneseo, New York, January 9, 1844).

"Encourage the Arts."
L. W. BRISTOL,

RESPECTFULLY informs the inhabitants of Mt. Morris and the adjoining towns, that he has taken Rooms in Thompson's Block, for a short time, and is prepared to take

DAGUERREOTYPE LIKENESSES,

On the new and improved system, (recently from France,) which is far superior to the old method ; being more clear, distinct and Life like, a comparison of which will prove the assertion. All are respectfully invited to call at his Rooms and examine for themselves.

Mt. Morris, January 11, 1847.

TO THE CITIZENS OF MT. MORRIS!

THE subscriber would most gratefully return his sincere thanks to the citizens generally for their very liberal patronage, and he trusts that by strict attention to his business, to merit a continuance of the same.

All those indebted to the subscriber are most respectfully requested to call and settle their bills immediately, and thereby save themselves cost, and no mistake. W. H. PARKER, the "supernatical" Barber, No. 2 Chapel-st.

599 lbs. Soft Shell Almonds for sale low at [sep24] R. R. CONKEY'S.

NOTICE is hereby given that an application will be made to the Legislature at its next meeting for the passage of a law, authorising and directing the Board of Supervisors of Livingston county, to raise by tax on county, a sum sufficient to purchase the toll bridge across the Genesee River at Squakie Hill —Dated at Mt. Morris, Dec. 31. 1846.

DON'T READ THIS! Mr. Barnes would respectfully inform the citizens of Mt. Morris and vicinity that he has taken rooms at the American Hotel where all who are desirous of obtaining a true and durable likeness of themselves or friends would do well to call immediately as his engagements are such that his stay in this place must be necessarily limited, and the prices are low ranging from $1.25 to $4.00, work warranted good.[27]

Barnes must have had ample business because he extended his stay in Mount Morris.

DAGUERREOTYPE PORTRAITS Mr. Barnes, grateful for the very liberal patronage already received, and still hoping to render his work (as it is said to be) worthy of public confidence and esteem, would respectfully inform the citizens of Mt. Morris that he will remain at his rooms at the American Hotel a very few days longer, where all would do well to call immediately and obtain a perfect likeness of themselves and friends at a very low price.[28]

Apparently there was sufficient interest in obtaining daguerreotypes to keep North, Thompson, and Barnes in business through the end of the year. By January 1847, yet another itinerant, a "Mr. L. W. Bristol," arrived in Mount Morris to practice daguerreotypy.

ENCOURAGE THE ARTS L. W. BRISTOL Respectfully informs the inhabitants of Mt. Morris and adjoining towns that he has taken rooms in Thompson's block for a short time and is prepared to take Daguerreotype Likenesses on the new and improved system (recently from France) which is far superior to the old method, being more clear, distinct, and Life Like a comparison of which will prove assertion. All are respectfully invited to call at his rooms and examine for themselves.[29]

Bristol's stay in Mount Morris was short-lived because in February of the same year he announced that his rooms would be closed.

L. W. Bristol would return his grateful thanks to the citizens of Mt. Morris and vicinity for their very liberal patronage and would give notice that, owing to ill-health, his Daguerrean Rooms will be closed the remainder of the week. He will be happy to wait on all who wish a correct likeness of themselves or friends at any time the coming week.[30]

"Ill health" may have caused Bristol to close his business for a week, but soon after, he left Mount Morris recommending North to the public. The wording of his announcement indicates that he trained North in his newer, improved methods before leaving.

A CARD Mr. L. W. Bristol returns his thanks to the citizens of Mt. Morris for the liberal patronage that he had received during his stay in the place and would respectfully recommend those who still wish GOOD PICTURES to call on Mr. North in Thompson's Block who is fully qualified to take them on the NEW SYSTEM.[31]

North lost no time in presenting himself in a commercial way as a more accomplished daguerreotypist.

22. *Livingston County Whig* (Geneseo, New York, April 1, 1845 and April 7, 1846).

23. *Livingston County Whig* (Geneseo, New York, March 19, 1844).

24. *Livingston County Whig* (Geneseo, New York, September 9, 1845).

25. Ibid.

26. *Livingston County Whig* (Geneseo, New York, April 7, 1846).

27. *Livingston County Whig* (Geneseo, New York, September 8, 1846).

28. *Livingston County Whig* (Geneseo, New York, September 29, 1846).

29. *Livingston County Whig* (Geneseo, New York, January 12, 1847).

30. *Livingston County Whig* (Geneseo, New York, February 2, 1847).

31. *Livingston County Whig* (Geneseo, New York, February 23, 1847).

DAGUERREOTYPE PORTRAITS The subscriber having availed 'himself of the NEW SYSTEM of taking Daguerreotype Likenesses would inform the public that he will continue in the rooms lately occupied by L. W. Bristol in Thompson's Block for that purpose. Where those wishing inimitable life like representations for future generations can be accommodated on reasonable terms. All are respectfully invited to call and examine his work and "see themselves as seen by others". N. North.[32]

North continued to advertise taking daguerreotypes throughout 1847. By January 1848, however, he returned to ornamental painting, forming a partnership with one Alexander McLean and expanded his practice to include paper hanging and window glazing.[33]

NORTH AND MCLEAN HOUSE, SIGN AND CARRIAGE PAINTERS, Paper Hangers, and Glaziers—Shop on Chapel Street, three doors below the Methodist Church (upstairs). Mt. Morris, Jan. 18.[34]

Details of North's life during this period can be gleaned from a variety of newspaper and census reports. In March 1849, his mother, Olive, died while visiting her daughter in Colebrook, Ohio.[35] In the census of 1850 he is listed as a "painter" living with his wife, two children, and his wife's 15-year-old niece, Caroline G. Williams who was "attending school."[36] In the 1850–51 Western New York Business Directory "North and M'Lane" advertise under "Painters-House, Sign and Fancy."[37] Sometime in the late 1850s, the Norths moved to Darien, where they lived with Ann's father. In the 1860 census for Darien, North's occupation is recorded as "farmer."[38] In addition to their own children, with them lived "Clarissa North," born in 1855, the illegitimate daughter of Caroline Williams, whom the Norths presumably adopted.[39] In addition to running the Williams farm in the 1860s, North served as a justice of the peace for 10 years.[40] In February 1869, Ann's father died, and in May, the Norths sold the Darien property and bought land in nearby Attica for $7,000.[41] The 1870 census listed North as a farmer living in Attica with his wife, Ann, two children, and Clarissa.[42]

In 1872 Ann North died and was buried in the family plot in Maple Hill Cemetery, Darien. The following year 28-year-old Volney North died and was buried near his mother. In 1875, North's daughter, Mary Ann, died at the age of 32 and, like her mother and brother, was buried in Maple Hill Cemetery.[43]

In January, 1876 North married his late wife's sister, Caroline Williams Gibson.[44] The last four years of North's life were financially troubled. Records indicate that he sold most of his remaining Attica properties in small parcels and disposed of his second wife's holdings in the nearby village of Arcade.[45] North still enjoyed a measure of public esteem from his continuing involvement in community affairs. He served on the Attica Board of Education in 1878 and 1879, and, at the time of his death on June 15, 1880, he was vice-president of the Genesee County Pioneer Association. His obituary in the *Batavia Daily News* reads:

32. *Livingston County Whig* (Geneseo, New York, March 2, 1847).

33. Alexander McLean, born in Scotland in 1821, came to Mount Morris about 1842 and began his career as a house and ornamental painter. His advertisement in 1845 [*Livingston County Whig* (Geneseo, New York, September 16)] described the range of his work as "House, Sign, and Carriage Painting, Glazing, and Paper Hanging which will be done with dispatch in a workmanlike manner."

34. *Livingston County Whig* (Geneseo, New York, January 18, 1848).

35. *The Republican Advocate* (Batavia, New York, April 10, 1849).

36. United States Census, Livingston County, New York, 1850; on deposit Livingston County Courthouse, Geneseo, New York.

37. Buffalo, New York, 1850, p. 6295.

38. United States Census, Genesee County, New York, 1860; on deposit Genesee County Courthouse, Batavia, New York.

39. The presence of Clarissa North is noted in North's will, written November 4, 1875, and now in the surrogate's office, Wyoming County Courthouse, Warsaw, New York.

40. F. W. Beers, *Illustrated History of Wyoming County, New York* (New York, 1880), p. 144.

41. Record of Deeds, Wyoming County Courthouse, Warsaw, New York.

42. United States Census, Wyoming County, New York, 1870; on deposit Wyoming County Courthouse, Warsaw, New York.

43. Dexter North, *John North of Farmington, Connecticut and His Descendants* (Washington, D.C., 1921), p. 61.

44. Ibid.

45. Record of Deeds, Wyoming County Courthouse, Warsaw, New York.

46. *Batavia Daily News* (Batavia, New York, June 15, 1880).

47. F. W. Beers, *Illustrated History of Wyoming County, New York*, (New York, 1880), p. 144.

Mr. Noah North, of Attica, died very suddenly this morning at his home in that village. He was born in the town of Alexander in June, 1809, and was therefore 70 years of age. Mr. North has always been a resident of Genesee County, with the exception of a few years residence at Mt. Morris and ten years in Attica. Deceased was a brother of J. A. North, of Alexander, and uncle to S. E. North of this village. At the time of his death he was vice-president of the Genesee County Pioneer Association.[46]

A history of Wyoming County, published in 1880, called North a "farmer, manufacturer of lumber, painter, and teacher, who served on the board of education."[47]

Like his mentor, M. W. Hopkins, North's life and artistic career help clarify many of the theories about folk artists in 19th-century America. Although North lived into the second half of the century, his art never made the transition into the more romantic style of painting that came into vogue. By mid-century the plain style of portrait painting in which he had been trained was outdated. His continued interest in producing correct likenesses instead found an outlet in the new portrait medium of daguerreotypy and like many other folk artists, he returned to ornamental painting for his livelihood when portrait commissions were no longer forthcoming. Throughout his life, he remained a farmer who had artistic aspirations.

PIERREPONT EDWARD LACEY AND HIS DOG GUN
Attributed to M. W. Hopkins
Probably Scottsville, New York
c. 1836
Oil on canvas
H. 42″ W. 30″

MRS. R. HINTON AND HER DAUGHTERS JOSEPHINE AND MARY ELLEN
M. W. Hopkins
Possibly Cincinnati 1841
Inscribed "Josephine Hinton AE 5-1841 / Mrs. R. Hinton AE 35-1841 / Mary Ellen Hinton AE 11-1841 / Hopkins"
Oil on canvas
H. 29¾″ W. 44½″

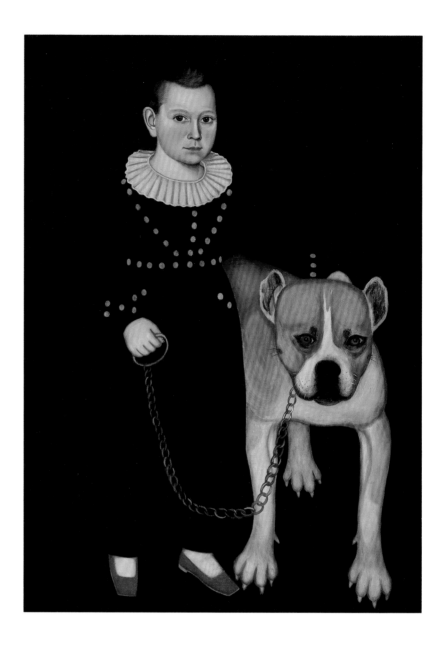

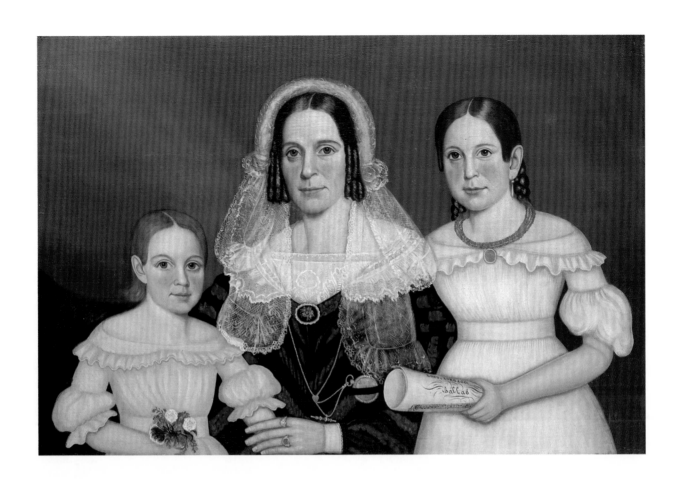

RACHEL DUTTON WILLEY
BROWN
Attributed to M. W. Hopkins
Probably Ogden, New York
c. 1835
Oil on wood panel
H. 28¼″ W. 21¾″

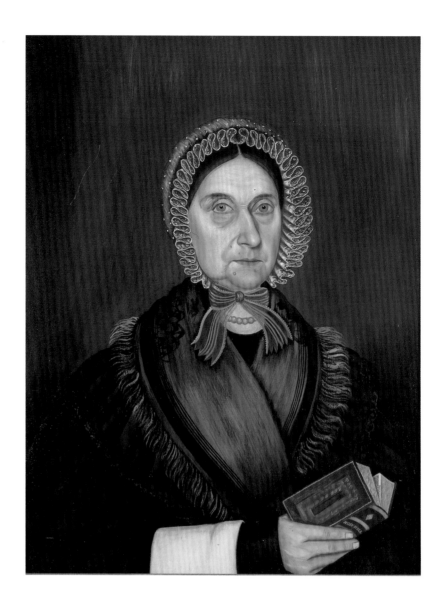

WILLIAM BAKER BROWN
Attributed to M. W. Hopkins
Probably Ogden, New York
1835
Oil on wood panel
H. 28¼″ W. 23¾″

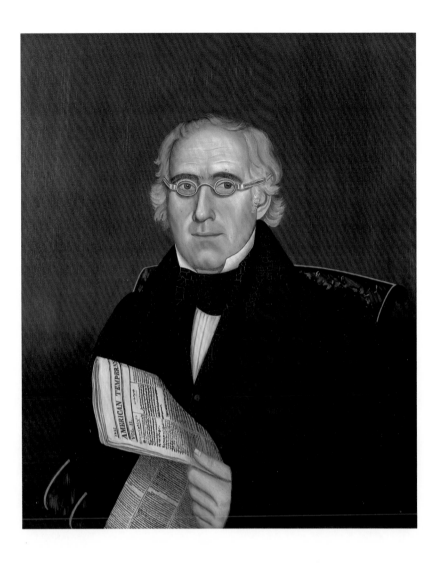

DEWIT CLINTON FARGO
Noah North
Probably Alexander, New York
1833
Inscribed in red on back: "No. 11 By
Noah North / Mr. Dewit Clinton
Fargo / Who died July 7th, 1833 /
AE 12 years"; on right side of panel
"July 8th, 1833"
Oil on wood panel
H. 26″ W. 21″

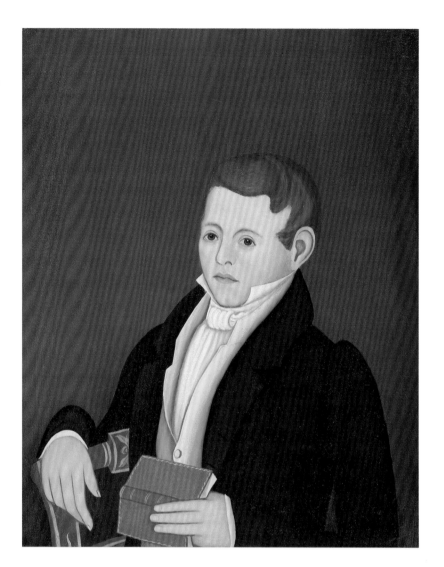

**EUNICE EGGLESTON
DARROW SPAFFORD**
Noah North
Holley, New York
1834
Inscribed: "No. 40 by N. North /
Mrs. Eunice Spafford / AE 55 years
/ Holley / 1834"
Oil on wood panel
H. 28″ W. 23⅜″

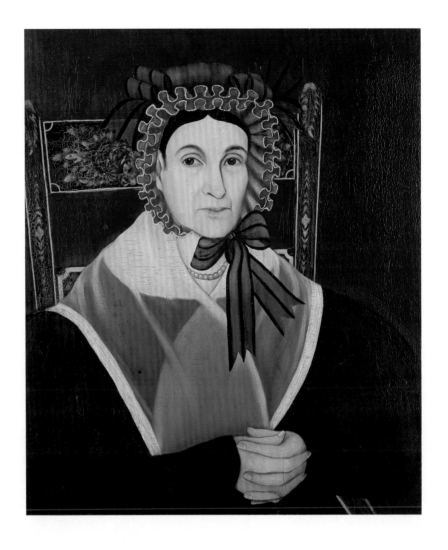

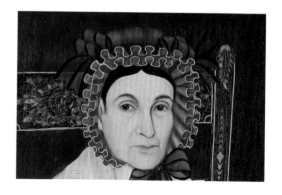

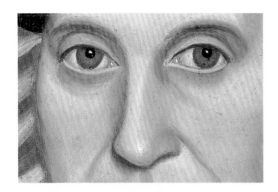

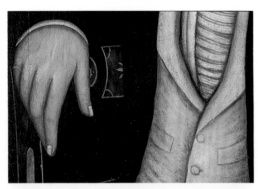

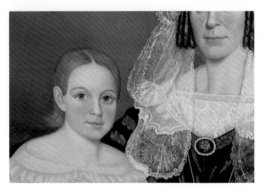

EYES Both artists placed a white highlight in the upper arc of the pupil and inner corner of the eye.

EARS Ears are characteristically oversize with prominent C- and D-shaped inner curves.

MOUTHS Hopkins and North painted a subject's mouth in linear strokes using salmon-colored paint.

HANDS The hands and fingernails in Hopkins' portraits appear square and blunt; in North's portraits, they are longer and tapered.

COSTUMES Both artists included extensive detail in depicting dresses and jewelry. Lace bonnets typical of the 1830s were rendered by layering paint in a technique called "impasto."

PROPS In their careers, Hopkins and North were also ornamental painters. Both carefully added furniture designs to the decorated chairs that appear in their portraits.

TECHNIQUE Hopkins created pattern on a sitter's dress by "graining," a way of applying paint that usually appears on furniture. North actually stenciled a pattern onto a chair with gold powders.

FANNY AIKEN
Attributed to M. W. Hopkins
Probably Orleans County,
New York
c. 1835
Oil on wood panel
H. 30″ W. 27″

Dr and Mrs. Ralph Katz

Details about the sitter remain un-
known. A family history, however,
indicates that the portrait was painted
in upstate New York ". . . by an
obscure artist named Hopkins."[1]

Shown life-size, Fanny was depicted
wearing a black dress and white ruf-
fled bonnet. The inclusion of her
hand holding a book may have been
an afterthought by the artist.

1. Interview with the owners, June
1985.

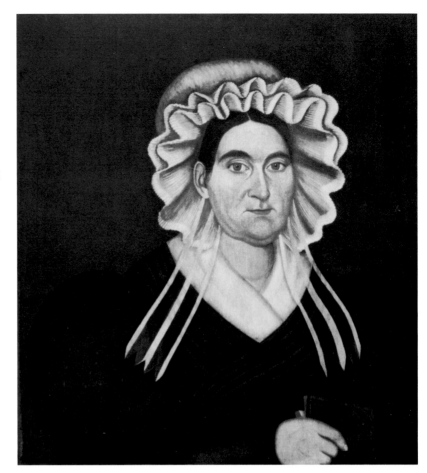

MARGARET PLACE BAKER
Attributed to M. W. Hopkins
Probably Cincinnati, Ohio
c. 1837
Oil on canvas
H. 30″ W. 24″

The Cincinnati Historical Society

Born in New York City in 1802,
Margaret Place married Cincinnati
merchant Lewis Baker sometime in
the 1820s. Little is known about her
life except that she died of consump-
tion in April 1837.[1] The Bakers lived
at the corner of Walnut and Fourth
streets, very near Hopkins' studio in
Cincinnati.

The portrait is one of Hopkins' most
stylish and the only known or extant
example in which he included a
drapery in the background. He
grained and free-hand painted the
Hitchcock-type chair.[2]

1. Letter to the author from Laura L.
Chace, librarian, the Cincinnati His-
torical Society, August 2, 1988.

2. The portrait is illustrated in color
in Robert Doty, *American Folk Art in
Ohio Collections* (Akron, Ohio:
Akron Art Institute, 1976), unpagi-
nated.

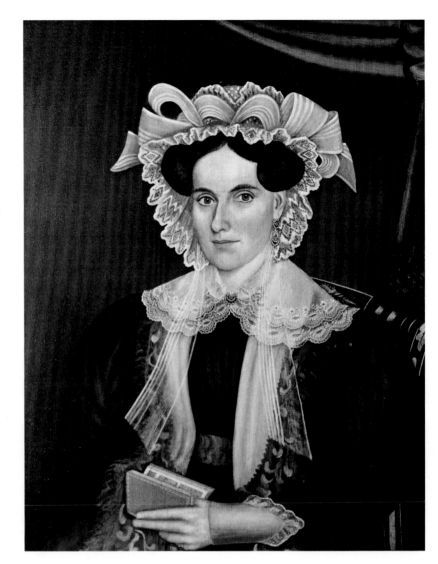

CALISTA GATES BRONSON
Attributed to Noah North
c. 1833
Probably Warsaw, New York
Oil on wood
H. 24″ W. 18″

ISAAC C. BRONSON
Attributed to Noah North
c. 1833
Probably Warsaw, New York
Oil on wood
H. 24″ W. 18″

Warsaw Historical Museum

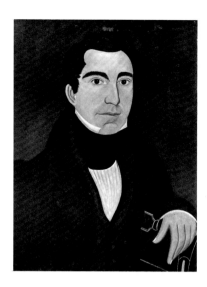

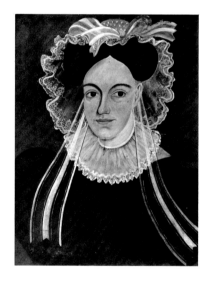

Isaac C. Bronson was born on September 6, 1803 in Onondaga County, New York, where his parents had moved in 1800 from Connecticut. In 1823, the family relocated to the Genesee County town of Sheldon. Bronson married Calista Gates, daughter of Deacon Seth Gates, in Sheldon in 1826. By early 1832, Bronson had established a successful leather and shoe trade in Warsaw, some 15 miles southeast of Noah North's home in Alexander. There he managed numerous businesses including a woolen mill and a grist mill and served as postmaster in the 1840s. He took an active part in securing the construction of the Attica and Hornellsville Railroad and served as director and on the executive committee of the company. Isaac and Calista and their eight children left Warsaw for Rockford, Illinois, in 1854, where he engaged in the cattle trade and farming until his death in 1870.[1]

The small format, crudely planed wood panel, and flat areas of paint suggest that these portraits are among North's earliest efforts. Slight modeling in the faces and props such as the Hitchcock-type chair, however, indicate that the artist had been exposed to more formal elements of portraiture, possibly through instruction from Hopkins.

North's earliest documented works, the portraits of Dr. Abijah W. Stoddard and his wife, numbers seven and eight, done after January 1 and before February 11, 1833, share similar stylistic qualities with the Bronson portraits. By December 1833, after he had completed at least 18 pictures, North's skill in handling paint had increased markedly.[2]

1. Andrew W. Young, *History of the Town of Warsaw* (Buffalo, New York, 1869), pp. 239–240.

2. Nancy C. Muller and Jacquelyn Oak, "Noah North (1809–1880)," *The Magazine Antiques* (November 1977), p. 939, illustrates the portrait of Sally Fargo, "No. 18 By N. North / Mrs. Sally Fargo / AE 39 years 1833." Mrs. Fargo's portrait shows North's increased sophistication.

RACHEL DUTTON WILLEY
BROWN
Attributed to M. W. Hopkins
Probably Ogden, New York
c. 1835
Oil on wood panel
H. 28¼" W. 21¾"

WILLIAM BAKER BROWN
Attributed to M. W. Hopkins
Probably Ogden, New York
1835
Oil on wood panel
H. 28¼" W. 23¾"

Genesee Country Museum

CATHERINE AND
REVEREND ZENAS CASE
The portraits of Catherine and Zenas
Case were stolen from a Michigan
antiques dealer in 1977.[1] Zenas Case
was a Presbyterian minister in Al-
bion in the mid-1830s. It is likely
that the portraits were painted by
Hopkins.

1. See *Antiques and the Arts Weekly*,
March 25, 1977. The paintings were
done in oil on wood panel.

The daughter of Benajah and Anna
Fuller Willey of East Haddam, Con-
necticut, Rachel moved with her
family to Ogden, New York, in
1804, where her brother, George W.
Willey, established the first settle-
ment in 1802.[1] One of the town's
first schoolteachers, she married Wil-
liam Baker Brown in 1807. The
couple had two children, Maria,
born in 1808, and William, born in
1809. Rachel died in 1848 and was
buried in the town cemetery in
Spencerport. Hopkins clearly in-
tended to capture a "correct like-
ness," rendering her facial features
with warts. Painted when she was 66
years old, Rachel's portrait relates
stylistically to Noah North's portrait
of Eunice Eggleston Darrow Spaf-
ford done in the neighboring town
of Holley in 1834. Both pictures
show older women wearing bonnets
typical of the period and gold-
colored beads. In both instances,
facial contouring was attempted, but
the heads appear very flat. Another
related example is the portrait of
Abigail Tolman Lewis owned by the
Western Reserve Historical Society,
Cleveland.

William Baker Brown was born in
Lyme, Connecticut, in 1785. He and
his father, Reverend Daniel Brown,
a Baptist minister, were among the
first settlers of Ogden in 1803.
Brown served in the War of 1812
and was appointed a colonel in the
New York State militia. A successful
farmer, he was appointed one of the
first judges of Monroe County in
1824 and served as a representative
to the state legislature in 1833.[2] After
his first wife's death in 1848, Brown
married Sarah V. Toan, a woman 40
years his junior, and the couple had
two children. He died in 1854 and
was buried next to his first wife and
father in the Brown family plot in
Spencerport, a canal village a few
miles north of Ogden.

Hopkins depicted Brown holding
the *American Temperance Intelligencer*,
Volume II, dated 1835, a periodical
published by the New York State
Temperance Society in Albany from
January 1834 until November 1836.[3]
Brown was elected vice-president of
the Monroe County Temperance As-
sociation in 1830 and later assumed
the office of president.[4] During the
same period, Hopkins was president
and a major spokesman for the Or-
leans County Temperance Society.
Like Hopkins, Brown was active in
the anti-Masonic movement, having
served as a witness in many of the
same trials of the Morgan con-
spirators.[5]

1. William F. Peck, *Landmarks of
Monroe County, New York* (Boston,
1895), pp. 48–49.

2. Ibid.

3. Upon comparison to the actual
volume in the collection of the
American Antiquarian Society, Wor-
cester, Massachusets, it is evident
that Hopkins copied the typography
exactly as it was printed.

4. *The Craftsman*, Rochester, New
York, January 12, 1830.

5. *The Orleans Advocate and Anti-
Masonic Telegraph*, February 11,
1829.

ABIGAIL CHURCH
Attributed to M. W. Hopkins or Noah North
Probably Churchville, New York
1836
Inscribed in black on back:
"Mrs. Abigail Church / AE 65, 1836"
Oil on wood panel
H. 27⅞" W. 23¾"

SAMUEL CHURCH
Attributed to M. W. Hopkins or Noah North
Probably Churchville, New York
1836
Inscribed in black on back: "Capt Samuel Church / AE 68, 1836"
Oil on wood panel
H. 27⅞" W. 23¾"

Rochester Historical Society

Samuel Church (1768–1844), born in Massachusetts, came to the town of Riga, New York with his father, Richard, and brother, Elihu, in 1806. The family established the first sawmill and gristmill and, later, the incorporated village of Churchville was named for them. Elihu Church[1] tells of pioneer life in western New York: "I emigrated from Berkshire [Massachusetts] to Phelps in Ontario County, New York, in 1796. . . . In that year, Mr. Wadsworth's handbills had reached Berkshire, offering to exchange wild lands for farms and had induced my brother, Samuel, to come and see the country.[2] We found it a densely and heavily timbered wilderness. . . . All of us raised small patches of summer crops. I had fifty acres cleared which I sowed to wheat. . . . I had an excellent crop [and] I removed the wheat to Geneva [where] I paid a debt I owned there for a barrel of whiskey. . . ."[3]

In November 1829, Samuel Church was called to serve on the jury at the trial of Morgan conspirator Elihu Mather—the same trial in which M. W. Hopkins testified on behalf of the people.[4] Church, like Hopkins, was also active in the temperance movement, serving as a representative to the Monroe County Temperance Society in 1835.[5] No details are known about the life of Abigail Church other than a brief note indicating that she was born in Massachusetts and came to western New York with her husband.[6] According to the inscription on the back of the painting, she was born in 1771.

The faces of the Churches are not as well-defined as other examples and have been over-painted in some areas. The artist has shown an older couple, conservatively dressed, who gaze at the viewer in a straightforward manner. Samuel holds a copy of *The Christian Advocate*, published by the Methodist Book Concern Publishers, New York City, Volume X, Number 37, in September of 1836.[7]

1. Seen in a portrait attributed to Charles Loring Elliott (1812–1868) now in the collection of the Genesee Country Museum, Mumford, New York. For specific information, see Jacquelyn Oak, "Genesee Country Portraits," *The Magazine Antiques*, in press.

2. James Wadsworth (1768–1844), land agent for the Phelps and Gorham Land Company.

3. Orasmus Turner, *History of the Pioneer Settlement of Phelps and Gorham's Purchase* (Rochester: 1851), pp. 502–504.

4. *The Craftsman*, Rochester, New York, November 24, 1829.

5. *American Temperance Intelligencer*, Albany, New York, October, 1835.

6. In the files of the Rochester Historical Society.

7. In the collection of the American Antiquarian Society, Worcester, Massachusetts.

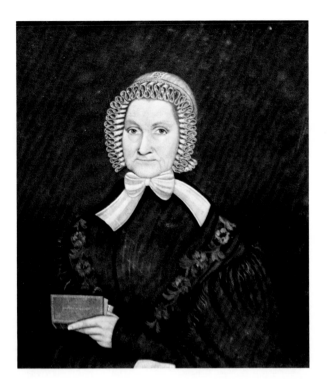 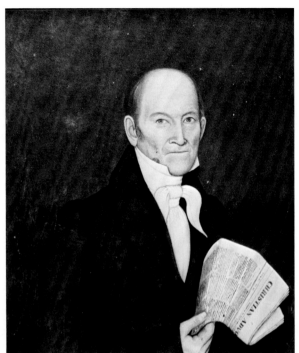

ANN MARIA CONNELL
M. W. Hopkins
Lancaster, Ohio
1838
Inscribed "Mrs. A. M. Connell /
AE-36-1838 / Hopkins"
Oil on canvas
H. 28¼" W. 24"

BENJAMIN CONNELL
M. W. Hopkins
Lancaster, Ohio
1838
Inscribed "AE-47-1838 / Hopkins /
Benj Connell Esq."
Oil on canvas, mounted on board
H. 27¼" W. 22¾"

MARTHA ELLEN CONNELL
Attributed to M. W. Hopkins
Probably Lancaster, Ohio
1838
Oil on canvas, mounted on board
H. 29½" W. 24"

Mr. and Mrs. G. Alan Van Why

Benjamin Connell (b. 1791) was
postmaster of Lancaster, Ohio, a
town near Columbus, where Hop-
kins had a studio in the late-1830s.[1]

The Connell portraits, executed after
Hopkins had been exposed to
academic styles of portrait painting
in Cincinnati and in the state capital,
Columbus, show greater assurance
in composition and facial modeling
than is seen in his earlier work.

A comparison of the portraits of
Ann Maria Connell and that of
Clarissa Hovey shows a remarkable
difference in the rendering of the
subjects, done only two years apart.
Ann Maria's portrait, however, while
showing more sophistication in the
handling of paint, is not as successful
as Hopkins' portraits that were done
in the earlier period in upstate New
York. The inclusion of a letter ad-
dressed to Mrs. Connell, postmarked
"Frederick," and undoubtedly allud-
ing to her husband's profession, may
prove to be a clue in elucidating the
subject.

Martha Ellen's portrait is very simi-
lar to that of Virginia Ada Wright,
done in nearby Columbus about the
same time.

1. Letter to the author from the
owner, May 1985.

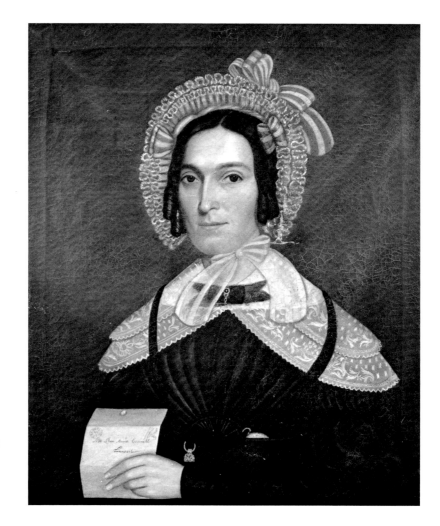

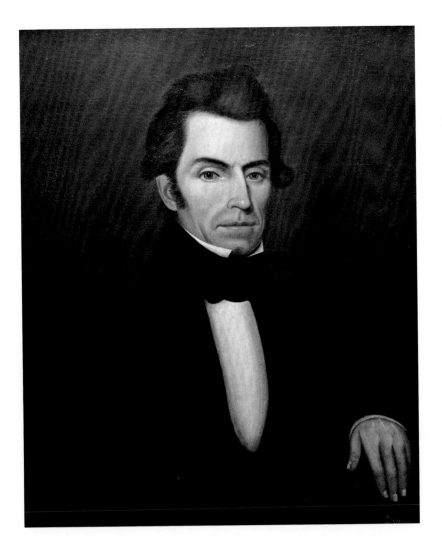
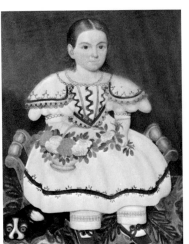

H. M. COX
Attributed to M. W. Hopkins or
Noah North
c. 1835
Oil on wood panel
H. 28⅛" W. 21⅞"

MOTHER OF H. M. COX
Attributed to M. W. Hopkins or
Noah North
c. 1835
Oil on wood panel
H. 28" W. 23¾"

Munson-Williams-Proctor Institute

Although H. M. Cox is identified by the Bible that she holds, and the older woman may be her mother, details about the two remain unknown. The Bible, in the portrait of the older woman, is open to Psalms 34 and 35; analysis of the pages seems to give no indication of any particular importance to the sitters. "Come ye children, hearken unto me; I will teach you the fear of the Lord" is a recurring motif.

H. M. Cox's portrait compares closely to that of Marietta Ryan and *Girl with Flower Basket.*[1] The sketchy quality of the mother's portrait indicates that the artist took a "short hand" approach to the painting's completion.

1. See Beatrix T. Rumford (ed.), *American Folk Portraits Paintings and Drawings from the Abby Aldrich Rockefeller Folk Art Center* (Boston: New York Graphic Society in Association with the Colonial Williamsburg Foundation, 1981), pp. 143–144. Another related painting, *Girl with Flower Basket*, is in the collection of the Thomas Colville Pension Trust.

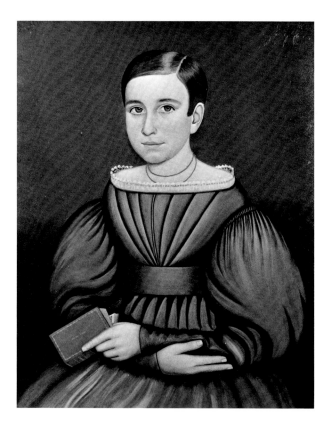

PRUDENCE WRIGHT DAVIS
Attributed to M. W. Hopkins or
Noah North
Possibly Angelica, New York
c. 1834
Oil on wood panel
H. 28″ W. 25″

Mr. and Mrs. Robert B. Bromeley

Prudence N. Wright of Greenwich,
Connecticut, married Smith Davis,
of Angelica, New York, September
23, 1834. Davis, born in Otsego
County, New York, in 1808, came
to Angelica in 1817. Exactly where
and when the painting was done is
unknown although it may have been
a wedding portrait. Angelica, in Al-
legany County, is considerably south
of the area in which Hopkins and
North took likenesses. Its location
directly on the Genesee River, how-
ever, made the town easily accessible
from the northern counties.

In Prudence's portrait, the artist de-
picted a comely young woman
wearing her finest dress and jewelry.
Unlike some other portraits done in
the same period, the subject bears an
elaborate, upswept hair style rather
than a bonnet.

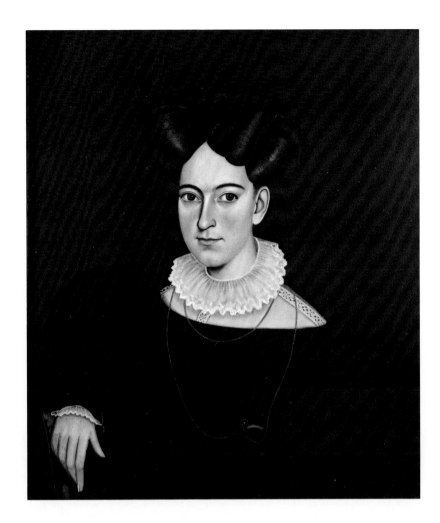

ADA AND DAVID F. DODGE
Attributed to M. W. Hopkins
Possibly Pompey, New York
c. 1835
Oil on wood panel
Sizes unknown

Whereabouts unknown

David F. Dodge and his wife, Ada, were residents of Pompey, New York, the town in which M. W. Hopkins grew up, in the 1820s and 1830s. Dodge, a schoolteacher, served as a deacon in the Presbyterian Church, as a captain in the militia, and as a leading member of the Pompey Lyceum.[1] He was elected master of Military Lodge No. 93, F. and A.M., in Pompey in 1817 and 1818.[2]

The Dodge portraits share typical Hopkins and North characteristics and may have been done by Hopkins when he visited his family in Pompey.[3]

1. Sylvia Shoebridge (et. al.), *Pompey Our Town in Profile* (Pompey, New York, 1976), pp. 195–197.

2. William C. Peacher, *Craft Masonry in Onondaga County, New York* (Syracuse: American Lodge of Research, 1962), pp. 35–36.

3. Many members of M. W. Hopkins' family remained in Pompey. See Shoebridge, pp. 129–133.

DEWIT CLINTON FARGO
Noah North
Probably Alexander, New York
1833
Inscribed in red on back: "No. 11 By Noah North / Mr. Dewit Clinton Fargo / Who died July 7th, 1833 / AE 12 years"; on right side of panel "July 8th, 1833"
Oil on wood panel
H. 26" W. 21"

Sybil B. and Arthur B. Kern

Named for DeWitt Clinton (1769–1828), governor of New York from 1817 until 1823, Dewit Clinton Fargo was the son of Orange T. and Sally Fargo of Alexander, New York. The portrait was painted posthumously and the cause of the boy's death is unknown. The date "July 8th, 1833" on the back of the painting is in the same brown paint that North used as underpaint on the front—an indication that he started the portrait one day after Dewit's death. The artist has recorded the sad event by portraying the boy in an adult pose, unlike other children, who are often shown with their pets. North used a "short-hand" method in depicting the subject with the paint thinly applied and the face and body less modelled than other examples. Assuming consistent numbering, Dewit's likeness was the 11th taken by North. The portrait resembles numbers seven and eight, the portraits of Abijah W. Stoddard and his wife, done after January 1 but before February 11, 1833. The placement of the subjects' bodies and the inclusion of the decorated chairs and the book indicate that the artist had been exposed to at least some elements of formal portraiture.

The child mortality rate was high during the period when North painted and it was not uncommon for parents to commission portraits of children who died young. According to his journal, Joseph Whiting Stock (1815–1855), for example, began the portrait of little Jane Henrietta Russell "from corpse" in 1844, completing it the next year.[1] In stark contrast to the mournful image of Dewit Clinton Fargo, however, Stock's portrait of Miss Russell shows a happy child, smiling sweetly, surrounded by some of her possessions, including a doll. She holds a drooping rose, symbolizing an innocent life that ended too soon.[2]

North and Hopkins were among the many 19th-century parents who suffered the loss of children. Hopkins and his first wife, Abigail Pollard, had three children who died in infancy and William Milton, a son by his second wife, Almira, died in 1827 at the age of four months. North's daughter, Mary Ann, and son, Volney, died as young adults in 1875 and 1873.

1. Nancy C. Muller, *Paintings and Drawings at the Shelburne Museum* (Shelburne, Vermont: Shelburne Museum, 1976), pp. 112 and 130.

2. Many artists as diverse as North in western New York, Stock, in Massachusetts, Charles Willson Peale (1741–1827) in Pennsylvania, John Henry Hopkins (1792–1868) in Vermont, (long confused with M. W. Hopkins), Lilly Martin Spencer (1822–1902) in Ohio and New York, Susan C. Waters (1823–1900) in southern New York, and William Sidney Mount (1807–1868) in New York City and Long Island, painted posthumous portraits. Mount disliked the practice complaining, "I hope to paint no more portraits after death, or from Daguerreotypes" and devised a separate price scale for the work: "Portraits taken after death double price—even at that price, I am not paid for the anxiety of mind I have to undergo to make my efforts satisfactory to the bereaved friends and relatives." Martha V. Pike, *A Time to Mourn: Expressions of Grief in Nineteenth Century America* (Stony Brook: The Museums at Stony Brook, 1980), p. 73.

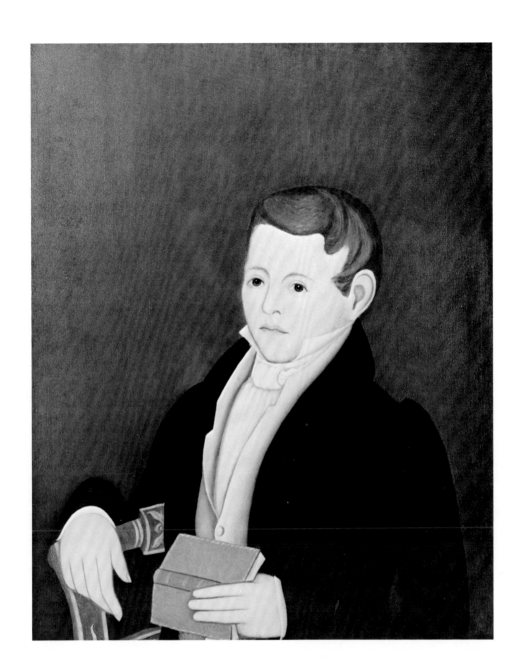

SALLY FARGO
Noah North
Probably Alexander, New York
1833
Inscribed in red on back: "No. 18 By
N. North / Mrs. Sally Fargo / AE 39
years 1833" and on stretcher "Dec.
25, 1833"
Oil on canvas
H. 27" W. 24"

Private Collection

Sally (probably Sarah) Fargo, born
in Vermont in 1796, was the wife of
Orange T. Fargo (b. 1794), an inn-
keeper and farmer in Alexander,
New York. Masons held regular
meetings at the Fargo tavern, located
midway between Alexander and
Batavia, prior to the Morgan "excite-
ment" in 1826, and it has been noted
that, during the 1830s and '40s,
" . . . it was a favorite place for balls
and parties."[1] Both Fargos were ac-
tive in the Genesee County Agricul-
tural Association for many years.
Their son, Dewit Clinton, one of
three children, was depicted by
North in a posthumous portrait in
1833. The Fargos lived on a farm ad-
jacent to that of the Norths.

Sally's portrait is most closely related
to that of Sarah Angelina Sweet Dar-
row, although it is not as compe-
tently painted. Both portraits show
attractive young women wearing
frilly bonnets, facing the viewer with
a direct gaze. Their hands rest on an
ornamented chair. In "The Editors'
Attic," a department in *The Maga-
zine Antiques*, Sally's portrait is pic-
tured in reply to a query by Ohio re-
searcher Rhea Mansfield Knittle.[2]
Mrs. Knittle's research notes listed
North as having worked in Ken-
tucky and Cincinnati.[3] Although no
advertisements for North in this area
have been found by the author, it is
likely that North worked with Hop-
kins in Cincinnati and, possibly,
across the Ohio River in Covington,
Kentucky, in the late 1830s.

1. F. W. Beers, *Gazeteer and Bio-
graphical Record of Genesee County,
1788–1890* (Syracuse: 1890), p. 148.

2. For December 1951, p. 547.

3. Mrs. Knittle's research notes, once
owned by antiques dealer William
Samaha in Ohio, are now destroyed.

P. F. FRAZEE
*Attributed to M. W. Hopkins
or Noah North*
c. 1834
Oil on canvas
H. 30" W. 24"

Harvey and Isobel Kahn

AGNES FRAZEE AND BABY
*Attributed to M. W. Hopkins
or Noah North*
c. 1834
Oil on canvas
H. 31" W. 27"

Philadelphia Museum of Art, gift of
Edgar William and Bernice Chrysler
Garbisch

No trace of a "Frazee" family ap-
pears in western New York in the
1830s, although both portraits can be
confidently dated to 1834. For many
years, "P. F. Frazee" was mistakenly
thought to have been the painter,
rather than the sitter.[1]

Agnes' portrait is one of a group that
shows handsome young women
holding babies.

1. Interview with the owner, Oc-
tober 23, 1988. See also Frederick F.
Sherman, "Portrait Painters in Oils,"
Art in America (December 1933), p.
28: "Frazee, P. F. A poorly painted
portrait in oils of a young man in a
black suit with waistcoat and flowing
black tie, I examined in Bernards-
ville, New Jersey, bore the inscrip-
tion 'P. F. Frazee Painted.'"

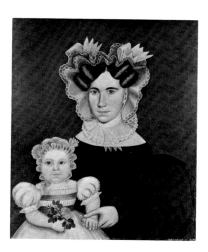

**MRS. R. HINTON AND HER
DAUGHTERS JOSEPHINE
AND MARY ELLEN**
M. W. Hopkins
Possibly Cincinnati 1841
Inscribed "Josephine Hinton AE 5-
1841 / Mrs. R. Hinton AE 35-1841
/ Mary Ellen Hinton AE 11-1841 /
Hopkins"
Oil on canvas
H. 29¾" W. 44½"

Sewell C. Biggs

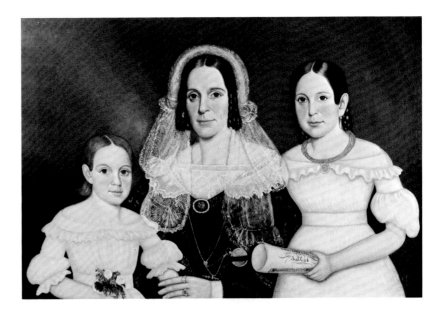

Although the Hintons are identified
in the inscription, nothing else is
known about them. Extensive inves-
tigation in New York and Ohio rec-
ords has failed to reveal any
documentation that can be conclu-
sively linked to this family.[1]

The Hinton portrait, one of the art-
ist's most ambitious and technically
proficient, illustrates Hopkins' skills
as a portraitist and ornamental paint-
er. Hopkins used a method of apply-
ing paint called "graining," a
technique usually found on furniture,
to create the pattern on Mrs. Hin-
ton's black and red dress. Mary Ellen
Hinton holds a piece of sheet music
entitled *Long, Long Ago*, an English
ballad first published in 1837; the
precise lettering recalls that Hopkins
was also a sign painter.

Judging from the fashionable way in
which the Hintons are dressed, they
were very well-to-do. By 1841,
Hopkins had opened a studio in Cin-
cinnati and it is possible that the por-
trait was painted there. Because the
painting differs from many of the
other documented New York State
and Ohio examples, however, there
is a possibility that the portrait was
completed on one of Hopkins'
numerous trips to the South. Further
research may prove that Hopkins'
style changed considerably as he
moved from region to region and
that the physical characteristics of his
sitters varied in different areas.

1. The portrait is illustrated in John
A. H. Sweeney, "Paintings from the
Sewell C. Biggs Collection," *The
Magazine Antiques* (April 1981), p.
892 erroneously attributed to John
Henry Hopkins (1792–1868).

CLARISSA HOVEY
M. W. Hopkins
Probably Barre, New York
1836
Inscribed in on back "Mrs. Clarissa
Hovey / AE 52 1836 / Hopkins"
Oil on wood panel
H. 28½" W. 24"

Sybil B. and Arthur B. Kern

Clarissa Hovey (b. 1784) was prob-
ably the wife of the Reverend
Jonathan Hovey, pastor of the Pres-
byterian Church in Barre, New
York, a small town seven miles
south of Albion.[1]

The discovery of the portrait of
Clarissa Hovey, stylistically attrib-
uted to Noah North but signed
"Hopkins," prompted the re-
evaluation of the entire body of
work.[2] Further research and com-
parison with a signed, dated, and
labeled example of Hopkins' work
in the collection of the New York
State Historical Association revealed
that the styles of North and Hopkins
were virtually identical and the sitters
who commissioned them often
shared similar social concerns.

1. James H. Hotchkin, *A History of
the Purchase and Settlement of Western
New York and the Rise and Progress and
Present State of the Presbyterian Church
in that Section of New York* (New
York: M. W. Dodd, 1848), p. 513.

2. Jacquelyn Oak, "American folk
portraits in the collection of Sybil B.
and Arthur B. Kern," *The Magazine
Antiques* (September 1982), p. 567.

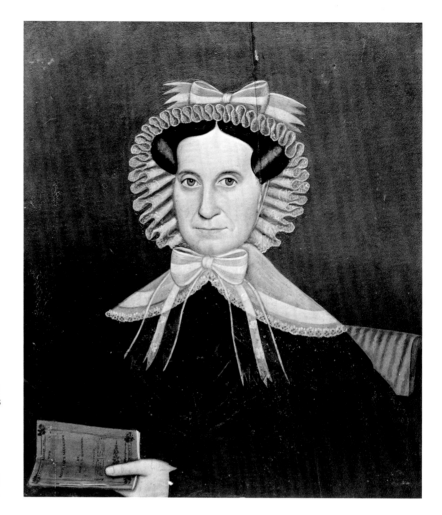

GRACIE BEARDSLEY JEFFERSON JACKMAN AND HER DAUGHTER
Attributed to M. W. Hopkins or Noah North
Probably Alexander, New York
c. 1835
Written in crayon, upper left back:
"Gracie Beardsley Jefferson, wife of J. R. Jackman 1835–6"
Oil on wood panel
H. 27⅞″ W. 23½″

JAMES R. JACKMAN
Attributed to M. W. Hopkins or Noah North
Probably Alexander, New York
c. 1835
Written in crayon on back "Major Jackman, husband of Gracie"
Oil on wood panel
H. 27⅞″ W. 23⅛″

Flint Institute of Arts

Gracie (or Gracia as her name appears on her tombstone) Beardsley Jefferson Jackman was born in 1803 in Hungersfield, New York and married James R. Jackman (b. 1793, Vershire, Vermont, d. 1864, Alexander, New York) at the age of 13. Between 1819 and 1835, the couple had seven children, five of whom reached adulthood. The baby shown in the portrait is probably Sarah, born in 1833 in Alexander. Like their neighbors, Aphia Salisbury and Gaius B. Rich, the Jackmans were among the Genesee country's most affluent and prominent residents. Having earned the title of "Major" during service in the War of 1812, James practiced law in Alexander and, in 1836, was elected a judge of the county court of Genesee County. Judge Jackman's life was characterized by public service and activity in the same reform movements in which Hopkins and North participated. In the 1830s and '40s, he served as a director of the Genesee County Temperance Society, was appointed to the Whig county convention committee, acted as town auditor, and headed the movement to aid displaced Tonawanda Indians.[1]

James' likeness follows a typical Hopkins/North stock pose. The subject wears an embroidered vest and his hand rests on a "pillow back" Hitchcock-type chair. The artist had considerable difficulty in rendering the facial features; the left eye is out of perspective and the hair is sketched.[2] The portrait of Gracie (painted when she was 31) is one of the most pleasing images. Wearing a becoming dotted swiss, ruffled lace bonnet, pleated ruff, and a delicate earring, Gracie exudes contentment and self-confidence. Dressed in an embroidered dress and frilly bonnet, the baby, probably Sarah, is shown wearing a coral necklace and holding a rose. Although the artist had trouble depicting the baby's eyes, arms, and hands, the total effect is quite successful. Gracie and the baby sit in a chair on which the decoration has been painted to simulate stenciling.

1. *The Republican Advocate* (Batavia, New York), March 24, 1846. "A large convention of the citizens of Genesee County assembled at the Court House in Batavia on the 21st day of March, 1846 . . . to take into consideration the situation of the Tonnawanda [sic] Indians. . . . Their inquiries have led them to the knowledge that these Indians are continually molested by the intrusion of whites upon their lands. . . . On motion . . . James R. Jackman was chosen President. . . ."

2. The artist encountered the same problem in completing the portraits of several other men.

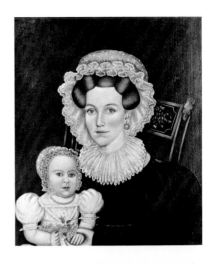

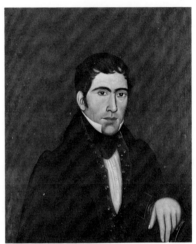

**ANN GENNETT
PIXLEY LACEY**
Attributed to M. W. Hopkins
Probably Scottsville, New York
c. 1837
Oil on canvas
H. 30″ W. 25″

Memorial Art Gallery, University of
Rochester

Daughter of William and Abbey
Lewis Pixley, Ann Gennett was born
in Kirkland, New York in 1809. The
family moved to Chili, Monroe
County, south of Rochester, where
William prospered as a farmer.
About 1830 she married Allen Tobias
Lacey, son of Isaac Lacey, a neigh-
boring farmer and political associate
of her father. Ann Gennett's father,
husband, and father-in-law partici-
pated in the anti-Masonic movement
and later in Whig politics. Isaac
Lacey and William Pixley were
members of the anti-Masonic con-
vention of Monroe County in 1830[1]
and Allen T. Lacey served on the
Monroe County committee to inves-
tigate the death of William Morgan.[2]
It is likely that they became ac-
quainted with M. W. Hopkins
through their political activities.
Likenesses of their two children,
Pierrepont Edward (named for his
paternal uncle) and Eliza Pixley, born
in 1834, were also taken by the artist.
Ann Gennett died of cancer in 1841.

1. *The Craftsman*, (Rochester, New
York), October 2, 1830.

2. *Narrative and Facts and Cir-
cumstances Relating to the Kidnapping
and Presumed Murder of William Mor-
gan* (Brookfield, Massachusetts: E.
and G. Merriam, 1827), p. 37.

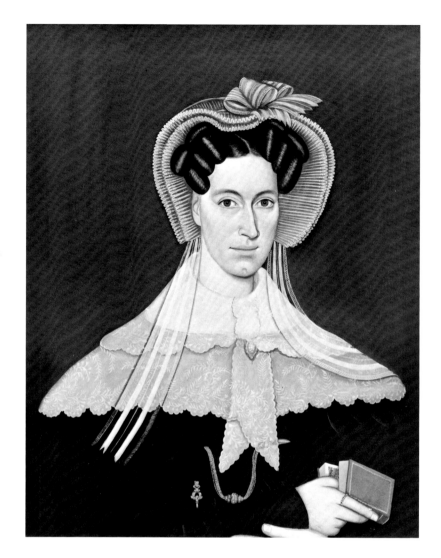

ELIZA PIXLEY LACEY
Attributed to M. W. Hopkins
Probably Scottsville, New York
c. 1837
Oil on canvas
H. 30″ W. 25″

Memorial Art Gallery, University of
Rochester

One of two children of Allen T. and
Ann Gennett Pixley Lacey, Eliza
was born in Chili, New York in
1834 and died at the age of five. Her
likeness, undoubtedly taken when
she was about three, is one of the
artist's most endearing. The child is
shown wearing a bright pink dress
with matching pantelettes and she
holds a basket of flowers; her hand
rests on the arm of a small empire-
style bench. Below the figure, with
a few abstract brush strokes, the
artist has created the effect of a fig-
ured carpet.

The artist painted several little girls
holding flower baskets. Eliza, how-
ever, was the youngest and most
closely resembles the likeness of
Martha Ellen Connell, painted when
the subject was about three or four
years old in 1838 in Lancaster, Ohio.

Eliza's portrait and those of her
mother and brother were owned by
collateral descendents until they were
given to the Memorial Art Gallery
in 1978.

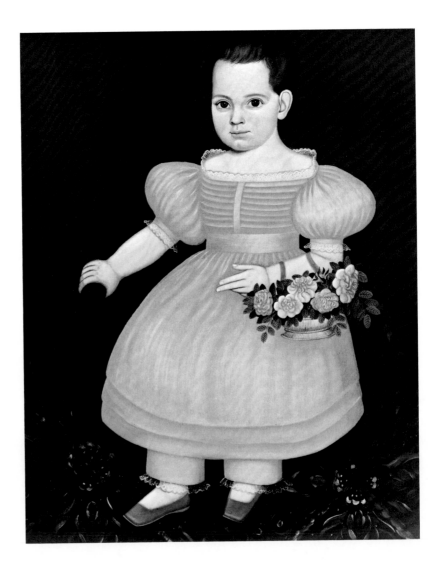

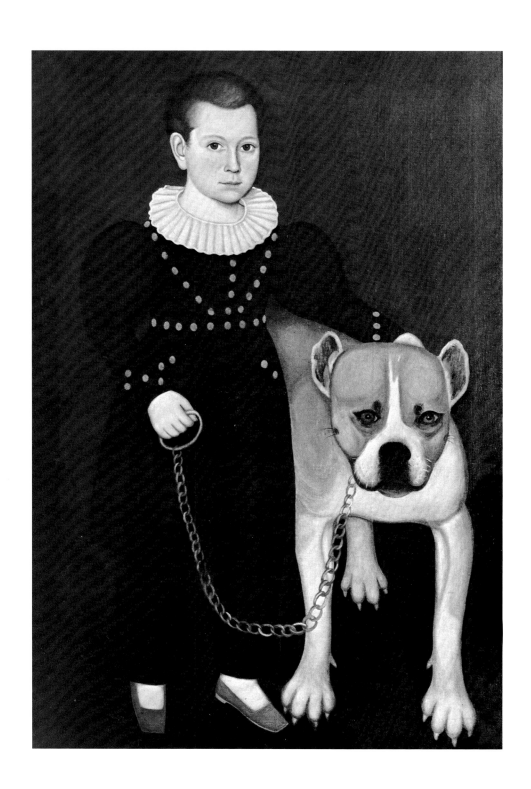

PIERREPONT EDWARD LACEY AND HIS DOG GUN
Attributed to M. W. Hopkins
Probably Scottsville, New York
c. 1836
Oil on canvas
H. 42" W. 30"

Memorial Art Gallery, University of Rochester

Born in 1832 in Chili, New York, Pierrepont Edward Lacey was the son of Allen and Ann Gennett Pixley Lacey. The family moved to nearby Scottsville in 1835 and it was there that this portrait, and the portraits of Pierrepont's mother and sister Eliza, were painted. Ann Gennett died of cancer in 1841 and shortly thereafter Allen Lacey remarried. In 1847 the family moved to Marshall, Michigan. Pierrepont married Agnes Antoinette McClure in 1858 and the couple had one son. Pierrepont's father and both grandfathers—Isaac Lacey and William Pixley—were successful farmers in Chili and Scottsville. All three men took an active part in the anti-Masonic movement and Whig politics.[1]

The portrait of Pierrepont, nearly full-size, is one of the most ambitious and engaging likenesses done by Hopkins. Solid and sturdy, the young boy, dressed in a black suit and bright red shoes, looks candidly out to the viewer, bolstered by the protection of his huge dog. Unlike other animals frequently included in folk paintings that may have been products of the artists' imagination or based on popular illustrations, "Gun" was a real pet. According to family history, the Laceys raised mastiffs when they lived in Scottsville. *Boy Holding Dog*, in the collection of the Abby Aldrich Rockefeller Folk Art Center, compares closely to Pierrepont's portrait.[2] Typical of Hopkins' rendering of heads and facial features seen in both paintings are the shaping of the inner ear, the salmon-colored smiling lips, the broad arching of the eyebrows, the slightly indented temples, the soft modeling of the eye socket, and the shading of the side of the nose.

Ammi Phillips' painting, *Boy with Dog*, done in the 1850s, showing a little boy holding onto a very large dog, is quite similar in effect.[3]

1. *The Craftsman* (Rochester, New York, October 2, 1830).

2. Beatrix T. Rumford (ed.), *American Folk Portraits Paintings and Drawings from the Abby Aldrich Rockefeller Folk Art Center* (Boston: New York Graphic Society, 1981), p. 145.

3. See Sotheby's auction catalogue, *American Folk and 19th Century Paintings and Drawings, American Decorative Prints*, January 27, 1983, Item 185.

ABIGAIL TOLMAN LEWIS
Attributed to M. W. Hopkins or Noah North
Possibly Hamilton County, Ohio
c. 1840
H. 36" W. 31"
Oil on canvas

Western Reserve Historical Society

Born in Scituate, Massachusetts, in 1772, Abigail Tolman married Samuel Lewis (1771–1842) of Falmouth, Massachusetts, in 1794. The couple moved to Hamilton County, Ohio, near Cincinnati, where they operated a prosperous farm.[1] They had nine children.[2]

Mrs. Lewis' portrait is practically identical to Noah North's portrait of Eunice Eggleston Darrow Spafford. In both paintings, the artist has depicted an older woman, seated in a decorated chair, wearing a bonnet and gold beads. The portrait also closely resembles the portrait of Rachel Dutton Willey Brown, attributed to M. W. Hopkins. It is likely that Abigail's portrait was executed while Hopkins and North were working in Ohio.

Both Abigail and Samuel Lewis were depicted in portraits painted about 1800, before they moved to Ohio. It has been suggested that John Brewster, Jr. (1766–1854), Abigail's cousin, might have been the painter.[3]

1. Frederick Freeman, *The History of Cape Cod: The Annals of the Thirteen Towns of Barnstable County, Massachusetts* (Boston: 1862), p. 481.

2. Jermayne Smart, *The Folk Art of the Western Reserve* (Ph.D. dissertation, Case Western Reserve University, 1939), pp. 245–248.

3. See *The Clarion* (Spring-Summer 1984), p. 3.

EMILY BIDWELL MILLER
Attributed to M. W. Hopkins or
Noah North
Probably Scottsville, New York
c. 1835
Oil on canvas mounted on masonite
H. 28″ W. 23¾″

NATHAN FLINT MILLER
Attributed to M. W. Hopkins or
Noah North
Probably Scottsville, New York
c. 1835
Oil on canvas mounted on masonite
H. 28″ W. 23½″

Harvard Medical School, gift of Dr.
Terry Clark

Nathan Flint Miller (1811–1878), a
trader, merchant, and farmer who
lived in Scottsville, New York, mar-
ried Emily Bidwell in 1835. It is
likely that these portraits commemo-
rate the wedding. In Emily's like-
ness, the artist included many elabo-
rate pieces of jewelry, suggesting that
the subject was dressed in her finest
apparel when she sat for her portrait.

Portraits of Nathan's older brother,
Elijah Talcott Miller and his wife,
Ruth Tillotson Miller, are owned by
the Memorial Art Gallery, Univer-
sity of Rochester.[1]

1. As described in Nancy C. Muller
and Jacquelyn Oak, "Noah North
(1809–1880)," *The Magazine An-
tiques* (November 1977), p. 943.

RUTH TILLOTSON MILLER
Attributed to M. W. Hopkins or
Noah North
Probably Scottsville, New York
c. 1835
Oil on wood panel
H. 27" W. 23"

ELIJAH TALCOTT MILLER
Attributed to M. W. Hopkins or
Noah North
Probably Scottsville, New York
c. 1835
Oil on wood panel
H. 27" W. 23"

Memorial Art Gallery, University of
Rochester

A trader, merchant, and farmer,
Elijah Miller was born in Farming-
ton, Connecticut, the son of Elijah
and Chloe Allyn Miller. About 1825
he moved to Chili, New York, and
two years later to neighboring
Scottsville. He married Ruth Tillot-
son (1803–1863) in Farmington in
1824. The couple had eight children.

The late Harris K. Prior, former di-
rector of the Memorial Art Gallery,
University of Rochester, attributed
the Miller portraits, as well as several
others now known to have been
painted by Hopkins and North, to
the "Scottsville limner" in the early
1970s.[1]

1. *The Genesee Country* (Rochester:
Memorial Art Gallery, University of
Rochester, 1975), pp. 83–84.

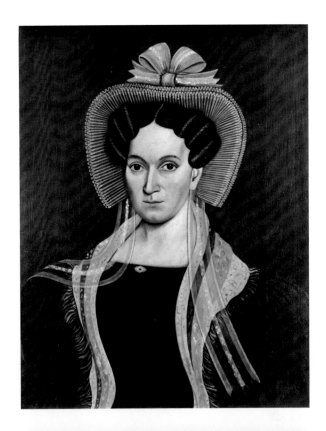

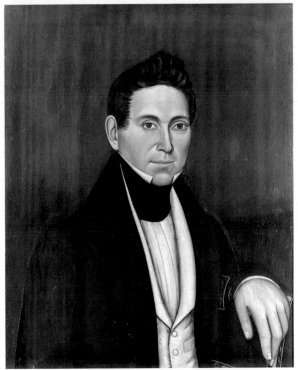

JOHN MILLIKEN
Attributed to Noah North
Probably Holley, New York
c. 1834
Oil on wood panel
H. 28½" W. 22½"

Private Collection

John Milliken was born in Sharon, New Hampshire, in 1786, the eldest son of Mary McAllister and Samuel Milliken. About 1825, John, his wife Fanny, and his younger brother left New Hampshire and settled in Clarendon, New York, on a farm two miles southwest of Holley. John (who died in Albion in 1843) and his wife had seven children.[1]

The attribution to North is based on several factors, all of which relate John Milliken's portrait to the signed, dated, and numbered portrait of Eunice Eggleston Darrow Spafford. The faces of both portraits are elongated and painted in pale tones with minimal brushwork. Other typical characteristics both share are mouths painted in a light salmon color, eye highlights, panel construction, and placement of the figure on the support. Milliken's chair is grained and stenciled with gold powders, as are the ones in the portraits of Mrs. Spafford and Sarah Angelina Sweet Darrow.[2]

Cleaning and minor restoration revealed that the artist did not attempt to hide Milliken's hare lip.

1. Gideon Tibbetts Ridlon, Sr. *History of the Families of Milliken . . . Millikin . . . Mulliken* (Lewiston, Maine: privately printed, 1907), p. 242.

2. Ibid. One of Mrs. Spafford's sons, John Darrow (1810–1894) married Milliken's niece, Mary Milliken (1814–1889) in 1832.

JAMES AGARD NORTH
Attributed to Noah North
Probably Alexander, New York
Inscribed "July 3, 1833"
Oil on wood panel
H. 26½" W. 21½"

William M. North

Noah North's younger brother, James Agard North, was born on the family farm in Alexander in 1813. For many years, he was a schoolteacher in Alexander. In 1847 he married Rebecca Safford (1822–1884) and the couple had three children. At the time of his death in 1893, he was a farmer.[1]

The plain likeness of James Agard is one of North's earliest efforts, painted when James was 20 and Noah was 24. The painting shows none of the details, such as facial highlights, that North used later in his career. The portrait of Dewit Clinton Fargo, completed three days after North executed this painting, compares closely to this likeness.

The portrait is owned by a direct descendant of James Agard North.

1. Safford E. North, *Our Country and Its People, A Descriptive and Biographical Record of Genesee County, New York* (Boston: 1899), p. 131.

FRANCIS DRAKE PARISH
Attributed to M. W. Hopkins
Probably Oberlin or Sandusky, Ohio
c. 1840
Oil on wood panel (detail)
H. 28¼" W. 23½"

Oberlin College Historical Portrait
Collection

Son of Elisha and Lois Wilder Parish,
Francis Drake Parish was born in
Naples, New York, in 1796. He at-
tended Hamilton College, Clinton,
New York, for two years and
studied law in Columbus, Ohio, be-
fore being admitted to the bar in
1822 in Sandusky, Ohio. Being an
active Congregational church
worker, he helped found the Amer-
ican Home Missionary Society in
1834 and later became the first presi-
dent of the Western Evangelical
Missionary Society sponsored by
Oberlin College. Parish's interests in
reform movements, notably temper-
ance, were also the concerns of
Oberlin College and he was made a
trustee in 1839.[1] He was an active
leader of the underground railway
and, in 1845, was arrested for pro-
tecting two fugitives.[2] Parish's ac-
tivism in church and civic affairs
continued until his death in 1886 at
Oberlin.[3]

It is likely that Parish and Hopkins
became acquainted through their
participation in the abolitionist
movement in Ohio.

1. He organized the Erie County
[Ohio] Temperance Society in 1831.
Letter to the author from William
Pifer-Foote, pastor, First Congrega-
tional United Church of Christ, San-
dusky, Ohio, January 23, 1987.

2. Ibid.

3. Robert Samuel Fletcher, *A History
of Oberlin College from Its Founding
Through the Civil War* (Oberlin,
Ohio: Oberlin College, 1943),
p. 666.

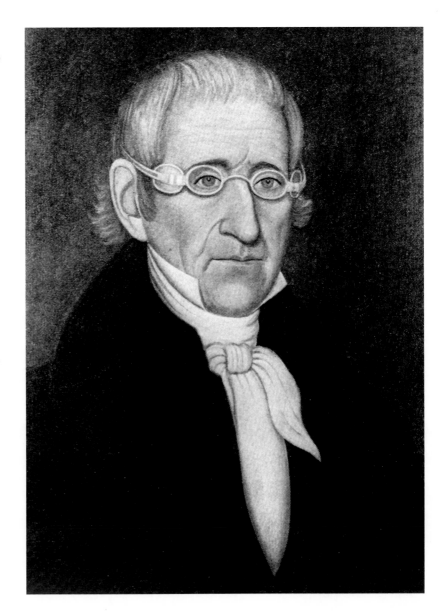

CORDELIA M. PIERSON
Attributed to M. W. Hopkins or
Noah North
c. 1836
Probably LeRoy, New York
Oil on wood panel
H. 27" W. 23⅞"

PHILO L. PIERSON
Attributed to M. W. Hopkins or
Noah North
c. 1836
Probably LeRoy, New York
Oil on wood panel
H. 26" W. 20¼"

SARAH MEHITABLE HULL
PIERSON
Attributed to M. W. Hopkins or
Noah North
c. 1836
Probably LeRoy, New York
Oil on wood panel
H. 28" W. 20⅛"

Private Collection

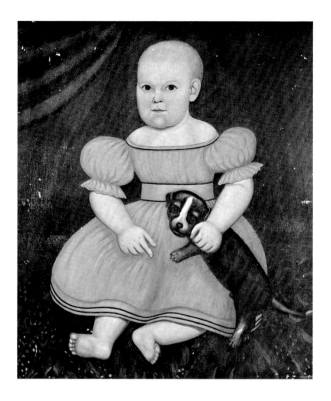

Philo Pierson, born at Stone Church, a hamlet outside LeRoy, New York, in 1808, was the son of Russell and Mary Crampton Pierson, who had emigrated from Connecticut about 1805. Philo owned a farm and was a carpenter who built many of the houses in LeRoy (many still standing) and several of the buildings of Ingham University, one of the first colleges exclusively for women in New York State. He married Sarah Mehitable Hull (1812–1856) in 1834. Cordelia, born in 1834, was the first of seven children, all of whom were born in LeRoy.[1]

The current owner of the portrait is a direct descendant of the sitters.

1. Interview with the owner, July 1984.

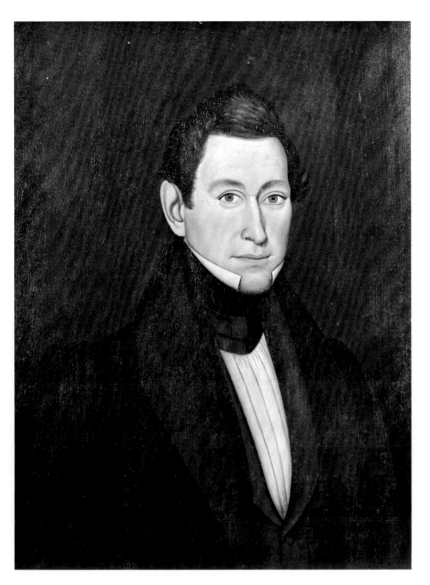
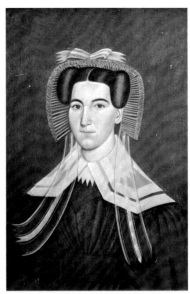

SARAH M. REED
M. W. Hopkins
Possibly Orleans County, New York
1836
Inscribed "Mrs. Sarah Reed / AE 75,
1836 / Hopkins Pr."
Oil on wood panel

Whereabouts unknown

There were many families named
Reed in the Albion area in 1836
although Sarah has not been conclu-
sively identified. The portrait closely
resembles that of Eunice Eggleston
Darrow Spafford by North.

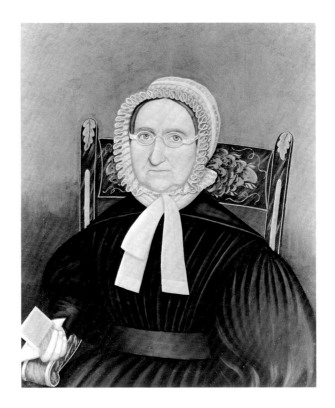

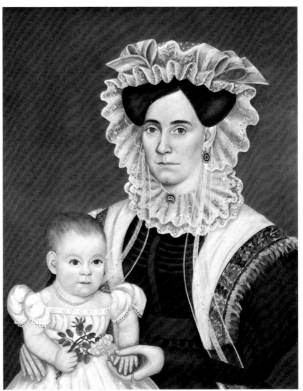

APHIA SALISBURY RICH
AND BABY EDWARD
Attributed to M. W. Hopkins
Inscribed on back "1833"
Probably Genesee County,
New York
Oil on wood panel
H. 30" W. 24½"

National Gallery of Art,
Washington, D.C., gift of Edgar
William and Bernice Chrysler
Garbisch

Born at Western (now Warren), New
York, in 1793, Aphia Salisbury was
the daughter of Edward S. and Adah
Crowell Salisbury. In 1816, she mar-
ried Gaius Barrett Rich (1790–1861)
and the couple spent their early years
together in Attica, where Gaius oper-
ated a store, was postmaster, and
subsequently established the Bank of
Attica. Although this portrait was
undoubtedly painted in Genesee
County, the family moved to Buffalo
in 1842, where Rich continued his
successful banking business. In her
obituary, Aphia is described as being
". . . still most affectionately remem-
bered in her early home for her
many social virtues; that kindness
and gentleness, that tender consid-
eration for others, that generous hos-
pitality which has won her so many
hearts here, could not fail to attach
her to most devoted friends. . . .
Early connected with the North
Presbyterian Church, she identified
herself with its interests—she loved
the church, its worship, its ordi-
nances; its faith has ever been her
never-failing consolation."[1]

One of seven children, Edward Salis-
bury Rich, born in Attica in 1832,
was named for his maternal grand-
father. His sister, Martha Sophronia
(born 1836), and grandmother, Adah
Crowell Salisbury (1762–1850), were
depicted about 1842 in a double por-
trait attributed to North, now in a
private collection.

The Rich family was among the
most well-known, well-respected,
and well-off citizens of the Genesee
country from the 1820s to the 1860s.
Gaius Rich, at the age of 10, moved
with his family from Worcester
County, Massachusetts, to St. Law-
rence County, New York, where he
assisted in the cultivation of a new
farm. About 1811, he began his
career as an entrepreneur by working
in a store in Rome, New York. The
next year, he established a branch of
the store in Rochester where, accord-
ing to family history, he also built
the first frame house and began the
first flour mill.[2] After their marriage
in 1816, Gaius and his wife lived in
Attica, where he continued his career
as a merchant and, in 1838, estab-
lished the Bank of Attica.[3] Made a
Master Mason in 1814 (in the same
class as Noah North, Sr., at Olive
Branch Lodge, Batavia),[4] he became
active in the anti-Masonic movement
and renounced Masonry in 1831. "It
has been the prevailing report in this
section of the county for some time
that Gaius B. Rich . . . some time
since renounced the institution of
Freemasonry as wicked and danger-
ous, corrupt and injurious. . . ."[5]
Rich moved the family to Buffalo in
1842, where he continued in the
banking business. He was a founder
of the North Presbyterian Church in
Buffalo and a substantial contributor
to numerous local charities until his
death in 1861.[6] It is likely that Rich
was related to Alpheus Barrett
(1806–1876), who "studied painting
under Milton W. Hopkins" in 1823
and later married Hopkins' niece.[7]

In her portrait, painted when she was
40, Aphia Salisbury Rich is depicted
wearing a frilly bonnet and ruff, and
an embroidered shawl, typical fash-
ion of the day. This painting is al-
most identical to the portrait of
Gracie Beardsley Jefferson Jackman,
also done in Genesee County, about
1834.[8] In Gracie Jackman's portrait,
as in this one, the artist has captured
the likeness of a handsome, dignified
young woman holding a baby. While
the artist clearly had difficulty in ren-
dering the babies' bodies in relation
to the mothers', the images are
among the artist's most pleasing.

1. *Buffalo Commercial Advertiser* (Buf-
falo, New York), February 16, 1868.

2. Julia Rich Hogan, *Genealogy of the
Rich Family* (Everett, Massachusetts:
Rich Family Association, 1969),
pp. 8–9.

3. F. W. Beers, *Illustrated History of
Wyoming County, New York* (New
York, New York, 1880), p. 134.

4. David Seaver, *Freemasonry at
Batavia, New York, 1811–1891*
(Batavia, New York: J. F. Hall and
Company, 1891), p. 13.

5. *The Republican Advocate* (Batavia,
New York), January 28, 1831.

6. He is described in his obituary in
the *Buffalo Commercial Advertiser*
(Buffalo, New York), October 26,
1861: "Gaius Barrett Rich . . . was
in more than one respect, a remarka-
ble man . . . in preserving to such an
extent, in the transition from poverty
to great wealth, so many commend-
able qualities. . . . In the community
. . . he was willing to be counted as
one, even though he might give
more to sustain the organization,
civil or religious, than any other ten.
. . . In his house and equipage, and
all his surroundings, he always
sought the proper mean between
parsimony and extravagance—his life
was a model of excellence."

7. Timothy Hopkins, *John Hopkins
of Cambridge, Massachusetts and Some
of his Descendants* (San Francisco:
Stanford University Press, 1932),
p. 225.

8. Richard J. Wattenmaker, *American
Naive Paintings* (Flint, Michigan: Flint
Institute of Arts, 1981), p. 53.

MARIETTA RYAN
Attributed to M. W. Hopkins
Probably Medina, New York
c. 1835
Oil on wood panel
H. 20½″ W. 17¼″

Mr. and Mrs. Barber B. Conable, Jr.

Marietta Ryan, one of 11 children of
John and Hannah Overdorf Ryan,
was born at Knowlesville, New
York, a village outside of Medina, in
1829. Her father worked on the con-
struction of the Erie Canal and had
charge of one of the line cannons
that telegraphed the news of the
completion of the canal from Albany
to Buffalo in 1825. A successful
businessman, Ryan opened the first
Medina sandstone quarry, was a
member of the first school board,
served as postmaster, and for several
terms was superintendent of the
western division of the canal.[1]

From at least as early as 1828 and in-
termittently until 1830, M. W. Hop-
kins captained the ". . . New and
Splendid Boat FLORIDA . . . ," a
canalboat that transported passengers
and freight from Albion to Albany
and Buffalo.[2]

One of several paintings of girls
holding flower baskets, Marietta
Ryan's portrait compares most
closely to *H. M. Cox*, owned by the
Munson-Williams-Proctor Institute,
and *Girl with Flower Basket* and *Boy
Holding Dog*, both in the collection
of the Abby Aldrich Rockefeller Folk
Art Center.[3] The girls' portraits share
virtually identical details in the
rendering of faces and flowers, al-
though more of the figure and the
right hand are shown in the Abby
Aldrich Rockefeller Folk Art Center
example and the dress is of medium
blue rather than white. The black
frame with gilded corner blocks is
original to the portrait (although it
shows evidence of some restoration)
and is identical in construction to the
one on *Boy Holding Dog*. The small
sizes (they vary only by ¼ inch),
details in the head (such as the indi-
vidual brush strokes at the hairline),
and placement of figures on the
board allow one to speculate that *Boy
Holding Dog*, also may have been a
Ryan child.

Marietta's portrait descended to her
great-granddaughter before being
purchased by the present owners.

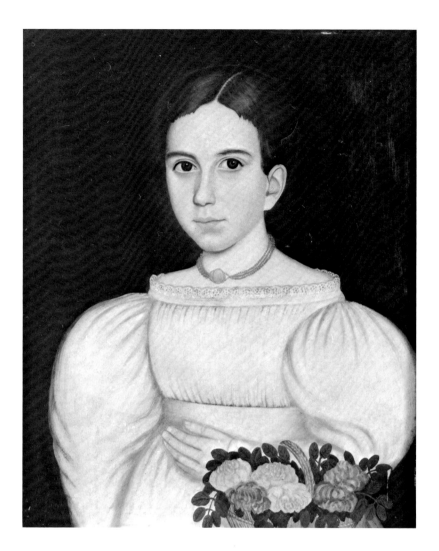

1. Sotheby's auction catalogue, *Fine
American Furniture, Folk Art, Folk
Paintings and Silver* (June 26, 1986),
Item 80.

2. *The Orleans Advocate* (Albion,
New York), February 20, 1828.

3. Beatrix T. Rumford (ed.), *Amer-
ican Folk Portraits, Paintings and Draw-
ings from the Abby Aldrich Rockefeller
Folk Art Center* (Boston: New York
Graphic Society in Association with
the Colonial Williamsburg Founda-
tion, 1981), pp. 143–145.

F. STODDARD
Noah North
Probably Pembroke, New York
Inscribed: "No. 7 / by Noah North
/ $7.50 / AE 31 years / 1833"
Oil on wood panel
H. 28" W. 23"

ABIJAH W. STODDARD
Noah North
Probably Pembroke, New York
Inscribed: "No. 8 / $7.50 / by Noah
North / 1833 / A. W. Stoddard / AE
43"
Oil on wood panel
H. 27¾" W. 23¼"

Private Collection

Abijah Warren Stoddard, son of Burr
and Sarah Blackman Stoddard, was
born in Hartford, New York, in
1789 and died in Milwaukee, Wis-
consin, in 1861. He married one
Delia Wright (d. 1821) and the
couple had two children. After his
first wife's death, he married the
woman (no identifiable name)
shown in this portrait by North.
Abijah W. Stoddard served with
Noah North, Sr., in 1818 in the 99th
regiment of infantry, New York
State militia, as a surgeon.[1] He was
the pioneer medical man of Pem-
broke, a town adjacent to Batavia
from 1811 until about 1854, when
he moved to Milwaukee.[2]

Judging by the notated age of Dr.
Stoddard, the portraits were painted
between January 1 and February 11,
1833 and are the earliest (to date)
examples signed by North. They
compare closely to "No. 11" by
North—Dewit Clinton Fargo—
painted in July 1833. The Stoddard
portraits lack many details (such as
highlights) seen in later portraits
done by the artist.

1. Hugh Hastings (ed.) *Military Min-
utes of the Council of Appointment of
the State of New York 1783–1821* (Al-
bany, New York: State of New
York, 1901), p. 2133.

2. F. W. Beers, *Gazeteer and Bio-
graphical Record of Genesee County,
New York* (Syracuse, New York:
J. W. Vose, 1890), p. 82.

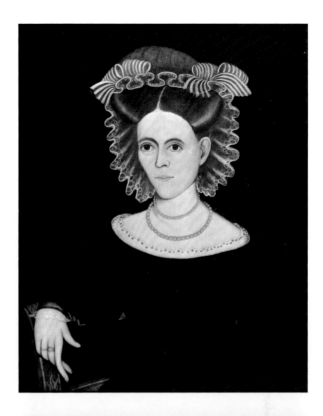

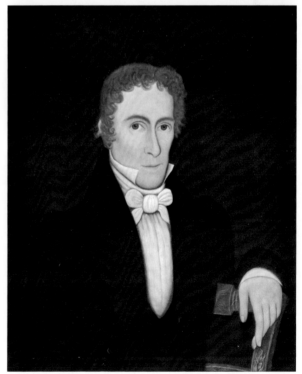

**EUNICE EGGLESTON
DARROW SPAFFORD**
Noah North
Holley, New York
1834
Inscribed: "No. 40 by N. North /
Mrs. Eunice Spafford / AE 55 years
/ Holley / 1834"
Oil on wood panel
H. 28" W. 23⅜"

Shelburne Museum

Eunice Eggleston was born in
Amenia, Dutchess County, New
York, in 1778. She married John
Darrow (1755–1813), a widower
with 11 children, in 1798 or 1799 in
Columbia County. Darrow, born in
New London or Greenwich, Con-
necticut, served in the Revolutionary
War and was a blacksmith. The
couple had six sons and one daugh-
ter, born in or around Chatham,
New York. After Darrow's death,
Eunice moved the family to Claren-
don, New York, a village some 25
miles west of Rochester, where they
had purchased land in 1812. By late
1815, Eunice had married a neigh-
bor, Bradstreet Spafford, a widower
with a daughter. Their daughter,
Harriet, and son, Thomas, were
among the first children born in
Clarendon. At the time of her death
in 1860, Eunice resided with her
fourth son, Nicholas, and his wife,
Sarah Angelina Sweet Darrow. She
is buried in Hillside Cemetery in
Holley.[1]

North's portrait of Mrs. Spafford
was painted in Holley, a canal town
five miles north of Clarendon. For
many years, this portrait and that of
Mrs. Spafford's daughter-in-law,
Sarah Angelina Sweet Darrow, were
owned by descendants and hung in
the house where they were painted.
This is the only instance where the
artist has included the name of the
town in the inscription.

North used a somber palette in his
depiction of Mrs. Spafford, done
when she was 55 years old. The
paint is thinly applied on the wood
surface with slight impasto on the
ruffles of the bonnet. The grain-
painted chair, with designs of mel-
ons, leaves, and other stylized floral
motifs, indicates that North was
conversant with the technique of
stenciling with gold powders. This
suggests that he had learned the craft
of furniture decoration, possibly
from Hopkins (who advertised as a
chairmaker, gilder, and glazier in
1824), although he did not actively
engage in ornamental painting until
the mid-1840s. The portrait of John
Milliken attributed to North, in a
private collection, also contains a
stenciled chair as does the portrait of
Mrs. Spafford's daugher-in-law,
Sarah Angelina Sweet Darrow.

The Spafford portrait compares most
closely to the likeness of Rachel Dut-
ton Willey Brown, painted in 1835,
owned by the Genesee Country Mu-
seum, and Abigail Tolman Lewis,
painted about 1838, owned by the
Western Reserve Historical Society.
All three portraits show older
women, dressed conservatively,
wearing a gold-colored, beaded
necklace painted in identical manner.

One of North's most well-
documented portraits, Eunice Spaf-
ford, was purchased by pioneer folk
art collector Electra Havemeyer
Webb for Shelburne Museum in
1954 for $325.[2]

1. Irene M. Gibson, *Descendants of
John Darrow and Eunice Spafford* (Hol-
ley, New York: privately printed,
1975), pp. 6–17.

2. A letter to the author (January 30,
1975) from the dealer, Robert
McGuire, who sold the painting to
Mrs. Webb, explained its prove-
nance: "The painting came from
Rochester, New York, where it hung
over the mantel of a dentist's wife
who was a picker, absolutely fond of
money. I did, however, have to wait
seven years for Mrs. Spafford until
the old gentleman who gave the pic-
ture to my source died, showing, I
feel, prudence, if not conscience, on
her part!"

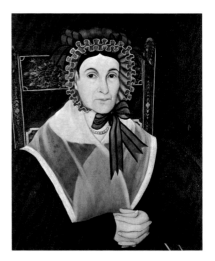

**ADAH CROWELL
SALISBURY AND MARTHA
SOPHRONIA RICH**
Attributed to Noah North
Probably Attica, New York
c. 1842
Oil on canvas
H. 33″ W. 29″

Private Collection

Adah Crowell was born in 1762 and
died in 1850. She married Edward
Salisbury (1765–1832) in Western,
New York. Her daughter and grand-
son, Aphia Salisbury Rich and Ed-
ward, were painted by Hopkins
about 1833.

Martha Sophronia Rich, daughter of
Aphia and Gaius B. Rich, one of
seven children, was born in 1836.[1]
In 1856, she married Charles Town-
send of Buffalo. She died in 1909.[2]

The portrait is the only example that
has come to light that was done by
North in the 1840s.

1. Julia Rich Hogan, *Genealogy of the
Rich Family* (Everett, Massachusetts:
Rich Family Association, 1969), p. 7.

2. *Buffalo Commercial Advertiser* (Buf-
falo, New York), June 10, 1856.

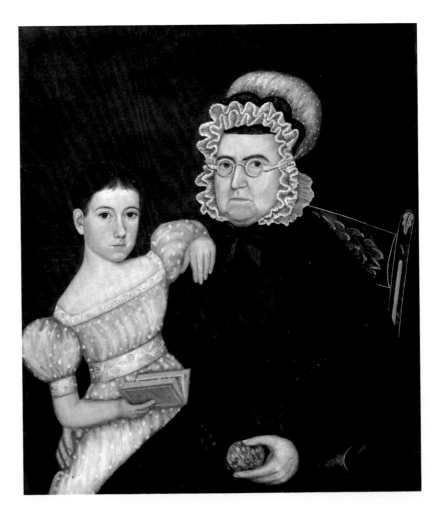

OLIVER IDE VAUGHAN
Noah North
Darien, New York
Inscribed "By N. North, Darien,
Nov. the 4th, 1833"
Oil on wood panel
H. 26″ W. 22″

Holland Land Office Museum

Oliver Ide Vaughan and his parents,
Jonathan and Sophia, lived on a farm
adjacent to the North property. Jona-
than Vaughan, like Noah North, Sr.,
was one of the pioneer settlers of
Genesee County and in 1809 helped
to establish the town of Alexander,
New York.[1] Oliver, 10 years
younger than the artist, drowned in
the Tonawanda Creek on November
4, 1833, and was painted by North
posthumously.[2]

Considering the circumstances, it is
not surprising that the portrait is stiff
and shows none of the assurance of
other works of the period. Like the
posthumous portrait of another
young neighbor, Dewit Clinton
Fargo, the subject of this painting
displays a melancholy expression.
The bodies of Oliver Ide Vaughan
and Noah North repose in plots
about 15 feet apart in Maple Hill
Cemetery in Darien, New York.

1. Pamphlet, "Entertaining Facts and
Fancies in Regard to Genesee County
History Makers," n.d., unpaginated,
on deposit Holland Land Office Mu-
seum, Batavia, New York, p. 16.

2. *The Republican Advocate,* (Batavia,
New York), November 10, 1833.

REVEREND HUGH WALLIS
Noah North
Probably Pembroke, New York
1833
Inscribed "No. 15 By Noah North /
Rev. Hugh Wallis / 1833 / AE 66
years"
Oil on canvas
H. 29″ W. 24″

Private Collection

The Reverend Wallis (b. 1767), a
Presbyterian minister, graduated
from Dartmouth College in 1791.
According to his journal, he spent a
few years in Pompey, New York,
(where he baptized M. W. Hopkins'
sister Charlotte in 1803) and, about
1820, moved to Darien, New York.[1]
He founded the First Congregational
Society of Darien in 1823.[2] In the
late 1820s, he married Alsemeda
North, the artist's sister.[3]

In a very plain likeness, North de-
picted his brother-in-law wearing a
black coat and white stock.

The present owner is a direct descen-
dant of Reverend Wallis.

1. *Journal of Reverend Hugh Wallis,
1800–1838* (ms., on deposit, Genesee
County Historian's office, Batavia,
New York), p. 13.

2. Safford E. North, *Our Country and
Its People, A Descriptive and Biographi-
cal Record of Genesee County, New
York* (Boston, 1899), p. 163.

3. Dexter North, *John North of Farm-
ington, Connecticut and His Descendants*
(Washington, D.C., 1921), p. 63.

ELIZUR WEBSTER
Marked "Salisbury"
Warsaw, New York
c. 1920
Photograph
H. 8″ W. 6″

ELIZABETH WARREN WEBSTER
Marked "Salisbury"
Warsaw, New York
c. 1920
Photograph
H. 8″ W. 6″

Warsaw Historical Museum

These two photographs show portraits of Elizur and Elizabeth Webster, easily attributable to Hopkins or North. Undoubtedly painted in the mid-1830s, the portraits are presently unlocated.

Elizur Webster, born in East Hartford, Connecticut, in 1767, moved to Hampton, New York, as a youth and married Elizabeth Warren (b. 1774). In 1803, he acquired a tract of 3,000 acres and moved to what became the town of Warsaw. He accumulated a large fortune for his time, building the first sawmill, the first tavern, and the first cider mill. He was elected supervisor at the first town meeting in 1808. In 1813 Webster was appointed one of the associate judges of the County Court. In 1816 and 1817 he was a representative for Genesee County in the General Assembly and in 1821 he was a member of the constitutional convention of the state. In 1838, Webster sold his farm in Warsaw and moved to Chautauqua County, where he died in 1854.[1]

1. Andrew W. Young, *History of the Town of Warsaw, New York* (Buffalo, New York, 1869), p. 347.

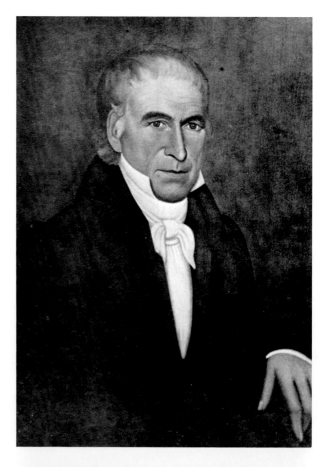

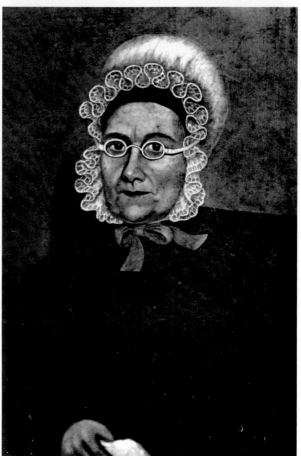

VIRGINIA ADA WRIGHT
Attributed to M. W. Hopkins
Probably Columbus, Ohio
c. 1840
Oil on canvas
H. 42″ W. 26″

Private Collection

Born in 1835 in Columbus, Virginia was the daughter of Smithson and Matilda Wright. Her father was prominent in Columbus, serving as county auditor, mayor (twice in the late 1830s and early 1840s) and as clerk of the Ohio House of Representatives. She died in 1909.[1]

Many of the elements seen in this portrait are also present in the portrait of Martha Ellen Connell, done about 1838 in Lancaster, Ohio, just outside Columbus. Hopkins' studio was located on High Street in Columbus, across from the Ohio State House. It is interesting to note that Smithson Wright, an influential man in Columbus, chose Hopkins to paint his daughter's portrait when there were many academically-trained artists also working in the city.[2]

The portrait is owned by a direct descendant.

1. Letter to the author from the owners, February 3, 1987.

2. One of the most notable is William Bambrough (1792–1860). See Edna M. Clark, *Ohio Art and Artists* (Richmond, Virginia, 1932).

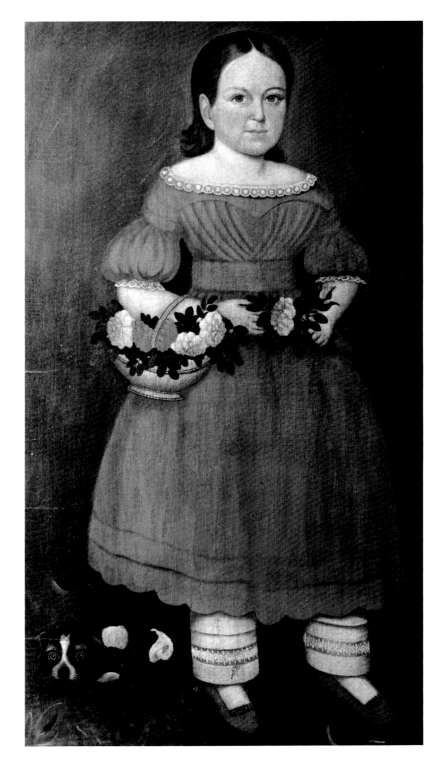

BOY HOLDING DOG
Attributed to M. W. Hopkins
Possibly Medina, New York
c. 1835
Oil on wood panel
H. 20¾″ W. 17½″

Abby Aldrich Rockefeller Folk
Art Center

Based on the similarities of this por-
trait to those seen in the portrait of
Marietta Ryan, and details in the
frame construction, *Boy Holding Dog*
may also have been a Ryan child. As
has been noted, the artist probably
relied on a popular illustration when
he rendered the puppy.[1] The likeness
remains one of the artist's most sen-
sitive and endearing.

1. Beatrix T. Rumford (ed.), *Amer-
ican Folk Portraits Paintings and Draw-
ings from the Abby Aldrich Rockefeller
Folk Art Center* (Boston: New York
Graphic Society in Association with
the Colonial Williamsburg Founda-
tion, 1981), p. 145.

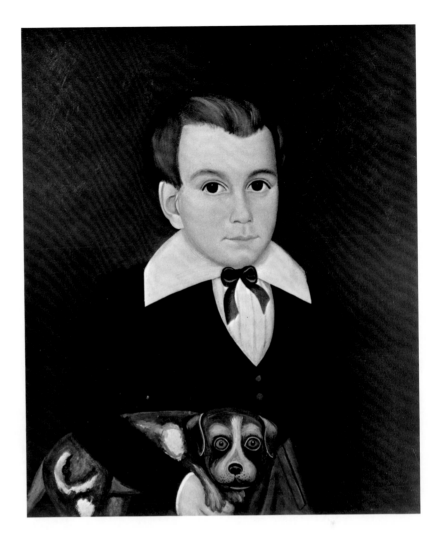

GIRL WITH FLOWER BASKET
Attributed to M. W. Hopkins or Noah North
Probably Orleans County, New York
c. 1835
Oil on wood panel
H. 27″ W. 21″

Abby Aldrich Rockefeller Folk Art Center

Girl with Flower Basket closely resembles the portrait of H. M. Cox, owned by the Munson-Williams-Proctor Institute and another *Girl with Flower Basket*, in a private collection.

As has been observed, the artist kept a great deal of the color value in the little girl's dress by depicting most of the shadow areas with base pigment rather than black or earth tones. Her dress is almost as strong a color statement as the flowers and her coral necklace.[1]

1. Beatrix T. Rumford (ed.), *American Folk Portraits Paintings and Drawings from the Abby Aldrich Rockefeller Folk Art Center* (Boston: New York Graphic Society in Association with the Colonial Williamsburg Foundation, 1981), p. 144.

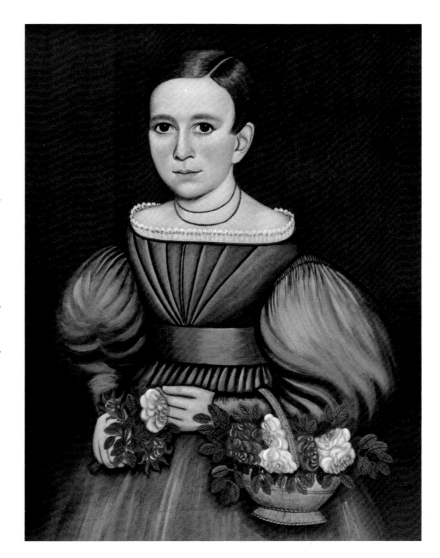

GIRL WITH CORAL
NECKLACE
Attributed to M. W. Hopkins or
Noah North
c. 1840
Oil on canvas
H. 20″ W. 16″

Whereabouts unknown

The young girl is shown wearing an
elaborate coral necklace and ruffled
dress.[1] The painting was offered for
sale in 1943, but attempts to locate it
have been unsuccessful.[2]

1. Nancy C. Muller and Jacquelyn
Oak, "Noah North (1809–1880),"
The Magazine Antiques (November
1977), p. 945.

2. *The Old Print Shop Portfolio* (April
1943), p. 191.

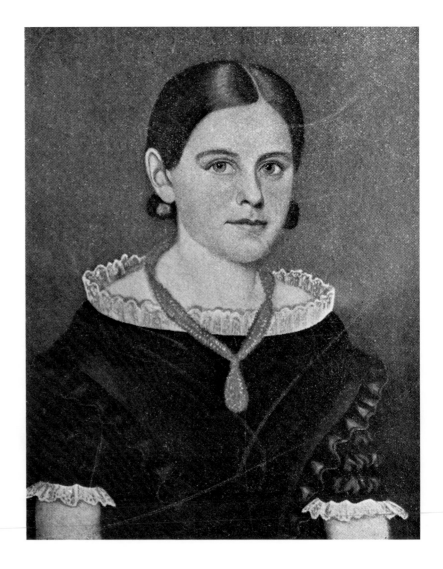

MAN IN BLACK COAT
Attributed to M. W. Hopkins or
Noah North
c. 1833
Oil on wood panel
H. 30″ W. 24″

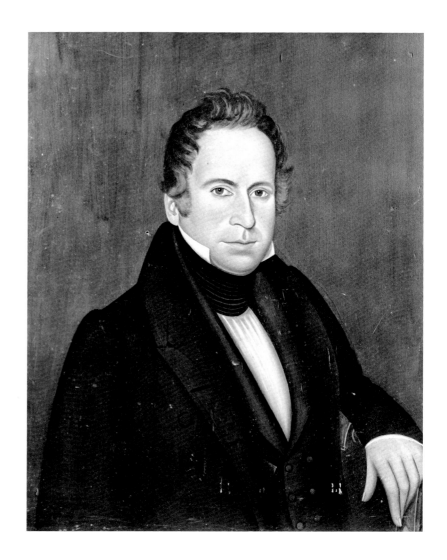

**WOMAN IN LACE COLLAR
AND CAP WITH RIBBONS**
*Attributed to M. W. Hopkins or
Noah North*
c. 1833
Oil on wood panel
H. 30″ W. 24″

Whereabouts unknown

In 1973, these companion portraits
were in the collection of Mr. and
Mrs. Peter Tillou.[1]

1. See *Nineteenth-Century Folk Paint-
ing: Our Spirited National Heritage*
(Storrs, Connecticut: William Ben-
ton Museum of Art, 1973), Illustra-
tion 88, and p. 180.

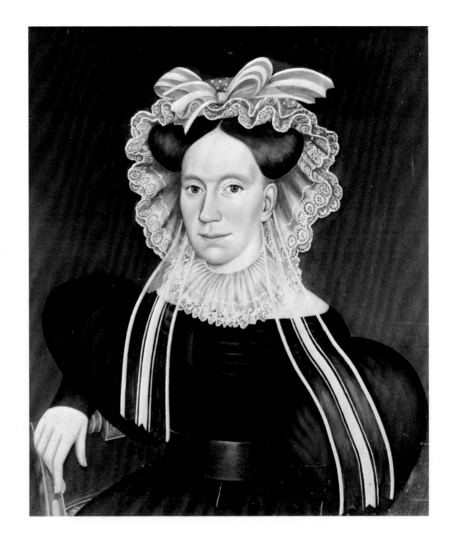

**MAN WITH THE
MISSIONARY HERALD**
*Attributed to M. W. Hopkins or
Noah North*
1837
Oil on wood panel
H. 28″ W. 23½″

Dr. and Mrs. Ralph Katz

As is suggested by the inclusion of
the January 1837 copy of *The Mis-
sionary Herald*, published in Boston,
the sitter may be the Reverend John
Eddy Chandler (1817–1894), hus-
band of M. W. Hopkins' daughter
Charlotte Maria. In 1846, the
Chandlers and their four children
were sent by the American Board of
Commissioners for Foreign Missions
to Madura, India, where they were
missionaries for 40 years.[1]

1. Timothy Hopkins, *John Hopkins
of Cambridge, Massachusetts and Some
of His Descendants* (San Francisco:
Stanford University Press, 1932),
p. 226.

GENTLEMAN IN YELLOW VEST
Attributed to M. W. Hopkins or Noah North
c. 1835
Oil on wood panel
H. 27″ W. 21⅛″

New York State Historical Association, Cooperstown

This painting remains a puzzle. Many of its stylistic attributes closely relate to the work of Hopkins and North (or another painter who was familiar with their style). The rendering of the clothing, including the intricate floral pattern of the vest, the shirt collar, and the impasto on the buttons, is characteristic of Hopkins and North. The warm tones seen in the subject's face contrast sharply with the black jacket and dark brown background, another detail frequently found in the artists' portraits. The man's features, however, obviously painted quickly in a "shorthand" manner, are inconsistent with the naturalistic facial forms usually achieved by Hopkins and North.[1] On the verso, a chalk sketch of a man placed high on the support suggests that the artist had a false start and reversed the board.

The portrait poses several questions: was it painted by more than one person (i.e., one person painted the body, another painted the head)? Was it painted by someone who was familiar with some elements of the work of Hopkins and North, but lacked the technical skill necessary to capture a "correct likeness"? Is the portrait an example of the work of one of Hopkins' other students, such as Alpheus Barrett? If the portrait was commissioned for a set fee, did the artist spend so much time detailing the clothing that he ran out of time to paint the face? As research progresses and other examples of the portraits of Hopkins' students are documented, perhaps the artist who created *Gentleman in Yellow Vest* can be conclusively identified.[2]

1. Paul S. D'Ambrosio and Charlotte M. Emans, *Folk Art's Many Faces Portraits in the New York State Historical Association* (Cooperstown, New York: 1987), pp. 182–184.

2. Folk art scholar Helen Kellogg has suggested that the artist may have been Maine painter Royall Brewster Smith (1801–1849).

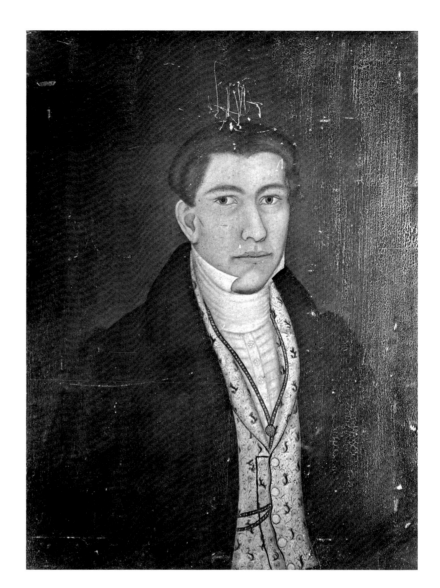

PORTRAIT OF A YOUNG WOMAN
Attributed to M. W. Hopkins or Noah North
c. 1835
Oil on wood panel
H. 30″ W. 25″

Dr. and Mrs. Fouad A. Rabiah

The unidentified young woman bears an upswept hairstyle and gold jewelry, stylistic features found in other portraits by the artist. The red book adds a touch of color to the otherwise somber composition.

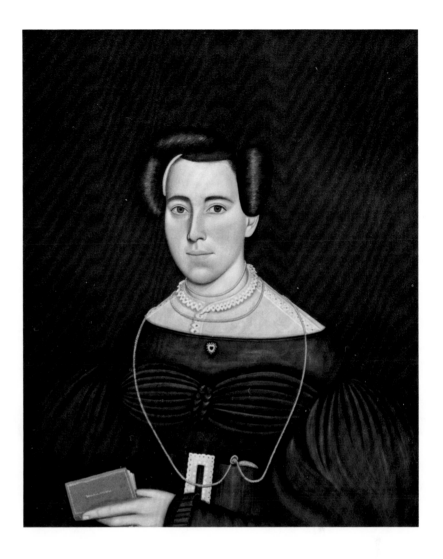

UNIDENTIFIED MAN
M. W. Hopkins
Albion, New York
1833
Inscribed, "Taken March 1833 at
Albion / M. W. Hopkins / M.W.H";
with label reading, "Portrait Painting
/ M. W. Hopkins, / Limner, / Will
pursue his Profession in this place for
a short time. / Ladies and Gentlemen
/ are respectfully invited to call at his
room and examine specimens of his
work. / T. C. Strong's Print,
Albion."
Oil on canvas
H. 30" W. 25⅞"

New York State Historical
Association, Cooperstown

This likeness, with its extensive
documentation linking it to M. W.
Hopkins, prompted the re-evaluation
of the body of work once ascribed
to Noah North. Now one of nine
known portraits signed by Hopkins,
it exhibits many stylistic traits closely
linking Hopkins' work to that of
North. The subject is seated on a
Hitchcock-type stenciled chair with
one arm draped over the top rail, a
pose frequently used by both artists.
The inclusion of the chair is signifi-
cant because both Hopkins and
North were active in ornamental
painting, and Hopkins was a chair
maker and gilder.[1] The clearly de-
fined facial features, prominent ear
with a D-shaped inner area, high-
lighted pupils and pterygium (the
inner corner of the eye), square blunt
fingernails, impasto on shirt and vest
buttons, and muted brown back-
ground are stylistic features of both
painters. Of Hopkins' sitters, the
well-modeled face has a more three-
dimensional, naturalistic quality than
is evident in North's portraits.

Although the earliest references to
Hopkins as a portrait painter date
from March 1833,[2] he must have
been painting portraits as early as
1830.[3] The label originally affixed to
the back of this portrait not only re-
veals that Hopkins pursued portrait
painting in Albion in 1833, it links
Hopkins with Timothy C. Strong,
printer, editor, and publisher of the
*Orleans Advocate and Anti-Masonic
Telegraph*. Strong, like Hopkins, was
a leading figure in the anti-Masonic
movement in Albion.[4]

The portrait was given to the New
York State Historical Association by
Bertram K. and Nina Fletcher Little
in 1971. Mrs. Little remarked about
the portrait,[5] "I remember the paint-
ing had an interesting old painter's
label attached to the back. It was for
this reason I picked up the picture,
which was not in very good condi-
tion. I knew someone would find
out about Hopkins someday."

1. Paul S. D'Ambrosio and Charlotte
M. Emans, *Folk Art's Many Faces Por-
traits in the New York State Historical
Association* (Cooperstown, New
York: New York State Historical
Association, 1987) pp. 100–101.

2. *The Orleans Advocate and Anti-
Masonic Telegraph* (Albion, New
York), March 20, 1833.

3. *The Craftsman* (Rochester, New
York), December 22, 1830.

4. Elijah J. Roberts, editor of *The
Craftsman*, vilifies Strong regularly
in print, usually referring to him as
"Judas Iscariot." In an editorial in
1829, Roberts attacks Albion, pre-
sumably because of Strong and Hop-
kins, in an account of a trip he took
from Rochester to Buffalo: "On the
dawn of day we found ourselves ap-
proaching the village of Albion, the
county of Orleans. The celebrity
which this place has acquired from
the intolerance of some of its citi-
zens, and the bitterness and malevo-
lence with which all good men are
persecuted and hunted down induced
us to continue our voyage without
stopping." *The Craftsman* (Rochester,
New York), August 4, 1829.

5. Conversation with the author,
May 24, 1984, Brookline, Massachu-
setts.

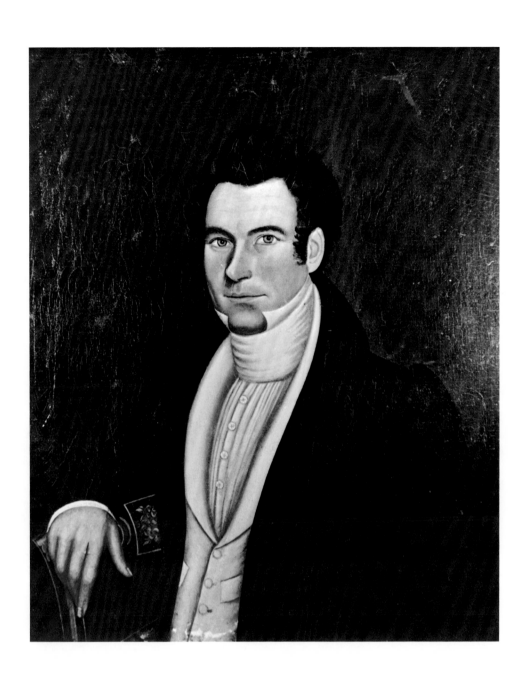

PORTRAIT OF MAN
Attributed to M. W. Hopkins or
Noah North
c. 1835
Oil on wood panel
H. 27½" W. 21⅞"

The Art Institute of Chicago

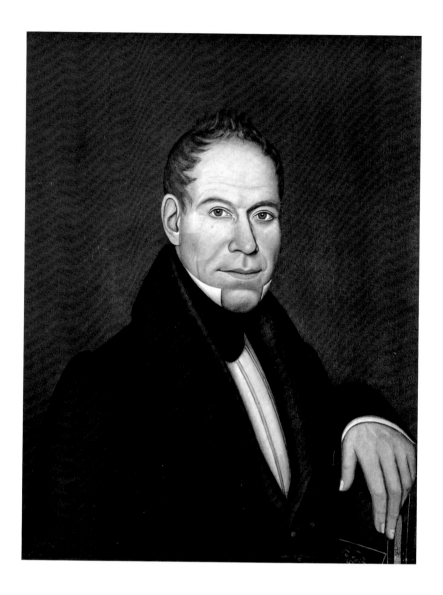

PORTRAIT OF WOMAN
Attributed to M. W. Hopkins or
Noah North
c. 1835
Oil on wood panel
H. 27⅝″ W. 22¼″

The Art Institute of Chicago

The identities of the sitters remain
unknown. The portraits follow a
typical Hopkins and North pattern.

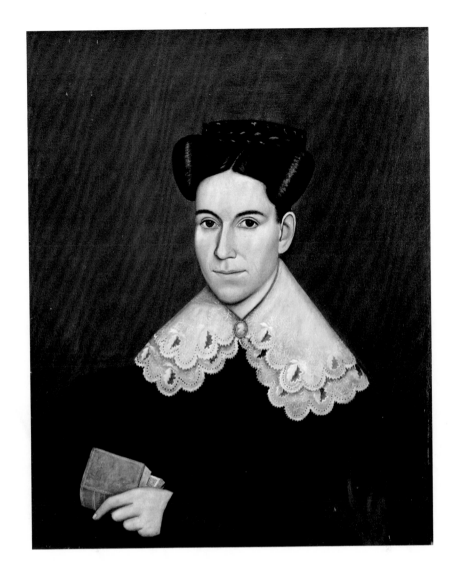

Meriden-Stinehour Press
Composition, Printing and Binding

Richard Pace
Design